Arts of the
Pacific Islands

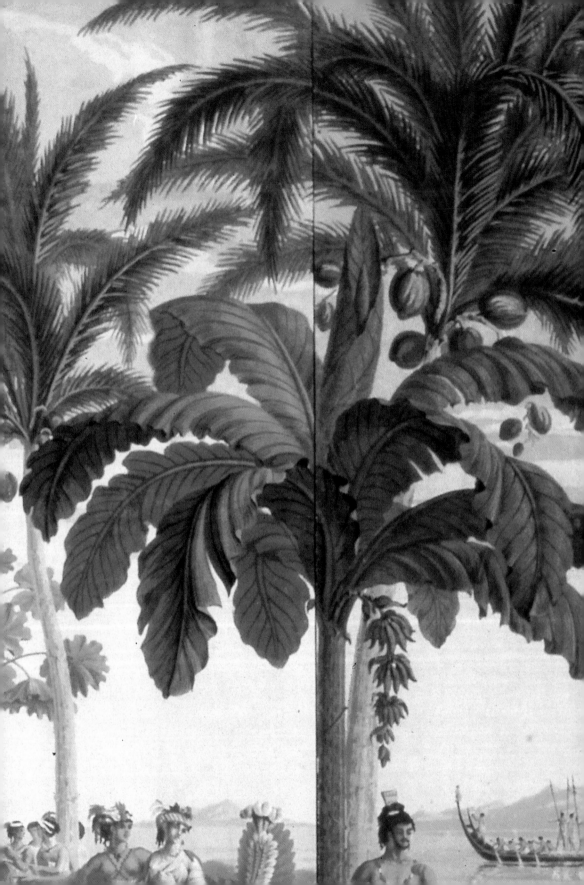

Arts of the
Pacific Islands

Anne D'Alleva

PERSPECTIVES

HARRY N. ABRAMS, INC., PUBLISHERS

Acknowledgements

This book is intended as an introduction to some of the principal themes and issues of Pacific Islands art. My hope is that it will foster greater appreciation and understanding of Pacific art, for it grows out of my own respect and enthusiasm for these traditions.

Among friends and colleagues, I would like to thank Suzanne Preston Blier, Natalie Boymel Kampen, Kent Holland, and, especially, Martha Grimes, for their sound advice and encouragement. Michael Gunn, Leonard Mason, Michael O'Hanlon, Karen Stevenson, Jim Vivieaere, and Virginia-Lee Webb all made helpful suggestions. Douglas Newton made many valuable suggestions in the course of this project and reviewed the chapter on New Guinea, for which I thank him. Jerome Feldman's review of the Micronesian chapter is also much appreciated. Peter Gathercole read the manuscript with sensitivity and insight, and I am grateful for his contributions.

At Calmann & King, Lee Ripley Greenfield, Jacky Colliss Harvey, and Kara Hattersley-Smith provided expert editorial guidance. Tim Barringer and Eve Sinaiko both contributed substantially to the cogency of the arguments presented here. I am especially grateful to Susan Bolsom-Morris for her hard work and resourcefulness in assembling the illustrations. Numerous individuals and institutions generously supplied both images and information, for which I thank them.

Finally, I would like to thank my parents, Nicolo and Maureen D'Alleva, and my sisters Catherine and Mary for their constant encouragement. Very special thanks are due Bill Lynn, without whose loving support I could not have completed this project. This book is dedicated to my nephew Rory, whose enthusiasm for words and images has been both a joy and an inspiration.

Frontispiece *Savages of the Pacific*, 1804–5, pages 26–7 (detail)

Series Consultant Tim Barringer (University of Birmingham)
Series Manager, Harry N. Abrams, Inc. Eve Sinaiko
Senior Editor Kara Hattersley-Smith
Designer Karen Stafford
Cover Designer Judith Hudson
Picture Editor Susan Bolsom-Morris

Library of Congress Cataloging-in-Publication Data

D'Alleva, Anne.
 Arts of the Pacific islands / Anne D'Alleva.
 p. cm. — (Perspectives)
 Includes bibliographical references and index.
 ISBN 0-8109-2722-5 (pbk.)
 1. Ethnic art — Oceania. I. Title. II. Series: Perspectives
(Harry N. Abrams, Inc.)
N7399.7.D36 1998
709'.95 — dc21 97–22414

This book was produced by Calmann & King Ltd, London
Printed and bound in Hong Kong

Harry N. Abrams, Inc.

100 Fifth Avenue

New York, N.Y. 10011

www.abramsbooks.com

Contents

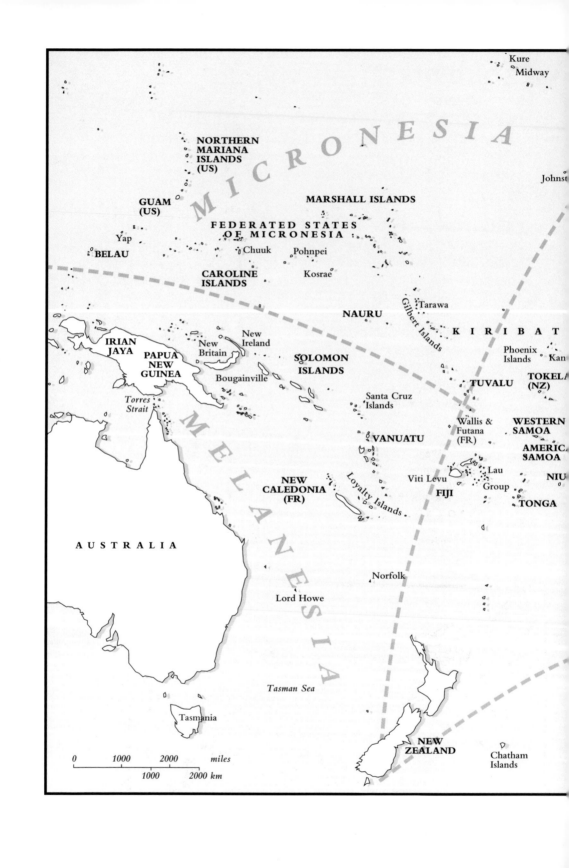

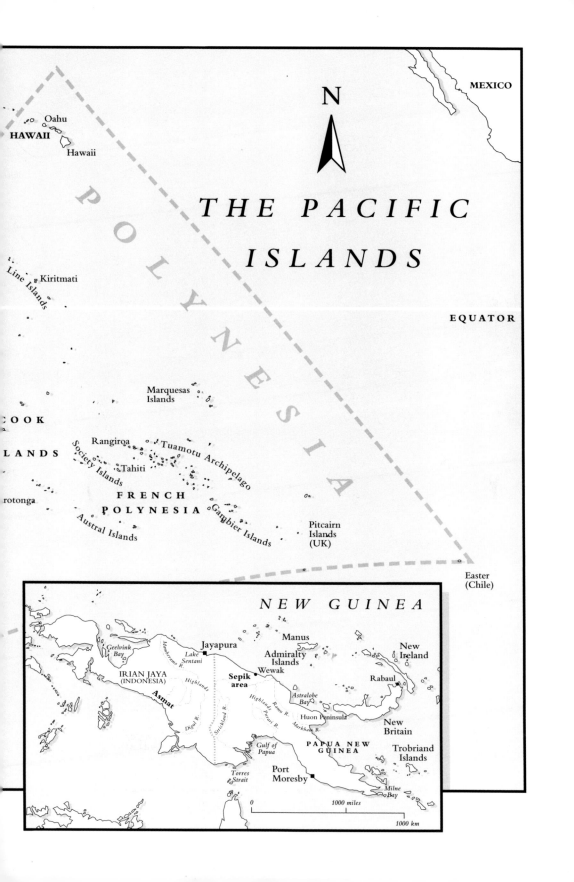

MEXICO

N

THE PACIFIC ISLANDS

EQUATOR

Oahu
HAWAII
Hawaii

Line Islands
Kiritmati

POLYNESIA

Marquesas
Islands

COOK

LANDS

Rangiroa
Society Islands
Tahiti
Tuamotu Archipelago

rotonga

FRENCH POLYNESIA
Gambier Islands

Austral Islands

Pitcairn
Islands
(UK)

Easter
(Chile)

NEW GUINEA

Manus
Geelvink
Bay
Mamberamo R.
Lake
Sentani
Jayapura
Admiralty
Islands
Wewak
New
Ireland
IRIAN JAYA
(INDONESIA)
Highlands
Sepik area
Rabaul
Asmat
Highlands
Astralobe
Bay
Ramu R.
Huon Peninsula
New
Britain
Digul R.
Strickland R.
Purari R.
Markham R.
Gulf of
Papua
PAPUA NEW GUINEA
Trobriand
Islands
Torres
Strait
Port
Moresby
Milne
Bay

0 1000 miles
 1000 km

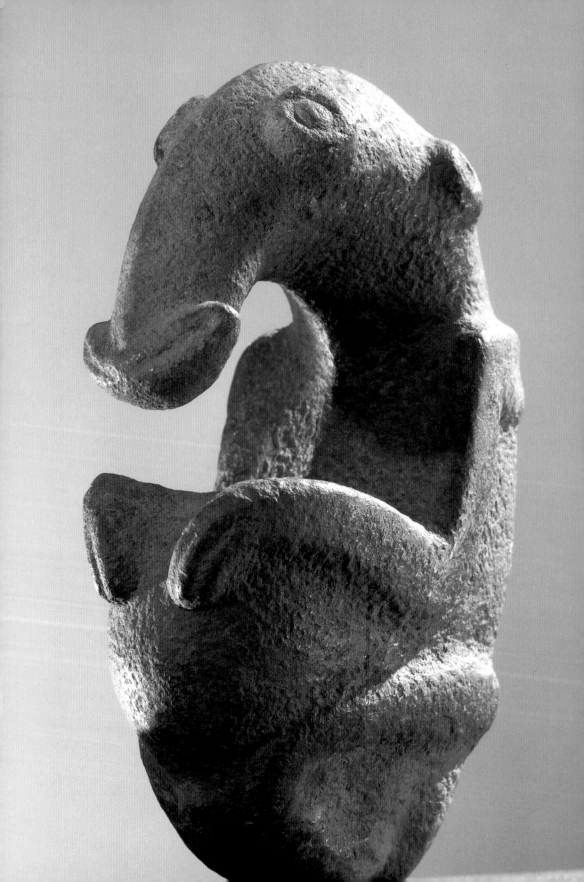

The Power of Pacific Art

1. The Ambum Stone, prehistoric period. Ambum Valley, Western Highlands Province, Papua New Guinea. Igneous rock, 7¼ x 5½ x 3" (19.8 x 14 x 7.5 cm). National Gallery of Australia, Canberra.

"Art of the Pacific Islands." The phrase itself conjures up images of the exotic and the fabulous in the Western imagination. Every student of art knows that Gauguin found his richest inspiration in Tahiti and the Marquesas Islands, that Picasso combed the flea markets of Paris for Pacific sculpture to decorate his studio. The Surrealists felt a deep affinity with Pacific art, which they thought was inspired by spirits and dreams just as their own work was. On a Surrealist map of the world published in 1929, Easter Island, the Bismarck Archipelago, and New Guinea loom large. They dwarf the apparently more rational and thus less interesting areas of the world, such as Europe and the United States, which has entirely disappeared (FIG. 2).

Of course, it is easy to recognize this map as a fanciful expression of Surrealist tastes and interests, especially in its presentation of the Pacific Islands as places that can grow and change shape and that are literally "larger than life." But for all the Surrealists' inventiveness, such romantic and primitivist attitudes toward the Pacific did not originate with them, but have a long and complicated history that continues to shape Western responses to Pacific art today. Just as a bird-shaped Easter Island dominates the lower corner of the Surrealist map, the monumental stone figures of this small, isolated island dominate the Western idea of Pacific art. Among the most immediately and widely recognized Pacific art forms, Easter Island figures have served as a touchstone for all the ideas and emotions that Westerners have invested in their image of the Pacific, whether that image is of cultures that are a Paradise Lost, civilized or heathen, primitive or sophisticated (FIG. 3). In the eighteenth century alone, the Dutch explorer Jacob Roggeveen called Easter Island figures "idols" and Captain James Cook,

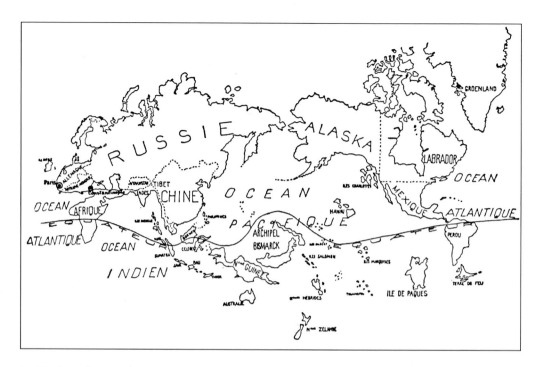

the English navigator, identified them as "monuments of antiquity" that marked burial places. In the preface to the official account of Cook's third voyage (1776–80), John Douglas noted, "a *feeling imagination* will probably be more struck with the contemplation of the colossuses of Easter Island, than of the mysterious remains of Stonehenge."

As fascinating and instructive as it is to study the European response to Pacific art, it is important to remember that Pacific art traditions have their own rich and complicated histories, and this book will focus on these other contexts for the arts of the Pacific Islands. In doing so, the intention is not to remove these works from the Western imagination – far from it. Rather, it is to give that visual power, that imaginative hold, another cast. Knowing the use and meaning of the objects within their own culture, explaining the power invested in and the aesthetic import of these works of art by those who made and used them, can enhance their visual effect, the almost visceral impact that they can have on Western viewers in their dazzling display of wood and stone, fiber and feathers.

Current scholarship, for example, suggests that Easter Island figures probably represented ancestors and that the open-air structures they adorned served as centers of worship. Quarried in Easter Island's volcanic mountains (mostly from one crater), the figures were partially sculpted there and then dragged miles to their final

locations. These statues belong to a tradition of monumental stone figures stretching from the Marquesas to the Austral Islands, and the architectural complexes they adorned have counterparts in the Society Islands, Tuamotus, and elsewhere in Polynesia. The richness of this story, the human achievement it describes, is a more profound and awe-inspiring reflection of the greatness of these sculptures than any fantastical imaginings.

As the cultural critic André Malraux (1901–76) once proposed, any art book can be a *musée imaginaire* – an "imaginary museum." In that spirit, this book takes the reader on an imaginary journey through the art of the Pacific Islands. It creates a gallery of images without having to observe the limitations imposed by space and time, or the weaknesses and strengths of any given museum collection. In order to give some insight into the profound meanings and visual richness of Pacific Islands art, it gathers together objects ancient and contemporary, and invites the reader to distant places and performances.

Of course, even a *musée imaginaire* is subject to certain limitations. The works of art cannot be seen in three dimensions or in motion, cannot be touched or smelled, cannot be performed. The reader easily recognizes and adapts to these conditions. More important, however, the very resources for Pacific art history impose limitations on our ability to understand these art traditions, for the documentation on which scholarship relies is often fragmentary and varied in nature. Though many Pacific art traditions

3. Stone figures on Ahu Naunau. Anakena, Easter Island (Rapanui), Chile.

The stone figures stand on a platform, *ahu*. The *ahu* was the focus of a ceremonial center, which usually also incorporated a ramp and a courtyard.

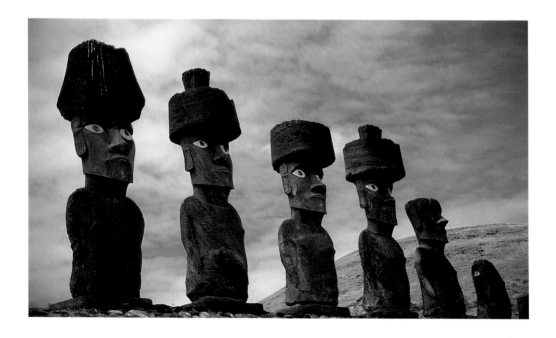

first observed by Europeans in the eighteenth or nineteenth centuries continue as vital cultural expressions today, others are no longer actively practiced, indeed some were suppressed by missionaries and colonial administrators. Those that have survived have changed and grown as they were passed on from generation to generation. The sources of information on historic works – the collections, written accounts, and visual images of explorers, missionaries, colonial officials, travelers, scholars, and Pacific islanders themselves – are varied in their perspectives, the questions that they posed and were able to answer, the objects they preserved and destroyed.

In spite of the difficulties and limitations that confront any explanation and discussion of Pacific art, what does remain, one hopes, is the sense of awe, the admiration for arts that are both beautiful and profound, with a history that commands our respect both for what we can know of it and what we cannot.

Art and Prehistory in the Pacific

The story of Pacific art begins with the human expansion into the region around 45,000 years ago, during the last Ice Age. At this time, when the oceans had receded well below their current levels, a great continental shelf called Sahul incorporated the present land masses of Australia (including Tasmania) and New Guinea and the large islands of New Britain and New Ireland close by. Narrow, easily navigable waterways separated Sahul from another continental shelf, Sunda, which included the present Indonesia and the Philippines. Sunda was the departure point for the first human migrations into the Pacific. Nothing has yet been discovered of the art traditions of these first Pacific peoples, probably because the earliest sites, on the coasts of Sahul, are now submerged. These peoples may have worked stone for tools and ornaments, and made cloth and baskets of plant materials and body paints of earth pigments.

The earliest known Pacific art consists of stone figures, and mortars and pestles from the highlands of Papua New Guinea. Most of these figures have not been excavated in controlled archaeological situations, but have been found during the construction of roads and gardens. As a result, they often cannot be dated with real accuracy. Nonetheless, most scholars believe that the earliest of them are around 8000 years old. Made of pecked and ground stone, these sculptures exhibit a high level of technological and aesthetic sophistication. The imagery presents a mixture of bird, animal, and human motifs that suggests rich spiritual

meanings. In a figure from the Western Highlands an animal head with an elongated snout, perhaps representing an anteater, is set on a human body, seated with hands perched on bended knees (FIG. 1). Other artworks from this area include sculptures of small animals, pestles in the form of phallic birds, and bowls shaped like birds with spread wings.

As the Ice Age ended and the sea waters rose, the descendants of these first migrants into the region, the Papuan-language speakers, continued to settle the vast and newly formed island of New Guinea as well as other islands. A very different culture, called Lapita after a site discovered in the Reef Islands of Santa Cruz, begins to appear in the archaeological record around 2000 BCE (before the common era, or BC). These groups spoke Austronesian languages that were quite distinct from the Papuan languages of their predecessors. The origins of the Lapita are unclear. One theory proposes that the Lapita peoples originated in eastern Indonesia or the Philippines, and from there migrated to northwestern Melanesia. Another theory suggests that the culture developed in New Britain and New Ireland and subsequently expanded to Vanuatu, New Caledonia, and Fiji, Tonga, and Samoa. Lapita sites are often located along coastlines rather than inland, suggesting that they were primarily seafaring traders and not settled agriculturists. The archaeological record shows, for example, that the people of the Lapita culture traded obsidian from sources in the Admiralty Islands and New Britain to New Caledonia for hundreds of years.

The arts of the Lapita people are known archaeologically through a variety of artefacts, including ceramics, personal ornaments, and stone and shell tools. The ceramics exhibit a high degree of aesthetic sophistication, and are covered with intricate geometric patterns applied with toothed stamps. These designs may relate to Lapita barkcloth patterns and tattoos that have not been preserved archaeologically, for, in historic times, these art forms have often drawn on a common body of motifs. The geometric designs appear on pottery throughout the vast areas settled by the Lapita, suggesting that they maintained a high degree of cultural uniformity despite the extent of their settlements. Lapita designs share several motifs with the art of the contemporary Dong Son peoples of Southeast Asia, which in turn is evidence of the complexity of cultural and trading relationships in this region of the world.

Although figurative art is relatively rare in the Lapita tradition, some of the excavated ceramics and potsherds include human faces and figures. One of the most famous examples, excavated in

the Solomon Islands and dating to about 1000–900 BCE, presents a stylized human figure (FIG. 4). An oval face is set on an inverted triangle flanked at each side by a circle containing a quatrefoil floral motif. These geometric elements may represent an abstract human body; the facial features themselves are simple and stylized, but certainly not abstract. Each part of the composition is articulated by bands of stamped motifs. Scholars often interpret such Lapita designs, both geometric and figural, as the source of much later Melanesian and Polynesian imagery.

4. Design from Lapita pottery vessel, c. 1000–900 BCE (detail). Gawa, Reef Islands, Solomon Islands.

Lapita potters used a variety of tools, including toothed combs and styluses, to impress designs in the wet clay.

The Lapita culture spread through the western Pacific, as far as Samoa and Tonga, and in each island group it differentiated, adapting to the local environment and developing unique histories. As the Lapita people expanded, they lost the cultural unity that so marked the earlier phases of their history, but, along with the earlier Papuan peoples, they contributed to some of the diverse cultures of the Pacific that exist today. In western Polynesia, separated from the Lapita cultural centers in island Melanesia by long distances, Lapita culture gave way early in the first millennium to specifically Polynesian cultures. Developments included a shift to undecorated pottery and a change in the shape of adze blades. By about 300 BCE in Samoa and Tonga, pottery disappeared, possibly supplanted by the polished wooden bowls that are so characteristic of later Polynesian art traditions.

In order to traverse these great distances, the Lapita must have been skilled navigators and sailors, just like their descendants, the Polynesians. Navigational techniques still in use in Micronesia may provide insights into the ancient traditions of Lapita and Polynesian seafaring. In traditional navigational schools on Puluwat in the Caroline Islands, students learn how to sail outrigger canoes. As Puluwat sailors conceptualize a voyage between two islands, it is the islands that move rather than the canoe: the starting point recedes as the destination approaches. Puluwat map the skies by the constellations and the ocean by its distinguishing features: islands, reefs, swells, areas of rough water. Similarly, a Marshall Islands stick chart uses shells to indicate specific islands and patterns of sticks lashed together to illustrate currents and common wave formations in a form that is both supremely functional and aesthetically appealing (FIG. 5).

Opposite
5. Sailing chart. Marshall Islands. Wood, shells, and vegetable fiber, 3'3¼" (1 m). Collected by Admiral Davis during the cruise of HMS *Royalist*, 1890–93. British Museum, London.

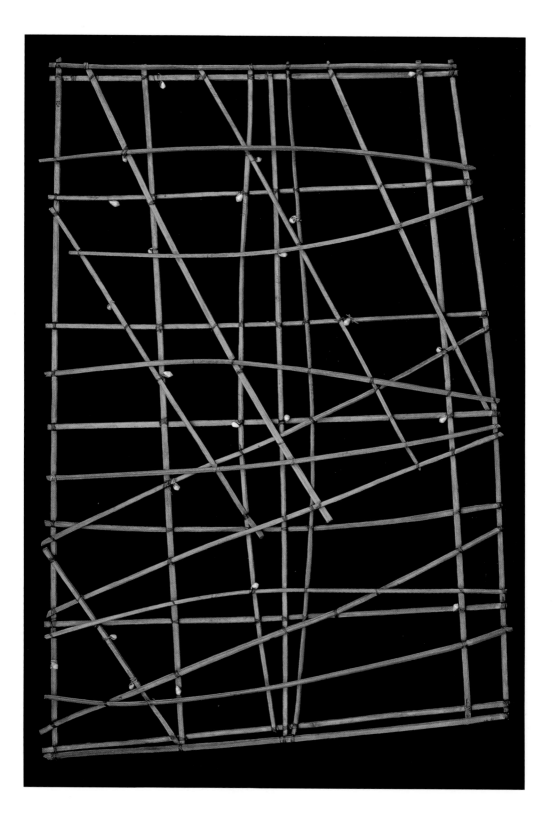

Culture Areas of the Pacific

When Europeans began to explore the Pacific in the sixteenth century, they noted with astonishment both the variations in cultures and peoples that they met and also remarkable continuities in culture and population over long distances. To account for both the differences and similarities between cultures in widespread parts of the Pacific, the French explorer J. S. C. Dumont d'Urville (1790–1842) proposed in 1831 a division of the Pacific into three regions: Melanesia ("black islands"), Polynesia ("many islands"), and Micronesia ("small islands"). Melanesia encompasses the islands known as New Guinea, the Admiralty Islands, New Britain, New Ireland, New Caledonia, the Solomon Islands, and Vanuatu, among others. Polynesia includes a vast triangle of the Pacific Ocean, anchored at its corners by New Zealand, Hawaii, and Easter Island (Rapanui). Within the triangle are Samoa, Tonga, Fiji, the Cook Islands, Tahiti and the Society Islands, the Marquesas, the Tuamotus, and the Austral Islands. Micronesia is a large area of the western Pacific dotted with coral atolls, low islands formed of coral reefs built up on submerged volcanoes, and a few volcanic and raised islands. It includes Kiribati, Belau and the Caroline Islands, the Mariana Islands, and the Marshall Islands.

D'Urville's schema is one that is still widely used in a general way to make sense of these cultures, although there has been a change in the way in which the meaning of these cultural divisions is understood. As the translation of the terms Melanesia, Polynesia, and Micronesia makes clear, d'Urville's classification posited direct causal relationships between race, environment, and culture that are not tenable today. Nonetheless, this concept is still useful as a way of identifying regions exhibiting similarities in language, social organization, religion, economics, and artistic practice. All these characteristics are of course affected by the distinctive history and environment of any given island group and its people.

In terms of social organization Melanesian cultures are broadly speaking relatively open to the advancement of individuals according to ability and wealth rather than heredity or inherited status. Grade societies, largely organized by men, focus the structures that provide social, spiritual, and political power, and serve as a forum for much artistic production. In the Polynesian islands the most important positions are inherited. The elite lineages provide most of the artistic patronage in this area and artists, *tahunga* or *kahunga*, enjoy special status. Art objects are usually designed to last, for they gain meaning and value as they are passed

down from generation to generation. In Micronesia, too, most societies are hierarchical and power tends to be passed down by birth rather than ability. Here, too, elite lineages sponsor much artwork, although the community itself can also be an important patron.

Distinctive aesthetics also characterize the visual arts of these three regions. Melanesian art employs a variety of materials, often presenting within one piece a dazzling array of organic materials, including leaves, flowers, feathers, and shells. Performance is an essential aspect of many pieces, both aesthetically and symbolically. In Polynesia, the emphasis is on fine work, finish, and polish, whether in a plaited mat, barkcloth, or wood or stone figure. The art of Micronesia is characterized by simple, elegant forms and complex surface decoration. The materials – coral, wood, fiber, shark teeth – reflect the special nature of the predominant coral-atoll environment.

The visual arts clearly demonstrate the need to think of these culture areas not as regions defined by inviolable boundaries – as if they were simply another form of the nation-state – but zones of cultural activity that shade into each other. This is as true of the visual arts as it is of language, social organization, religion, and performing arts. A canoe prow from Kaniet, a coral atoll near the Admiralty Islands, demonstrates how varied an artwork's cultural origins and associations can be (FIG. 6). Although the island is situated geographically in Melanesia, Kaniet culture also exhibits both Micronesian and Indonesian traits. The large Kaniet sailing canoes of the nineteenth and early twentieth centuries bore these tall, spiraling ornaments on both prow and stern. They were set so that they

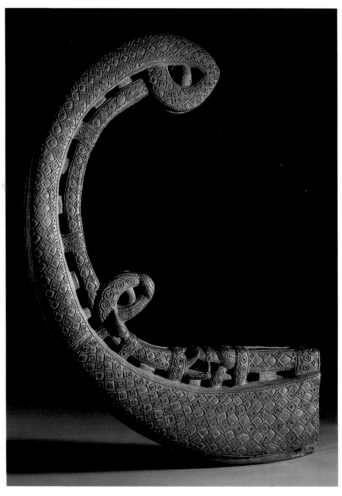

6. Canoe prow. Kaniet Manus Province, Papua New Guinea. Wood, length 18⅛" (46 cm). Otago Museum, Dunedin.

The intricate patterns carved on the prow, and painted along the length of the canoe itself, are reminiscent of the complex designs on Indonesian and Micronesian textiles.

scrolled inward, and are reminiscent of the spiraling handles of boat-shaped Admiralty Islands bowls and certain types of canoe prows found in many Melanesian cultures. This kind of spiral may in fact derive from Lapita art and so cannot be considered exclusive to Melanesia, Polynesia, or Micronesia, but must be set within the larger Austronesian cultural complex that crosses these regional boundaries. The form of the boat with scrolling prow and stern may relate to spirit-canoe ("ship of the dead") motifs common to Austronesian cultures in the areas of Indonesia, Melanesia, and perhaps Polynesia.

The division into Pacific culture areas is not a last word but a first. Just as the Surrealist map had a value in opening up to the Western world the expressive potential of Pacific cultures for their art, this tripartite division is a means of conceptually organizing and providing a means of access to the almost overwhelming array of cultures and art forms of the Pacific. In this context, it is important to be aware that organizing an image of the Pacific requires choices to be made.

Art and Power in the Pacific

Just as Pacific art has the power to move Western viewers, so too it can, within its own context, affect people, not only aesthetically but spiritually and socially as well. The use of art objects permits spirits or ancestors to be contacted and made active in this world, leaders to be inaugurated, individuals to move from childhood to adulthood or from the world of the living to the world of the dead. Seen from this perspective, art not only reflects a culture's beliefs and ways of life but also shapes important cultural values as well as community and individual experience. In this sense, Pacific art must be approached not *in* social context but *as* social context. At the same time, social forces and historical events affect the ways that artworks are made, used, and perceived. This perspective on aesthetics is critically important from an art-historical point of view. If objects are social agents, if they have the power to affect individuals and communities, they do so not only because of the way in which they are used, but also because of their appearance: what they symbolize, how they are made, and what they are made of. In this context, stylistic change is not "merely" an expression of changing taste but is charged with social and spiritual significance. This is perhaps most easily demonstrated in the historic period, particularly in accounting for the effect of missionizing and colonization in the nineteenth and twentieth centuries. The incorporation of European materials and motifs

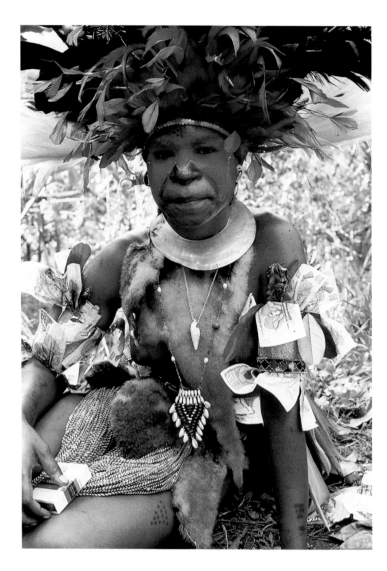

7. Kala Wala decorated for the presentation of bride wealth, 1980. Wahgi people, Western Highlands Province, Papua New Guinea.

Among her traditional feather, fiber, and shell ornaments, Kala Wala wears rip tops from beer bottles as earrings.

has sometimes signaled a profound cultural shift in the society's or individual's sense of identity and worth, but this kind of appropriation, in its selectivity, can also signal continued strength and vitality. Thus Kala Wala, a bride from the highlands of New Guinea, wears not only the traditional, treasured feather headdress and pearl shell collar but also currency notes inserted in her armbands, a gift from her natal clanspeople, as signs of her family's power and prosperity (FIG. 7).

This idea of a power in which the social, spiritual, and political are interwoven is analogous to the Pacific concept of *mana*, a word carried to all three culture regions of the Pacific by the Lapita and other Austronesian-speaking settlers. One of the few

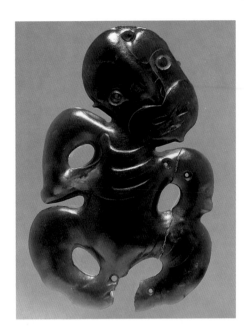

8. Pendant (*hei-tiki*), c. 1200–1500. Ngati Porou people, Maori, Aotearoa, New Zealand. Greenstone, height 4¾" (12 cm). Collection of the Hawke's Bay Cultural Trust, Napier.

This *hei-tiki* has a personal name, Rutataewhenga, because it depicts an ancestor. It is an heirloom of the Ngati Hine subtribe of Ngati Porou. The Ngati Hine are the descendants of Hinemate, a powerful woman who lived about ten generations ago. This *hei-tiki*'s history suggests that it was made at least ten and possibly twenty generations before Hinemate.

Pacific words adopted into European languages, *mana* conveys a meaning that depends on the culture. In Polynesia, *mana* can be the manifestation of the power of the gods in the human world. It is an active force, one associated with and inherited from divine ancestors. It is essential to all human endeavors, to the success of priests, warriors, leaders, and artists. In Melanesian cultures, *mana* can also be considered a force, although sometimes it is more like an invisible substance, invested in people and in objects, so that it can be said that people and human efforts and things *are mana*.

In all cultures that employ this concept, artworks are a primary way of making *mana* present in this world. Both the materials from which they are made and the images they depict address this concern. A small greenstone pendant from New Zealand is a good example of this concept, for greenstone treasures of all sorts are *manatunga*, "standing *mana*" (FIG. 8). Called a *hei-tiki*, or "ancestor pendant," these ornaments are important heirlooms, passed down through the generations and worn on important occasions, and exchanged to ratify peace treaties, alliances, funerals, and marriages. They linked ancestors and the living, collapsing the distances of space, time, and cosmos. Like other important *hei-tiki*, this example has its own personal name, and would be greeted in its own right when its custodian wore it to the *marae*, or ceremonial center.

In the Pacific, certain types of objects are invested with power and an associated aesthetic value, in ways that may be unfamiliar to a modern Western viewer. The medium, the material from which an artwork is made, is often invested with power, as in the case of the greenstone used by the Maori to make precious ornaments and heirlooms. In addition, certain artistic processes – sculpting, painting, canoe-building – may themselves be charged with spiritual power. Architecture, too, can visually and structurally organize people's experience of power in its several manifestations. In an Abelam village in Papua New Guinea, for example, the spirit house (*korambo*) is both the center of political power, where the elder men gather to discuss community affairs, and of spiritual power, where the spirits reside. Its significance is signaled visually and spatially by its soaring, peaked roof and massive size, and by the way it dwarfs the surrounding family houses (FIG. 9).

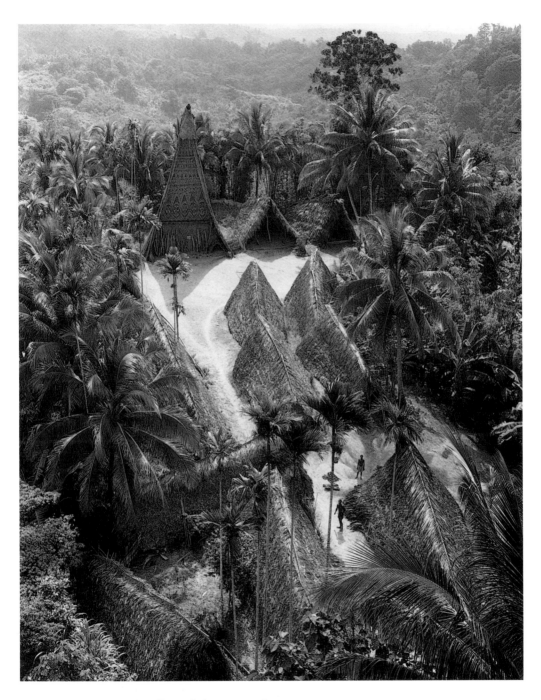

9. Aerial view of Buknitibe village. Abelam, East Sepik Province, Papua
New Guinea.

A dance called *mindja* celebrates the completion of a new spirit house. Men
and women gather from the surrounding villages to participate. This is the
only time that women are allowed to enter the spirit house.

Perhaps the clearest demonstration of the symbolic importance of the medium is in the high aesthetic and social value of cloth in the Pacific. In Western artistic hierarchies cloth is placed in a secondary position to painting and sculpture. Throughout the Pacific, however, social, political, and spiritual meanings are attached to cloth in its materials, iconography, and use. The ceremonial cloths, *machiy*, of Fais Island in Micronesia, are a good example of the visual richness and complex meanings that can characterize Pacific textiles. *Machiy* are considered sacred and are closely associated with a community's leaders, ancestors, and guardian spirits (FIG. 10). Women of certain lineages gave these cloths as tributes to a village leader who would offer them to his ancestral spirits, and then store them for later use. They were a necessary element in the initiation rituals of high-born youths, the inauguration of new leaders, and the burial of important elders. They are still used as tribute gifts and burial shrouds.

Since many Pacific cultures believe that people as well as artworks are invested or charged with power, the decoration of the body can express the power and prestige of an individual both socially and spiritually. The body can be the locus for the intersection of the human and divine, especially when ancestors become present in or through their descendants. Both the representation of the body and the rituals that focus on the body, its decoration and movement, regulate and normalize this relationship

within social intercourse. Body decoration can be permanent, as in tattoos, or in the form of regalia, such as clothing, headdresses, and jewelry. Decoration of the body can make power seem inherent in the individual, as if vested in the body itself, and helps to make the power of the individual or lineage visible and active in society.

The centrality of the body and its decoration in forming relations of power suggests that gender is a critical factor shaping the experience of the visual arts. In Pacific cultures, men and women sometimes have different roles to play as artists, viewers, and patrons. While women's artistic activity can sometimes seem less engaged than men's with the important symbolic activities of a community, their roles are often seen as culturally valuable. Among Sepik River cultures in Papua New Guinea, women generally do not enter the men's house and cannot view its most sacred treasures, such as the flutes that give voice to the ancestors, yet they are essential audiences for the public dance performances of the masks. In some Sepik cultures, women carry out the initiation of girls in ceremonies that parallel the more well-known boys' initiations. In Micronesia and Polynesia, women gain prestige as the producers of the highly decorated woven textiles and barkcloth, such as the *machiy* of Fais Island, but both men and women use them. It is important to remember that factors such as age and social status also affect an individual's experience of the visual arts, which may differ radically from the normative or usual experience.

Understanding the Context of Pacific Art

In order to understand and interpret the meaning of Pacific art, scholars rely on the accounts of Pacific Islanders themselves, as well as the works of outside observers: explorers, missionaries, merchants, scholars, and travelers. Relevant information comes from journals, logbooks, field notes, ethnographies, recordings, paintings, photographs, and drawings. As suggested above, the Western fascination with the Pacific has proved to be as revealing of Western cultural values as of those of the Pacific. In order to develop a balanced account of Pacific arts and culture, it is thus essential to evaluate sources for their perspectives and biases, conscious and unconscious, overt and covert. At the same time, it is important not to forget that these sources, both textual and visual, do also embody the values and interests of Pacific Islanders. Islanders collaborated, sometimes willingly and sometimes not, in the telling of these stories and the creation of these images, and

Opposite
10. WAISEMAL
Ceremonial textile
(*machiy*), 1976. Fais,
Caroline Islands, Federated
States of Micronesia.
Banana and hibiscus fiber,
26¾ x 82⅝" (68 x 210 cm).
On loan to the Peabody
and Essex Museum, Salem,
from Donald Rubenstein.

The complex patterns
woven into the *machiy*
include stylized human
figures and abstract motifs.
The overall design is strictly
symmetrical and
corresponds to the design
structure of other weavings,
tattoos, and the ground
plans of villages.

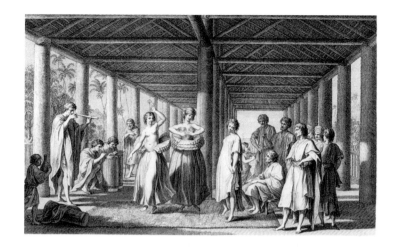

11. FRANCESCO BARTOLOZZI (1727–1815) after GIOVANNI BATTISTA CIPRIANI (1727–85) *A View of the Inside of a House in the Island of Ulietea, with a Representation of a Dance to the Music of the Country.* Engraving from John Hawkesworth, *An Account of the Voyages Undertaken by the Order of His Present Majesty for Making Discoveries in the Southern Hemisphere …* (London, W. Strahan & T. Cadell, 1773), vol. II, pl. 7.

This image was intended to have an appeal that was both sensual and philosophic. The composition is organized so that the male musicians and observers frame the dancing women as if to present them to the viewer's gaze. The viewer's eye, caught by the bold stance of the man standing on the right in the foreground, moves from right to left, from a fully draped to a half-nude figure. If the European discovery of such "Noble Savages" exposed just how corrupt more advanced civilizations had become, they also provided the possibility of reform, the idea that Europeans could create their own Tahiti, their own paradise on earth.

frequently had an ability either to provide or to withhold access to rituals, artworks, information, and interpretations.

While we usually account for point of view when reading textual sources, we are less used to examining visual images in this way. It is easy today to dismiss negative images, disseminated by missionaries and colonizers, of Pacific peoples as heathens and savages who had to be saved and civilized. It is a more complicated process to evaluate the more positive images of Pacific cultures, and to understand what they tell us about the observers as well as the observed. Any image, like any text, can be interpreted not only as fact – what was observed – but as a kind of visual allegory, that is, it tells not only a story about what it directly represents, but also another story on another level. Like textual sources, images portraying Pacific cultures reveal as much of Western world view as they do of that of the people observed. The Surrealist map of the Pacific represents the same phenomenon. It contains some elements of truth: there are islands called New Guinea and Easter Island, as marked on that map, but how they are placed and depicted tells as much about Surrealist interests as it does about the actual geography of the Pacific.

A celebrated image from James Cook's first Pacific voyage (1768–71), depicting three beautiful young Society Islands women dancing in a pavilion, is a case in point (FIG. 11). In some sense, the image is accurate: Society Islanders built open-sided pavilions such as the one depicted here, and women wore costumes with hip ruffs and voluminous skirts to perform a dance called *hura.* Cipriani, who did not accompany the voyage but worked from the drawings of the expedition artist, Sydney Parkinson, combined these elements to create an image that not only pleases the eye but invokes the figure of the Noble Savage. This subject was cen-

tral to European Enlightenment philosophy of the eighteenth century, which was characterized by a belief in natural laws, rationalism, and science. As conceived first by John Dryden (1631–1700) and then elaborated by Jean-Jacques Rousseau (1712–78), the Noble Savage lived a simple life guided by good instincts in a way lost to Europeans. The Classical inspiration of Cipriani's scene – from the columns of the pavilion to the togalike drape of the men's garments, and the gestures borrowed from Greek and Roman art – establishes the dignity and worth of Tahitian culture for a European audience. The devotion to pleasure, music, and dance, and the unselfconscious nudity of the dancer on the left demonstrate the Tahitians' supposed state of innocence, uncorrupted by the prudish concerns of civilized society. However, in order to achieve these effects, Cipriani is not always faithful to Parkinson's drawings or voyage accounts: *hura* dancers performed in unison, and the female figure on the right is taken from a drawing that does not depict a dancer at all but simply a woman wearing a tunic. In short, while Cipriani's print does record a great deal of what travelers saw, it also clearly reflects European responses to Tahitian culture. Not surprisingly, the images from Cook's voyages were widely disseminated and inspired numerous copies in a variety of media (FIG. 12).

Just as challenging are images from the nineteenth and early twentieth centuries that present Pacific cultures as dying civilizations, a particularly potent image in the colonial context as Pacific Islanders were being forced off their lands and were suffering depopulation as a result of introduced diseases, warfare, and cultural disruption. *Maori Women Weaving Flax Baskets* by the New Zealand painter Gottfried Lindauer (1839–1926) is replete with ethnographic detail: the carving of the house, the types of baskets the women make, the flax cloaks that they wear are all meticulously observed (FIG. 13). The combination of elements is odd, however, and designed to showcase as many aspects of Maori culture as possible, rather than to portray an actual scene of basketmaking. This image of patient basketmakers, living out their "primitive" and unchanging culture, their dreamy expressions conveying a sense of timelessness, would have provided a powerful contrast to New Zealand's rapid economic development at the beginning of the twentieth century and its important role as a self-governing colony within the British Empire. With a strong sense of their own modernity, white New Zealanders might well have keenly felt the quiet pathos inherent in the idea that the Maori, here depicted as timeless and unchanging, were bound inevitably for extinction. At the time, the *New Zealand Herald* reported

12. *Savages of the Pacific*, 1804–5. Wallpaper by J. C. Charvet, printed by Dufour. Paper, inks, each section 77 x 21" (195.6 x 53.3 cm). Honolulu Academy of the Arts, Honolulu.

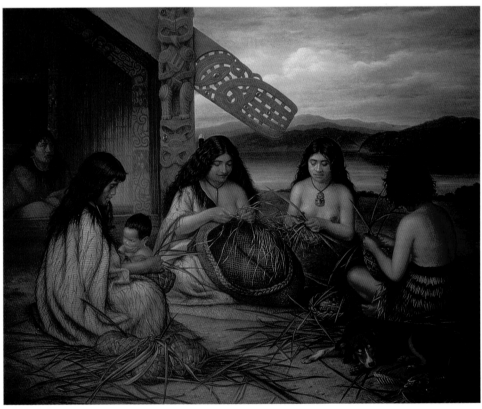

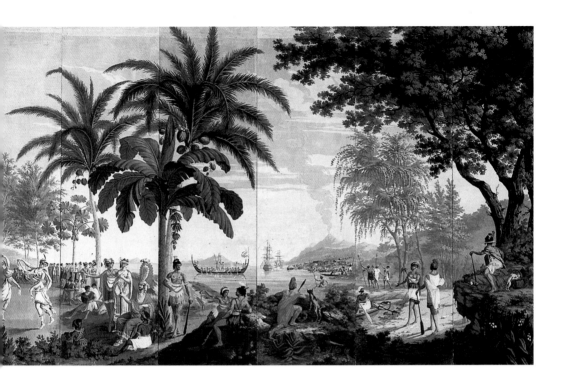

13. GOTTFRIED LINDAUER
Maori Women Weaving Flax Baskets, c. 1906. Oil on canvas, 7'5" x 6'9" (2.26 x 2.07 m). Auckland City Art Gallery, Auckland.

Despite claims of ethnographic authenticity, Lindauer often used photographs, book illustrations, and earlier paintings as sources for his imagery. This painting formed part of a series of large oils depicting Maori customs and lifestyles, commissioned by the Auckland businessman Henry Partridge.

on Lindauer's paintings and the collection of his patron, observing, "We have allowed an aboriginal race to largely pass away, with manners and customs largely unrecorded ... Mr Partridge has preserved many valuable records of the noble Maori race ... of a type of Maori now fast dying out."

Tradition and Change in the Pacific

Today, of course, no one would say that Pacific cultures are dying out, for their artistic vitality is truly impressive. There is artistic practice in every area: the renewed vigor of long-established artistic traditions, such as the Sepik men's house; the rebirth of others, such as the Polynesian long-distance voyaging canoes; and the creation of new traditions, especially as artists throughout the Pacific explore Western-inspired media and imagery. Despite the many differences of Pacific Island cultures, nearly all have experienced in the past two hundred years Christian missionary efforts, the imposition of colonial governments, and the necessity of adapting to Western-style government, education, and market economies. In the more recent past, many Pacific cultures have also experienced independence and nationhood. The visual arts both reflect and contribute to this cultural vitality and to the ongoing process of developing national and cultural identities in a post-colonial world.

As part of this process, the visual arts have a critical role to play in responding to the challenge of reimagining the nature of power – whether social, political, or spiritual – in contemporary Pacific communities and nations. The process of change and adaptation is a part of tradition and a part of contemporary culture. This is especially true of the arts, as artists incorporate Western-inspired motifs, materials, or techniques into traditional local practices. In New Britain, for example, Tolai artists use images of Christian saints to ornament Iniet-society dance wands that are now used during the opening celebrations of a Roman Catholic church (FIG. 14). Similarly, in west New Britain, the masks now danced on ceremonial occasions represent not only spirits, the traditional powers, but also newer powers, such as police officers.

Many contemporary Pacific artists work in Western artistic styles to respond to the history of the Pacific and its future, the nature of power and of identity. Jim Vivieaere, a Cook Islands artist who lives in New Zealand, is one of those who confronts these issues in his installations. For a recent piece, *Two Sky Rockets (One for Adornment)*, he placed two oil drums in the Pacific Gallery of Te Papa Tongarewa Museum of New Zealand (FIG. 15). One of the most striking aspects of the work is that visitors do not necessarily focus on the barrels immediately, amidst all the visual richness of the Pacific artworks on display. Once seen, the barrels evoke a variety of associations: contact, trade, exchange,

14. Dance wands at a church opening ceremony near Rabaul, 1975. Tolai people, New Britain, Papua New Guinea.

The Iniet medicine society has long used dance wands like these in its rituals. Here Christian saints have replaced the lively figures of spirits with raised arms that usually decorate these dance wands. The sense of energy and power conveyed by the figures remains constant, for the saints stand in similarly active poses.

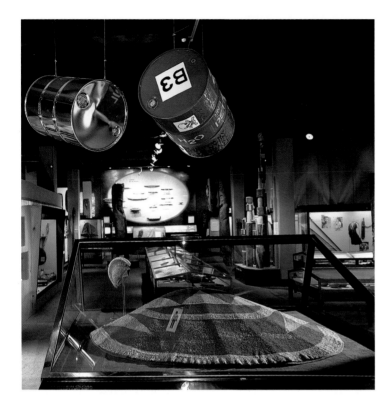

15. JIM VIVIEAERE
Two Sky Rockets (One for Adornment), 1994. 44-gallon drums, chrome plate, paint. Pacific Gallery, Museum of New Zealand Te Papa Tongarewa, Wellington.

Vivieaere created *Two Skyrockets* for a national survey exhibition of contemporary sculpture at Te Papa Tongarewa Museum of New Zealand. It was inspired by an image from Frank Hurley's 1923 film *Pearls and Savages*, in which a museum worker barters empty tomato cans for skulls and arrows with New Guinea warriors. In Vivieaere's installation, the chrome-plated drum was custom-built, the other was painted on site. Its red and yellow surface uses a sacred color combination for Polynesians and sets off the Hawaiian feather cape below.

colonization, the continued dependence of Islanders on foreign imports, the creativity of Islanders in putting both trade goods and the detritus of trade to use in new ways. Juxtaposed with the art and artefacts on view, these drums can make viewers aware of the history underlying the collection, the processes of trade, conquest, and colonization that shaped it. The surprise of finding these drums in an art gallery – where they are so unexpected – can heighten visitors' awareness of their assumptions about the Pacific, which they may not "see" or think about consciously, yet which shape their experience of the collection.

Jim Vivieaere's reconceptualization of the Pacific Gallery at Te Papa Tongarewa is a good starting point for reimagining Pacific art through the *musée imaginaire* presented here. In some ways his Pacific Gallery installation provides a model for this engagement with Pacific art in its capacity to surprise, to stimulate, and to take chances, and also, one hopes, in its appreciation of the visual delight, depth of thought, and profound spirituality to be found in Pacific art. This engagement requires an awareness of preconceived ideas about Pacific peoples and of the difficulties of achieving new understandings of Pacific art traditions, together with some sense of the rewards for doing so.

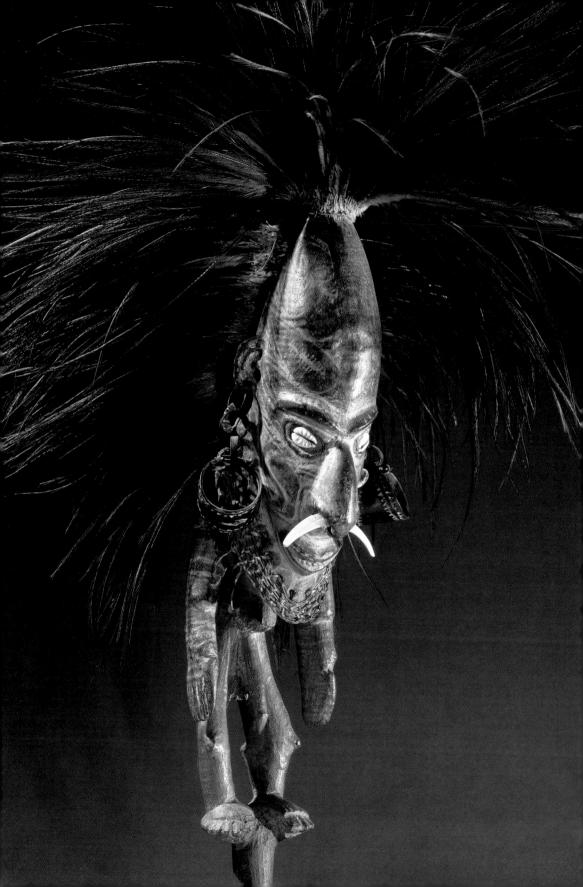

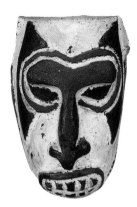

New Guinea: Where Ornaments are Bright

16. Flute figure. Biwat people, Yuat, East Sepik Province, Papua New Guinea. Wood, shells, basketry, feathers, turtle shell, paint, height 20½" (52 cm). Museum der Kulturen, Basel.

Although the figure was profusely decorated with feather, shell, hair, bone, and fiber ornaments, little beyond its eyes, nose, and mouth would have been visible when in use.

A ny understanding of style and meaning in the visual arts of New Guinea is inseparable from an understanding of the environment and history of the island. New Guinea lies to the northeast of Australia, its outline resembling that of the cassowary, a large flightless bird that is characteristic of New Guinea itself. One of the largest islands in the world, with a wide range of environments and climates, New Guinea has been likened to a miniature continent. A central mountain range running roughly east to west crosses the island, its highest peaks sometimes covered with snow. Great rivers flow from the central plateau, including the Mamberamo, Sepik, and Fly. To the north are rich plains and mountains, which often rise steeply from the sea. To the south of the central mountains, marshy lowlands crisscrossed by muddy rivers are the dominant environment. New Guinea's spectacular wildlife includes more than seven hundred species of birds, as well as hundreds of species of reptiles and mammals, including marsupials.

New Guinea is also home to a remarkable variety of cultures, languages, and art traditions. The vastly different environments, from swamplands to mountains, spurred a variety of cultural adaptations even as the challenging terrain sometimes prevented travel and communication between groups. Successive small-scale migrations over thousands of years from Southeast Asia contributed to this cultural diversity. More than seven hundred distinct languages, belonging to the Austronesian and Papuan

groups, are spoken on New Guinea, attesting to its long and complicated history. The Papuan languages, a large and diverse group, are the legacy of the earliest immigrants to the region. The Austronesian languages, spoken mainly in coastal areas, seem to be the result of later migrations.

New Guinea's history entered a new phase with the arrival of Europeans. Portuguese explorers first sighted the island in 1512, but it was the Portuguese Jorge de Meneses who in 1526 made the first landing, on the Vogelkop Peninsula at the island's northern end. He called the island Ilhas dos Papuas, "island of the Papuans," from the Malay word *papuwah*. During the course of the sixteenth century, the Spanish explorer Alvaro de Saavedra Cerón and others sailed the north coast, but the island remained little known to Europeans. Careful to protect their immensely profitable holdings in Indonesia, the Dutch in 1660 were the first Europeans to claim jurisdiction over New Guinea, through their client, the sultan of Tidore. It was not until the end of the nineteenth century that the Dutch, Germans, and British formally established colonial territories. This ushered in a period of intensive contact, especially with the arrival of missionaries, anthropologists, traders, planters, and colonial officials. The Australians took over administration of the British southeastern territory in 1905, and then captured the German holdings during World War I. With full independence in 1975, these two territories became the nation of Papua New Guinea. In 1962 Indonesia took control of the Dutch territory, the northern part of the island, renaming it first Irian Barat (West Irian) and then Irian Jaya, as it is now known.

Despite New Guinea's remarkable diversity of languages and peoples, scholars recognize several major artistic style regions: the Sepik River and its tributaries; the Gult of Papua; the interior highlands, the southern coast, home of the Asmat and Marindanim; northern New Guinea, including Lake Sentani and Geelvink Bay; southeastern New Guinea, including the Trobriand Islands; and the northeastern coast, site of the Huon Gulf and Astrolabe Bay. Within these regions, even peoples speaking different languages and with different histories may share elements of culture and aspects of artistic style. People throughout the island produce a wide variety of sculpture, painting, and architecture, although, exceptionally, the people of the highlands, the most populous group, concentrate their artistic efforts primarily on the decoration of the human body with ornaments, headdresses, wigs, and body paints.

In New Guinea, an artwork's aesthetic impact expresses its spiritual power and ability to affect the life of the community.

Among the Abelam, who live in the plains and hills to the north the middle Sepik River, an initiate coming face to face with enormous sculpted figures in the ceremonial house is overwhelmed by their physical size, brilliantly painted surfaces, and dramatic contours, and cannot doubt their spiritual power. Colors can be life forces – the Abelam apply pigments to special varieties of yams, used in rituals, to stimulate their growth. Similarly, for the Kwoma people of the Sepik River region, *kele*, the word for the color black, used by warriors as body paint, can also mean "beautiful and strong." The Wahgi people of the interior highlands describe dancers who are skillful or beautifully ornamented as bright or glittering.

The Men's House: Center of Art and Power

One of the great social and artistic institutions of New Guinea is the men's house. This is usually the most imposing structure in a village, not only visually but also socially and spiritually. Its roof soars above the family houses that surround it, dwarfing them in its massiveness. It is here that men gather to eat, talk, and relax; to discuss problems confronting the community; and to undertake the religious rituals that are at the center of spiritual life. Although christianization, colonization, the increased mobility of the population, and the migration of young men, first to plantations and then to cities for work, have weakened the status and influence of the men's house over recent decades, it still

17. Men's house, no date. Kapriman people, Kuvenmas Village, Blackwater River, middle Sepik River region, East Sepik Province, Papua New Guinea.

The finials that decorate the house's soaring gables represent protective spirits of a man and eagle.

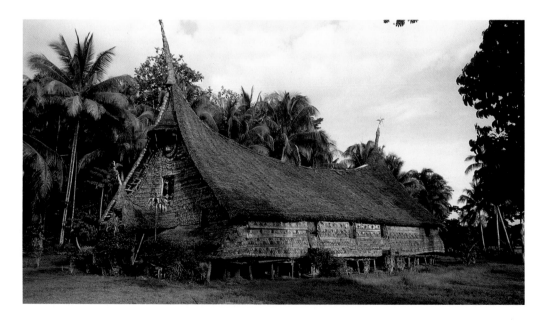

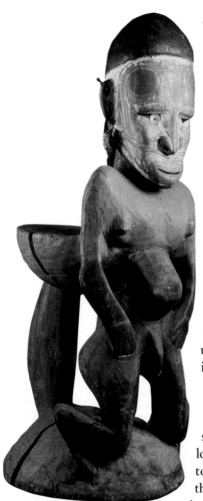

18. Orator's stool. Ngaura, Iatmul people, East Sepik Province, Papua New Guinea. Wood, pigment, height 30" (76 cm). Rautenstrauch-Joest Museum für Völkerkunde, Cologne.

The design of this figure's face-paint reflects a dualistic organization also seen in the Iatmul men's house, which is typically divided into parts for the two moieties that occupy it.

continues strong in many communities and has been revived in others. Although the principles of construction remain constant, however, men's houses are now often smaller and have less elaborately decorated schemes than in the past.

Perhaps the best studied men's houses are those of the Iatmul and neighboring peoples of the middle Sepik River region (FIG. 17). Typically, each village contains several of these monumental, peaked-roof buildings, before which lies a grass-covered ceremonial ground that is the center of community ritual and celebration. The internal division of the building reflects the social organization of the village. The house is divided longitudinally into two halves, each of which is reserved for a moiety, a group of village clans. One moiety, called Nyame (mother), is associated with everything that is dark: water, the swamp, night, the color black. The other, called Nyaui (sun), relates to everything bright: fire, the day, mountains, the sky, the color red. Each moiety and each clan has its own myths, embodied by animals, plants, features of the landscape, natural phenomena, and works of art. Each side of the house has its sitting platforms and hearths, appropriated by the different clans.

In the center of the men's house on the ground floor, between the areas occupied by each moiety, are the sacred slit drums and the orator's stool. The slit gongs, massive hollowed logs, are played on important occasions. The name "orator's stool" is misleading, for speakers do not ever sit on this sculpture, which is a composite of a stool and a standing human figure (FIG. 18). As they debate clan privileges, local politics, and other issues, orators stand next to the stool and strike its seat with bunches of leaves or place the leaves on the seat to underscore their main points. The figure represents both the most important spirit, *wagen*, of the community and the most important spirit of the clan on whose land the men's house stands. The chair can serve as the temporary abode of the spirit, and when the spirit is present, is considered "hot." The head of this spirit figure is made larger than life to emphasize that it is the most important part of the body, where the spirit resides. The painted motifs on the face recall the motifs painted on the faces of initiates, preserved skulls, and *mai* masks, making the connection between the head types that are spiritually significant for the community.

The typical Iatmul men's house has a second story. Here are kept the community's most sacred objects, bamboo flutes that emit the voices of the ancestors. This second story is usually screened

to protect these objects from the eyes of the uninitiated. On the interior, monumental female figures, sculpted with legs spread wide, adorn the roof supports at each end. The entire house is a conceptual representation of a mythic primordial ancestor and of the origins of time, both manifest on many levels.

One of the most important events staged at the men's house is the initiation of boys and young men into the mysteries of the sacred flutes. This marks their transition from childhood into adulthood. At this time, boys are separated from their mothers and siblings, taught the sacred and ritual knowledge they need for adult life, and undergo tests of courage and endurance to harden their characters. Tattooing of young men is common. At this time the *mai* masks appear in pairs, embodying mythical brothers and sisters (FIG. 19). Women dance with the masks and present them with food, while men sprinkle lime on them as a sign of admiration or cut off a small piece of the costume. A bamboo flute, concealed within the massive fiber costume, represents the voice of the ancestor. The masks are painted with delicate scrolling patterns that replicate the face paint worn by Iatmul initiates and

19. Photograph of *mai* masked dancers. Kararau village, Iatmul people, East Sepik Province, Papua New Guinea.

Unlike the sacred flutes and slit gongs, the masks belong to the clans, not the community, and so are stored in the house of a clan elder rather than in the men's house. Today, *mai* masks appear on important occasions other than initiation.

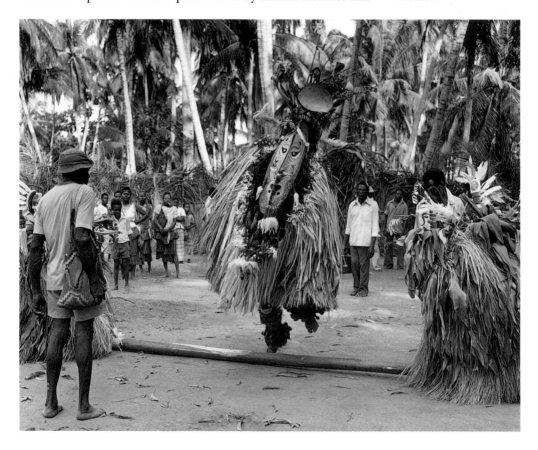

other members of the Iatmul clan on ritual occasions, and also the patterns that are painted on the clay-covered surfaces of preserved ancestral skulls. The patterns may have a protective function, but their meaning is not clear.

The long bamboo flutes are not embellished but they are the most sacred objects in any ritual. They are played in pairs by initiated men during feasts and initiation rituals. The pairs of flutes can be considered male or female, and each pair produces a distinctive melody. The melody can be played in two ways: first, by the overtones and the fundamental tone of one flute, and, second, by the alternate blowing of the flutes, which have different pitches. Sometimes these simple bamboo instruments bear remarkable carved figures as stoppers (see FIG. 16). Among the Biwat, these wooden figures represent the children of an ancestral crocodile spirit. They pass from father to daughter and mother to son, thus embodying the pride and identity of successive generations and of the religious community in which the flutes are played.

The imagery of Sepik men's houses includes totemic animals, which are considered the ancestors, protectors, or emblems of the various clans, as well as anthropomorphic figures which represent spirits or ancestors. The central importance of totemic animals and plants in shaping identity is suggested by a saying of the Manambu of the middle Sepik River: "We are crocodile and sago; they are cassowary and yam." The saying distinguishes between the Manambu and the surrounding hill people by contrasting not only their totemic ancestors but also their food staples and their different ways of life. Along the Keram River, a Sepik tributary, feathered panels, sometimes called dance shields, often bear depictions of clan totems (FIG. 20). The crocodile and the cassowary, whose feathers are much prized, are perhaps the most common totemic creatures associated with the decoration of Sepik men's houses and the ritual paraphernalia they contain. Crocodile images, for example, appear on the ends of the large slit gongs that range along the center of the ground floor of many men's houses. According to Iatmul and other Sepik accounts of the world's origins, the world floats on the back of a crocodile. The Arapesh, Nggala, and many other peoples of the upper Sepik believe that humans were created from the feathers of a female cassowary.

Among the Abelam, who live in the hills bordering the middle Sepik area, the ceremonial house, or korambo, continues as a vital cultural center and architectural form. The korambo is still built in ways similar to those documented in the early twentieth century; it looks almost like a huge roof set on the ground, for the ridge pole slopes down toward the back, and the low

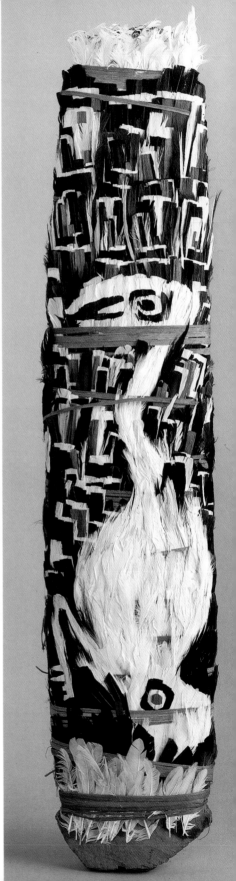

20. Feather panel depicting a cassowary bird. Kambot people, Keram River, East Sepik Province, Papua New Guinea. Feathers, cane bands, board, height 43¼″ (110 cm). Collected by Gregory Bateson. Cambridge Museum of Archaeology and Anthropology.

Feather panels were stored in the men's houses and displayed on special occasions. Made of cut feathers, these images rely for their visual power on texture, contrasting colors, and dramatic silhouettes.

side walls are hidden under the eaves. In contrast, dwelling house construction has changed greatly, the traditional A-shaped front with sloping ridge post having given way to a rectangular shape. The traditional ceremonial house may persist because it is the locus of rituals that link the present and the past in many ways. The circular clearing in front of the *korambo* serves as a dance ground and arena for the display of the decorated long yams that are the focus of a men's cult. The yams are considered

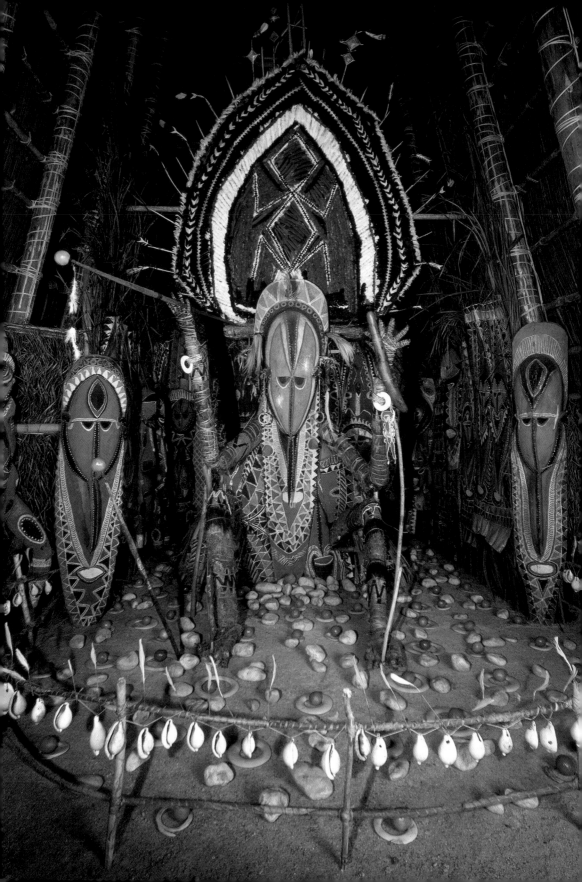

animal yet mortal and are beautifully decorated with fiber masks and other ornaments for display.

The palm-bark façade of the *korambo* bears registers of spiritual figures, painted with elaborate patterns in red, white, yellow, and orange. The Abelam read the façade from top to bottom, beginning with the designs at the apex and ending with the prominent row of figures at the bottom. The uppermost images often incorporate references to nature, including plants, animals, and insects. The anthropomorphic figures represent clan-specific ancestral spirits, the *ngwalndu* (*nduduwine, ngwalngwal*), or "grand-father man". Inside the *korambo*, a magnificent installation of paintings and sculptures repeats many of the motifs from the façade (FIG. 21). Elders guide the initiates into the house and teach them the meanings of the various elements of the assemblage, in order to help instil into them the mysteries of the spirit world.

At the time of exploration and colonization, the institution of the men's house was widespread throughout New Guinea. Far to the north, in Humboldt Bay, an area with long-standing cultural connections to Indonesia, the German scientist Otto Finsch documented the tradition in 1885. He drew one such structure in Tobati village and labeled it a *Tabuhaus*, or "sacred house" (FIG. 22). His drawing shows the house built on stilts in the water, with an adjacent platform supported by wooden posts. The local people said that the houses themselves, not just the idea for them, were imported from the coastal areas of Papua New Guinea. Finsch was able to establish that one house came from Vanimo; the building he sketched probably came from Nafri. This building type probably arrived in the area, along with its associated feasts and rituals, in the mid-nineteenth century. By 1925, the men's houses had declined in importance, partly because Protestant missionaries had introduced school education, supplanting the boys' training and initiation in the men's houses. As Finsch's drawing shows, wooden figures of animals and fish projected from the tall, peaked roof, and painted carvings decorated the outside walls. The finial depicts a human figure squatting or sitting

21. Interior of a ceremonial house (*korambo*). Bongiora, Abelam people, East Sepik Province, Papua New Guinea. Collected by G.F.N. Gerrits in 1972–73. Museum der Kulturen, Basel.

22. A "sacred house." Tobati village, Yotefa Bay, Humboldt Bay, Irian Jaya, 1885. Engraving after drawing by Otto Finsch.

In addition to its value in depicting the men's house, this drawing provides one of the earliest records of the distinctive canoes of the Humboldt Bay area.

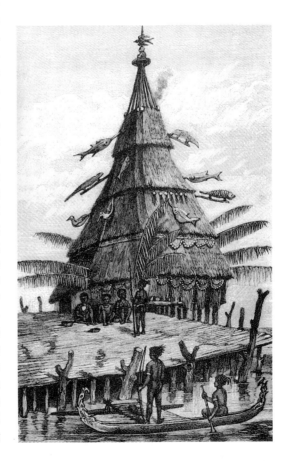

23. House post.
Sukarnapura, Lake
Sentani, Irian Jaya.
Wood, height 7'8"
(2.2 m). Tropenmuseum,
Amsterdam.

The curvilinear motifs
typical of Lake Sentani
art fill the flat surfaces of
the projecting root.

under a bird with spread wings. Such figures were protective and were called *karkarau* or *karau*, a word that means both human figure and frog. Each clan had its own coral-block fireplace around the perimeter of the interior, where the members cooked meat and around which they slept. The central space was open for dancing and playing the sacred flutes.

The men's house complex also existed at nearby Lake Sentani, an inland lake that was probably once a branch of the sea. Here the traditional men's houses were fairly low rectangular buildings, although early explorers also reported structures similar to those of Humboldt Bay. Unusually, Lake Sentani people did not keep the sacred flutes in the men's house, but in the care of the chiefs. Such hereditary leadership is itself a rare institution in New Guinea, suggesting that the men's house traditions had been grafted on to more established practices. The men's houses, called *ondoforo*, were built on pilings over the water, and were impressive both for their size and the richness of their ornamentation. The support posts, made from buttress roots carved to represent lizards, crocodiles, dogs, or human figures, nonetheless still reveal the form of the room (FIG. 23).

The Arts of Women: Alternatives and Complements to the Men's House

In New Guinea, women often practice rituals and rites of passage that are analogous to, if somewhat less elaborate than, those of men. Women also create distinctive art forms that play an important part in the lives of their communities. The scholarly literature often emphasizes that many New Guinea cultures consider women to be spiritually dangerous and relegate them to an inferior status. Today, however, the social roles of men and women in New Guinea societies and the significance of women's artistic production are recognized as more complicated. Although there are many restrictions on women's behavior and their status in New Guinea societies, they also have well-defined social roles and ways to achieve power and respect. If women's art is not the focus of public ritual to the same extent as men's, their art does address impor-

tant issues, such as relationships between groups and between this world and the spirit world, and has a recognized place in the life of the community.

Throughout New Guinea, women's artistic practice often centers on the production of cloth and textiles in various forms. In the Trobriand Islands, off the southeastern coast, women make skirts of shredded banana fiber that are an important form of wealth and richly symbolic (FIG. 24). It takes several days to prepare the fibers for a banana-leaf skirt and then a day to weave it. Traditionally dyed brilliant red and purple with plant extracts, the skirts now also incorporate commercial blue, yellow, and green

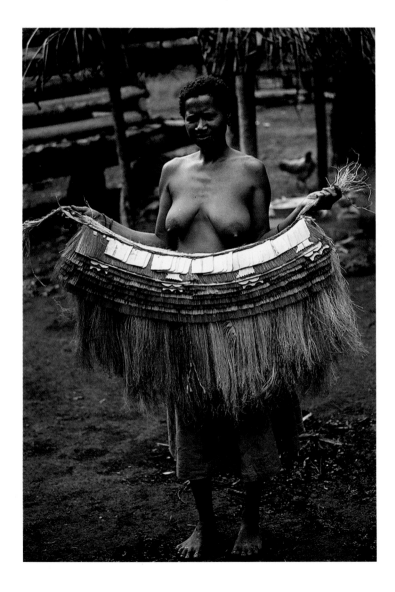

24. Women with fiber skirt. Trobriand Islands, Milne Bay Province, Papua New Guinea.

During mortuary rituals, women parade with the fiber skirts that they exchange.

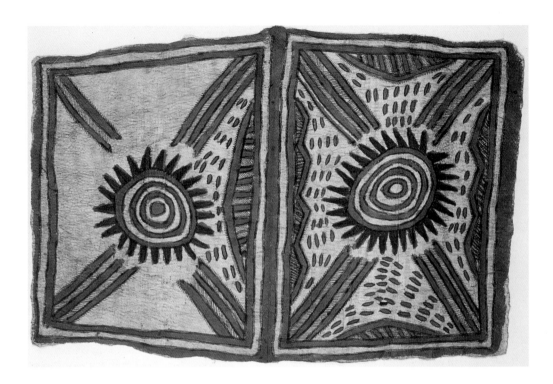

dyes. When a death occurs in their matrilineage, women distribute the banana-fiber skirts, along with bundles of dried banana leaves, to the deceased's in-laws. This gift recompenses them for the care they gave the deceased in life. Women make the skirts and control the leaf-bundle wealth, but men also take part in the distribution. Although this ability gives women economic power and reinforces their place within the matrilineage, Trobriand Islanders do not associate the skirts or leaf bundles with the ancestral or spiritual power, *mana*, that charges men's art and activities.

Among the Orokaiva and other groups of New Guinea's northern coast, women's art forms include both the decoration of barkcloth and tattooing. Orokaiva women paint the barkcloth with designs that are specific to their clans, including a motif like a sunburst (FIG. 25). Decorated barkcloths form highly prized gifts on ceremonial occasions. In this region, women specialists also practice tattooing, executing distinctive geometric and linear facial tattoos on young women making the transition to adulthood. The Maisin people of Collingwood Bay believe that tattoos enhance a young woman's beauty and demonstrate her strength. There is no standard pattern, for each image is the unique product of the "thoughts" (*mon*) of the tattooist. One common element is a vertical stack of Vs on the forehead, a motif also found on bark-

cloth. Today, just as barkcloth is often manufactured for sale, so too have the contextual meanings of tattooing changed. In Papua New Guinea's multicultural population, women's tattoos now also serve as a sign of cultural identity and ethnic pride.

Like many other textiles produced by women in New Guinea, the netbags made by highlands women can be both ceremonial and functional, and resonate with symbolic meanings (FIG. 26). Netted from a single thread spun on the thigh, they can be used to carry sweet potatoes or cartons of beer to market or they can be exchanged as gifts. A woman may wear highly decorated examples as special ornaments when attending the celebration of a bride-wealth payment or when going to market, and they can be exchanged as gifts. Men carry love or war magic in small netbags slung under the arm; the spirit of a deceased man lingers in his netbags, which are worn by his wife as mourning attire. Not surprisingly, the netbag serves as a rich metaphor for local values and practices: among the Wahgi, when a group of brothers offers a young woman in marriage back to their mother's clan, the principle they follow translates literally as "giving a skull in a netbag," an expression in which "netbag" serves as a synonym for both "bride" and "womb." Today, women make bags in the

26. Women wearing contemporary netbags at a marriage ceremony, 1990. Wahgi valley, Western Highlands Province, Papua New Guinea.

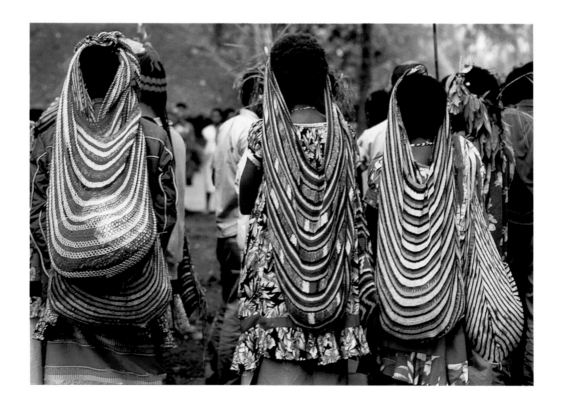

traditional striped patterns, but also work them with images and quotations in English and pidgin. Acrylic, nylon and other synthetic materials may be used instead of or in addition to the traditional plant fibers and marsupial fur.

Men and women not only use but also sometimes cooperate in the production of works of art. In the Lake Sentani/Humboldt Bay region, women made bark-skirts and ceramic pots, both of which were then decorated by men. Painted skirts, called *maro*, were worn by women for dance feasts and other important occasions (FIG. 27), and decorated their graves. As part of their initiation rituals men were taught painting as well as boat-building, netmaking and twining. Only ceremonial pots were painted; similarly, only barkcloth worn on important occasions was painted. Of the motifs used, lizards may represent spirits or clan ancestors and spiral patterns may be abstract renditions of turtles, hornbills, frogs, and varan (an indigenous monitor lizard).

Ceramic traditions throughout Papua New Guinea illustrate the difficulties of attributing a particular medium exclusively to one sex. Differences in gender associations and technique are evident between Austronesian-language speakers and Papuan-language speakers. The coastal peoples of Madang and the Huon Peninsula, who speak Austronesian languages, use a paddle-and-anvil technique, in which the walls of the vessel are pounded flat on an anvil and then shaped into a vessel with the help of a paddle. In these cultures, the potters are women. The vast majority of New Guinea potters use a coil technique, in which the clay is rolled into a long cylinder and then coiled on itself and smoothed out to build the vessel. Most of these potters are men; this is true of the Boiken and other groups in the Sepik River area. Among the Kwoma and other inland Sepik peoples, both men and women make spiral coiled pots. Although most pottery industries in Papua New Guinea produce utilitarian vessels only, such as cooking pots and eating vessels, others encompass both functional and ceremonial forms.

27. Cloth with lizard motif. Lake Sentani, Irian Jaya. Barkcloth, pigment, length 25" (64 cm). Tropenmuseum, Amsterdam.

The spiral motifs are a looser, more exuberant rendering of the interlocking spiral decorations found on Sentani carvings.

In Aibom village, settled by Iatmul-speaking peoples, along the Chambri Lakes in the middle Sepik River region, women are the primary potters. Pottery plays an important role in the economy of the village, for the Aibom, who do not gather or process sago themselves, rely on trade with people living in the hill country for this food source. The ceramic objects produced at Aibom include sago storage jars, cooking pots, hearths, sago frying dishes, serving bowls, eating dishes and gable-ridge ornaments. Important though their pottery production is, Aibom women do not execute any of the representational modeling

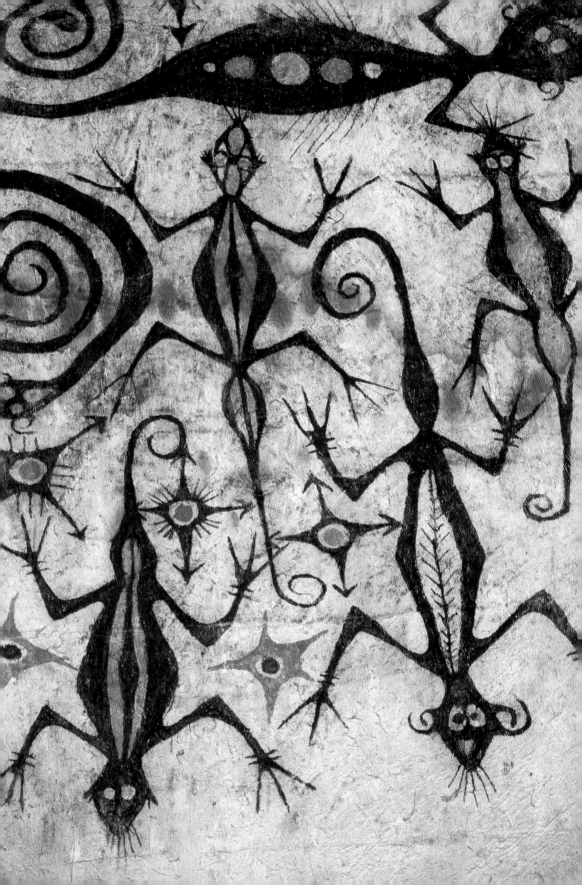

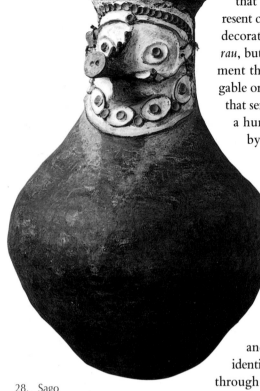

that is required, possibly because these images represent clan totems or cultural heroes. Women may apply decorative motifs to the large sago storage jars, *damarau*, but it is men who must model the faces that ornament the necks of the vessels (FIG. 28). In making the gable ornaments of men's houses, women form the pot that serves as a base, and on it men model the image of a human head or of a hermaphrodite surmounted by an eagle. In the past, men painted the vessels too, but now women often paint pots that are made for sale.

Spirits and Ancestors

Most anthropomorphic figures represent spirits or ancestors. Many spirits are often associated with the natural world, while others, the "culture heroes," by their exploits account for the ways in which the world began and human society developed. The focus on ancestors helps the individual develop a sense of identity and of place within the community. It is often through the arts that spirits visit this world and maintain ties between the living and the dead. Artworks can provide an abode for the spirit, as in the Sepik orator's stool discussed above, or they can help an individual represent or become a spirit. Masks, paints, costumes, and ornaments transfigure the body just as sculpture, painting, and architecture transform the human environment. The performative aspects of the visual arts are important here, for these transformations rely on the successful intersection of aesthetic and spiritual concerns.

In the Sepik River area, various figures stored in the men's house represent spirits that help men with hunting and headhunting. Among the most celebrated of these are the *yipwon* figures made along the Upper Karawari River, on the southern margins of the Sepik region (FIG. 29). *Yipwon* figures occur in all sizes, from small, portable charms to monumental sculpture. Large figures are inherited, so the greatest figures are often of a considerable age: several figures preserved in caves have been radiocarbon dated to the sixteenth century. Like the orator's stool, the *yipwon* is powerless unless activated, made "hot," by rituals that draw the spirit into it. This "hook style" figure represents the body in abstract form. The projecting central element represents the heart, and the hooks around it are ribs. The figure clearly stands on a single bent leg.

28. Sago storage jar. Aibom village, Iatmul people, East Sepik Province, Papua New Guinea. Ceramic, paint, fiber, height 32¼″ (82 cm), diameter 22¾″ (58 cm). Museum für Völkerkunde, Berlin.

A pig's head with an elongated snout ornaments the neck of this jar.

In Geelvink Bay, Irian Jaya, gods and spirits were rarely represented in sculptural form. Rather, the main focus was on ancestor figures called *korwar* (FIG. 30). *Korwar*s were made not by members of the family, but usually by shamans, *mon*, who were able to contact the spirits of the deceased. Once the figure was completed, the shaman drew the spirit of the deceased into the wooden figure as its new abode. For the most important people only, the figure might contain the actual skull of the deceased. The *korwar* allowed communication between the living and the deceased. The living asked the spirit for help and advice in illness or bereavement, and on the best time to undertake headhunting raids, voyages, or food-gathering expeditions. Miniature *korwar* figures served as amulets and were carried along on hunting and raiding expeditions.

The *korwar*'s head is usually the largest part of the figure, to emphasize its importance as the seat of power. The body itself seemingly had less visual significance, being sometimes rather summarily carved and often wrapped in a cloth. Many *korwar*s hold before them an openwork shield decorated with scrollwork or a smaller figure. The shield may derive from the form of the snake, either singly or in a pair. In Geelvink Bay religion, the snake symbolized death and night as well as *koréri*, the process of rejuvenation and generation, and was thus an appropriate symbol to associate with the *korwar*.

The relationship between the living and the dead is articulated in a rather different way among the Asmat people of Irian Jaya. There, masked dancers called *jipae* impersonate ancestral spirits who return to the village one last time before departing permanently for the land of the dead (FIG. 31). The costumes themselves, made of basketry, completely envelop the body of the dancer. They have eyes and noses, and yet the shapes are amorphous, not fully human or animal, and so represent something that is not of the everyday world, a quality enhanced by the performance. The *jipae* emerge from the edge of the forest and visit their relatives, who reassure the spirits of their happiness so that they can make their final departure without hesitation. At the same time, unrelated members of the village stage a mock battle to ensure

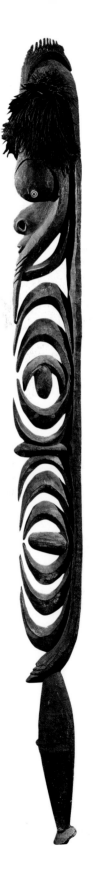

29. Hook figure (*yipwon*). Upper Karawari River, Yimar, Tshimbut village, East Sepik Province, Papua New Guinea. Wood, cassowary feathers, shell, button, traces of pigment, height 7'8½" (2.35 m). Museum der Kulturen, Basel.

The bulging curves of the face echo the hook forms, but also endow the head with a visual emphasis comparable to its spiritual importance.

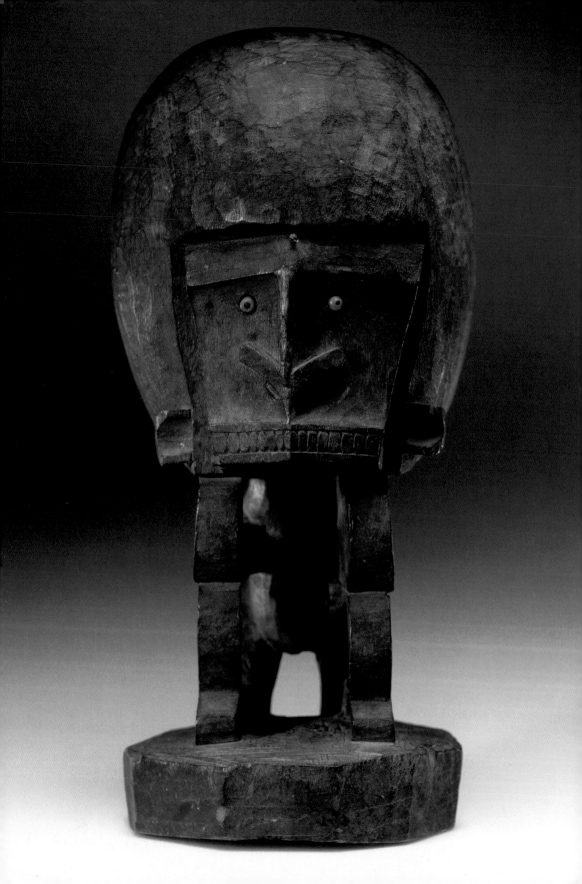

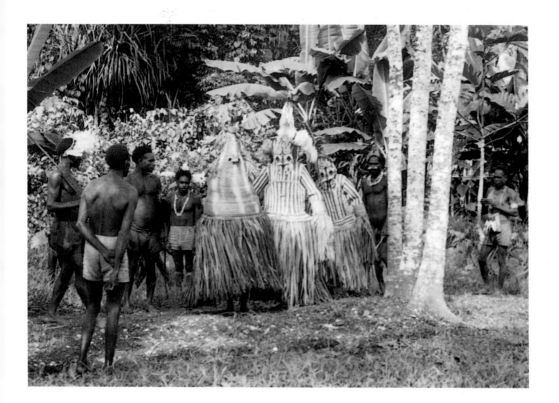

Left

30. *Korwar* figure.
Manokwari, Geelvink Bay,
Wandamen Bay,
Windesi:Bentuni, Irian Jaya.
Wood, glass beads, skull,
height 17″ (43 cm), diameter
10¾″ (27.5 cm). Collected
before 1902. Museum voor
Volkenkunde, Rotterdam.

The many different styles of
korwar figures do not always
correlate clearly with
particular geographical or
style areas. Figures that had
been discarded as powerless
were often sold.

Above

31. Masked dancers, or
jipae, 1961. Amanakai
village, Central Asmat, Irian
Jaya.

that the *jipae* realize that they are not truly welcome to stay any longer. At daybreak, the spirits take their final leave of the community.

Among the Elema people of the Gulf of Papua, large masks representing female sea spirits, *hevehe*, appear in the community as the culmination of a cycle of ceremonies, feasts, initiations, and performances that can take ten to twenty years to complete. This is partly because wealth must be accumulated and pigs fattened to provide the feasts that accompany each stage of the proceedings; quarrels, mourning, and sorcery may also cause delays. Spectacular masked performances, representing different spirits and totems, accompany each stage of this cycle (FIG. 32). The creation of the *hevehe* masks begins with the visit of a *ma-hevehe* spirit, who brings two daughters from the sea to leave in the men's house. Eventually, when the masks are complete, the *ma-hevehe*'s daughters, the masked dancers, are ready to emerge, and the women of the village call to the *hevehe* to show themselves. On the appointed day, about an hour before sunrise, the massive doors of the men's house swing open to reveal the *hevehe*. The large masks, often well over ten feet (3.04 m) in height, provide an awe-inspiring sight. Throughout the month that follows, the wearers of the

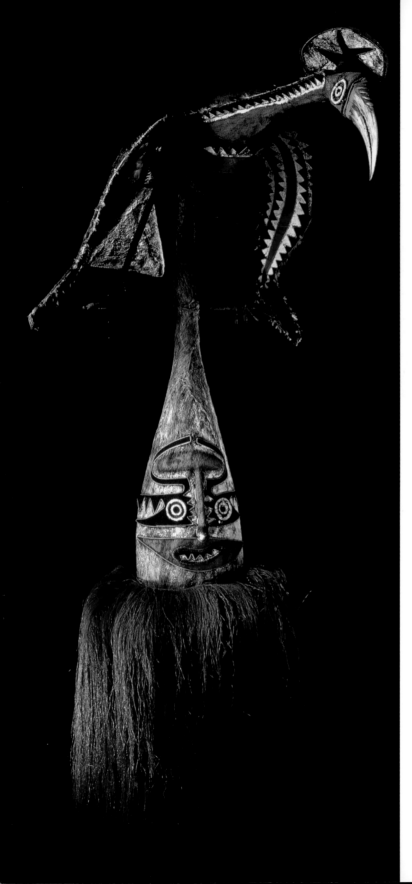

32. Mask (*eharo*). Elema people, Gulf of Papua, Gulf Province, Papua New Guinea. Barkcloth, cane, pigment, height 6'8½" (2.05 m) and diameter 4'3" (1.3 m). Museum voor Volkenkunde, Rotterdam.

Unlike the *hevehe* masks, *eharo* are not considered sacred. The figures that surmount these masks relate to the humorous stories and myths enacted by the dancers.

masks dance on the beach, accompanied by groups of dancing women. At the end of this celebratory period, clan members ritually kill the *hevehe* as the women mourn. The men then secretly dismantle the masks and burn them.

The construction of the masks and the appearance of the *hevehe* in the village demonstrate the tension between secrecy and revelation in relating to spirits and ancestors. The fact that the masks appear in public does not mean that everyone understands the rich spiritual meanings they convey, for these often relate to clan mythologies and ancestors, and there are different levels of knowledge in the community. Because they are uninitiated, for example, women are generally unaware that the shape of the mask itself, the long flat oval, is repeated in other sacred objects known only to men, such as ancestral boards carved with spirit images or bull roarers, flat ovals of wood on the end of a string that when twirled make a whirring noise, here interpreted as the voices of spirits and ancestors. The patterns that decorate the upper portion of the mask represent a variety of natural forms, such as plants, animals, and even sea foam.

33. Male dancers. Lonem village, Abelam, East Sepik Province, Papua New Guinea.

The dancers wear face-paint applied over closed eyes to enhance their other worldly appearance.

The Abelam approach the visual and bodily transformation of the performer into spirit in a strikingly different way. Young male dancers, their bodies not hidden but rather highly decorated with paint and ornaments, become "sacred beings," spirit visitors from the world of the ancestors (FIG. 33). The Abelam themselves see this ephemeral art form as one of their highest aesthetic achievements. A famous Abelam artist once declared, "All those carved and painted objects are marvelous and holy. But the most marvelous and beautiful thing of all is a man with body decoration, adorned with flowers and

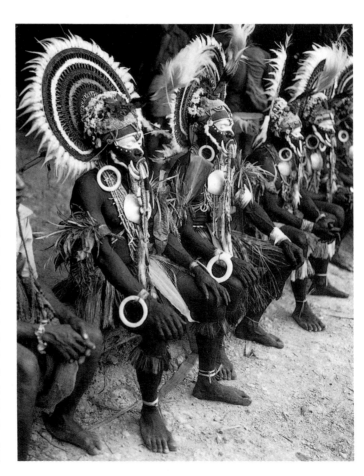

34. Racing canoe. Gogodola, Western Province, Papua New Guinea.

Among the Gogodola, an artist, *sakema*, who is a skilled carver and painter, enjoys a distinguished place in society. His role is a religious one, for the act of carving and painting places him in contact with the spirit world. When not carving, he traditionally lives an ordinary life, tending the garden, hunting, and felling sago palm for his wife. Today many younger artists also carve for cash earnings, producing works for secular dances and for the tourist market.

feathers." Their body decorations include fiber skirts, shell and boar-tusk ornaments, and they wear elaborate feather-and-fiber headdresses, or *noute*. Each dancer wears the fiber and boar-tusk ornament, *kara-ut*, suspended from his mouth, as warriors once did. A testimony to the strength and "heat" of the warrior, this striking ornament signifies the power of the spirit embodied by the dancer in this performance.

Among the Gogodola, who live in the flood plain and grasslands around the Arimia River, male clan ancestors appear in many anthropomorphic forms, including *salago lapila* or feathered images.

The *salago lapila* decorate the prows of large racing and cere-
monial canoes, an artistic tradition the Gogodola have recently
revived (FIG. 34). The canoes are long dugouts, made from sin-
gle massive logs that have been hollowed and shaped. Painted
on the sides just behind the prow is the owner's *gawa tao*, or
clan pattern, a schematic image of his totem based on concen-
tric circles incorporating asymmetric appendages. In the canoe
itself, directly behind the prow, stands the feathered ancestral
image, *salago lapila*, in a cluster of totemic plants. The crew makes
offerings to this figure before a race. The races take place in
early morning and as they come up the river, the white-feath-
ered *salago lapila* stand out in the light. Although the canoes were
formerly used in warfare as well as in races to celebrate truces, they
now perform mainly on special occasions such as Christmas, Inde-
pendence Day, or the official opening of a new church or school.

Among the islanders of the Torres Strait, between Australia
and Papua New Guinea, religious
practice focuses on ancestors who
traveled through the islands teach-
ing people how to hunt and grow
food. These ancestors instituted
ceremonies, especially initiation
and mortuary rituals, through which
their help could be obtained. The
masks worn on these occasions were
emblems of the ancestors and their
associated totems, often crocodiles.
The ceremonies were accompanied
by drumming, also a feature of pre-
sent-day church services and cel-
ebrations and funerals. Except in
the northern islands, where masks
are made of wood because of the
rarity of turtles, Torres Strait masks
are complex constructions of
turtleshell plates tied together and
decorated with cassowary feathers
and nut rattles (FIG. 35). The plates
themselves were incised with pat-
terns to accentuate the eyes, mouth,
and other features, and rubbed with
white lime to provide contrast.
Today, turtleshell masks have fallen
out of use in most areas.

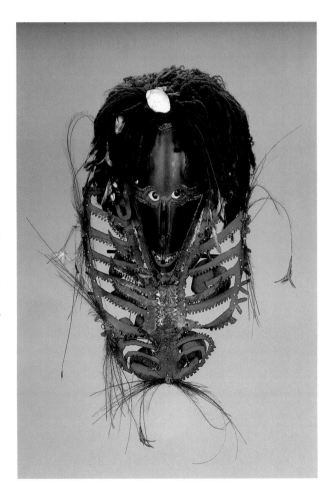

35. Mask. Torres Strait
Islands, Australia.
Turtleshell, human hair,
seedpod, cassowary
feathers. Australian
Museum, Sydney.

This mask wears a human-
hair wig that adds to its
lifelike quality.

36. Shield. Massim, Trobriand Islands, Milne Bay Province, Papua New Guinea. Wood, cane, pigment, height 28" (70.5 cm). Presented to the British Museum in 1893 by A. W. Franks. British Museum, London.

Among Trobiand Islanders, only the most courageous warriors painted their wooden shields, for to do so was a challenge sure to invite attacks. The shield imagery, especially if, as is thought, it included references to copulation, may have been a way of visually insulting the enemy.

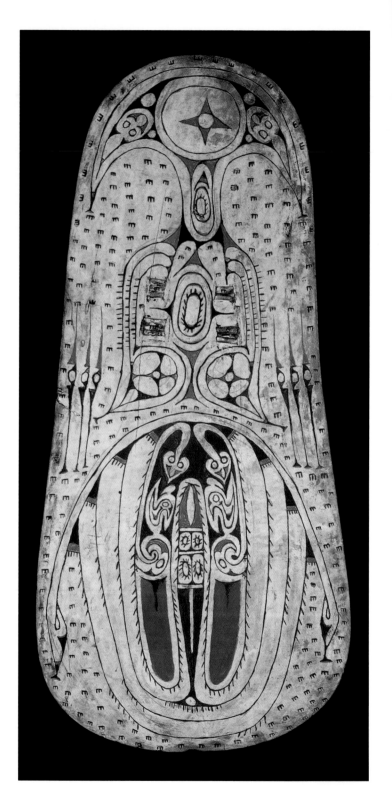

The understanding of spirits and their activities can be multiple and apparently contradictory, as the Trobriand Islanders clearly demonstrate in their ideas about conception. Birth starts from death, in Trobriand tradition, when the spirit of a deceased person goes to the island of the dead, Tuma. When the spirit bathes there, it sloughs off its skin, which becomes a spirit child, *waiwaia*. The spirit child cannot remain on Tuma, and so must return to the world of the living, where it enters the body of a woman who belongs to the same matrilineage as the original spirit. The *waiwaia* accomplishes this in various ways: it can come to her in a dream, through spells, or by bathing in the sea, where the *waiwaia* might be found floating back to the islands from Tuma. Following conception, frequent sexual intercourse was thought to help develop the fetus, adding to the mother's blood and to the spirit child something of the patrilineage as well. The apparently sexual imagery of Trobriand shields has caused an ongoing scholarly debate about the extent to which Trobrianders were traditionally aware of the role of copulation in reproduction (FIG. 36). The most recent interpretations suggest that painted shields represent copulation, spiritual beings, and sacred geography simultaneously. Each motif is given the name of a particular natural phenomenon: birds, fish, stars, snakes, rainbows. None of these refers overtly to supernatural beings or to copulation, and yet each term has a wealth of symbolic and esoteric associations with both these spheres.

Head-hunting and Exchange: The Balance of Power

At first glance, headhunting and exchange may seem to have little to do with each other, but both activities are concerned with keeping balance between communities, in both human and spirit relationships. Taking heads was a way to assert power over another community or to avenge an aggression against the community by others. The head is the focus of this power dynamic in many New Guinea cultures because it is considered the most sacred part of the body, the seat of a person's soul or essence. Many people sleep on headrests, which are not only comfortable and convenient but mark the importance of the head (FIG. 37). Similarly, the purpose of exchange is often not simply to acquire staples, but rather to create binding ties between individuals or communities. Those ties are not always symmetrical – exchange is one way to achieve an advantage over others. During ceremonial exchanges, individuals and groups may adopt several strategies to acquire and keep valuable artworks.

37. Headrest. Huon Gulf,
Morobe Province, Papua
New Guinea. Wood,
pigment, length 6" (15.2
cm), height 5" (12.3 cm).
Collected by Lajos Biró in
1899–1900. Ethnographic
Museum, Budapest.

Huon Gulf headrests, like
those from the Sepik and
other regions of New
Guinea, frequently
incorporate
anthropomorphic figures
that may represent
ancestors or spirits.

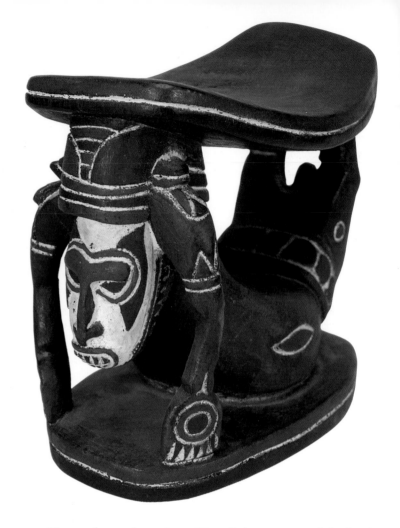

Many cultures throughout New Guinea preserved the heads
of important people or slain enemies as part of capturing the power
of the head and of the individual. These heads were usually
kept in the men's houses, although the heads of ancestors were
sometimes kept in family or clan houses. In the Sepik River
area, for example, preserved heads were kept in the men's house
and displayed on special racks painted with images of spirits
and hung with offerings of betel nut and shell currency. The skulls
would be cleaned of flesh and then modeled with clay, giving them
a lifelike appearance. In the men's houses of the Gulf of Papua,
the heads of ancestors, enemies, crocodiles, and pigs killed in
sacrifice were prominently displayed together. Sometimes the skulls
were set on carved and painted racks depicting spirits. Oval plaques,
called *gope*, that depicted ancestral spirits hung below them. Pig
and crocodile skulls typically rested on the floor below, with
wooden figures depicting spirits placed among them (FIG. 38).

The cultural logic of headhunting pervaded all aspects of Asmat life until the combined efforts of missionaries and government officials largely succeeded in suppressing the practice in the 1960s. No death was regarded as accidental or the result of old age: magic killed as surely as an enemy. Therefore, all deaths had to be avenged by the death of an enemy. Asmat shields, *jamasj*, provided both physical and spiritual protection in battle (FIG. 39). The symbols carved on the shield make reference to headhunting on numerous levels and radiate ancestral power. Like carved wooden figures, each shield received the personal name of a dead relative, almost always male, who might be portrayed in the finial at the top of the shield. This ancestor then added his power to that of the carrier. A "shield feast," or *jamasj pokmbu*, marked the beginning of a headhunting expedition planned to avenge the deaths of those for whom the shields were named. At the climax of the feast, the shields were placed in a long row in front of the men's house in a dazzling display of artistic and spiritual power.

Along the central Asmat coast, the dead are memorialized and the village incited to avenge their deaths by the creation and display

38. *Bioma* figure. Koiravi village, Era River, Gulf of Papua, Gulf Province, Papua New Guinea. Wood, paint, height 26½" (67.4 cm). Collected by John Vandercook in 1929. Brooklyn Museum of Art, Brooklyn.

The curved form of this figure suggests that it was carved from the board of an old canoe. Such boards were highly valued for the spiritual power that the canoe had absorbed during headhunting raids. The figure's two pairs of arms and two pairs of legs, alternately raised and lowered, create a sense of floating movement.

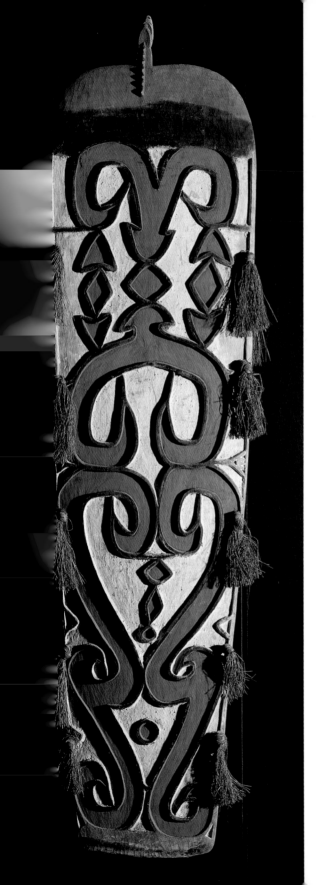

39. Shield. Basim village, Fajit River, Casuarina coast, central Asmat, Irian Jaya. Wood, lime, red ochre, charcoal, sago-leaf fiber, height 5'5" (1.66 m). Collected in 1961 by Adrian A. Gerbrands in Amanamkai village. Rijksmuseum voor Volkenkunde, Leiden.

The visual power of Asmat shields, carved in low relief, and accentuated with charcoal, ochre, and lime pigments, is remarkable, and their spiritual power cannot be underestimated. Certain motifs paralyzed a victim with fright so that he could be easily captured. The lower half of this shield shows two vertical, mirror-image pairs of S-shaped motifs called *eu wow* ("crocodile wood-carving"), representing a line along which the belly of a crocodile or of a headhunting victim was cut open.

of *bisj* poles (FIG. 40). Often more than fifteen feet (4.6 m) tall, they consist of sculpted human figures stacked on top of each other. The making of the *bisj* mimics the taking of a head. The carver cuts down the tree as if he were decapitating an enemy. He then skins the tree, the red sap of which is said to resemble the blood of a man being skinned. When the men carry the tree into the village, the women welcome it, shouting with joy, just as they would greet the arrival of an enemy's corpse. The carving then begins in a workroom or near the men's house. In the ceremony called *bisj mbu*, groups of *bisj* poles are placed on display in front of the men's house. In this way, the living promise to avenge the deaths of the people depicted on the poles, and the men support this promise during the festival by boasting of their valor and engaging in mock battles. Afterwards, the sculptures are taken to the swamp to rot, their supernatural strength transferred to the sago palms that provide the staple food.

The highlands people of New Guinea's central mountain range celebrate a series of exchanges, feasts, and rituals known as the Pig Festival, which begins approximately every twenty years and lasts for several years. Among the Wahgi, the early stage of the Pig Festival involves a series of rites that promote pig growth and enable the sponsoring clan to acquire the valuable decorations, especially feather plumes, that they will need in the years of dancing and performance to come. These are typically acquired from kin in other groups in exchange for pork from the clan's pigs, which will be killed at the end of the festival. During the final year of the Festival, the clansmen and some unmarried young women of the clan dress in their finest ornaments and wigs and dance two to three times a week on their ceremonial ground. The dances attract courting partners to the performers and overawe spectators from rival and enemy clans with the numbers, wealth, and power of the dancers, thereby deterring them from aggression. The Wahgi regard the success of a performance as evidence of the moral condition of the clan, and all grievances and problems must be aired and resolved in order for the dance to be a success.

New Guinea: Where Ornaments are Bright 59

Some dancers wear small, brightly painted boards, *geru*, during the Pig Festival and also on other occasions (FIG. 41). Just before the end of the Festival, the *geru* are used to ornament small, circular structures near the center of the dance ground. The structure is a miniature version of the cult house, or *bolyim*, that is the focus of the community's ritual life. At this structure, the clan slaughters the majority of its pigs and distributes the meat to kin, relatives, and exchange partners, especially those who have contributed to the dances. The Wahgi regard the pork fat thus consumed as particularly potent, for it symbolizes the growth and fertility sought during the Pig Festival, as well as the ancestral favor on which these qualities depend.

Perhaps the most famous exchange rituals in New Guinea are the *kula* voyages undertaken by Trobriand Islanders. Ever since the celebrated anthropologist Bronislaw Malinowski (1884–1942) first described them, they have fascinated outsiders and served as a basis for many theories of the meaning and nature of exchange. The basic exchange is deceptively simple: partners trade white conus-shell arm ornaments, *mwali*, for red chama-shell necklaces, *bagi*. Exchanges are complicated by the fact that each shell ornament is valued not only for its aesthetic appeal but also for its history, the number and fame of the people who have held it, and the difficulty they have had in acquiring it. Participants must use both persuasion and magic to "turn the minds" of their *kula* partners to release prized ornaments.

While *kula* traders nowadays sometimes travel by motorboat, large, elaborately carved canoes are still both functionally and symbolically important, for the voyages are long and dangerous. The openwork carved prow and breakwater are perhaps the canoes' most striking feature (FIG. 42). The prow incorporates bird, serpent, and human motifs, which refer to ancestors and totemic animals. The human figure depicted on the breakwater is Matakapota-iataia, a victorious culture hero, who was conceptualized as leading the voyagers into battle and other undertakings. He and the totemic images work in two ways, protecting the voyagers and attacking their trading partners.

The prow and splashboard are set in place with spells that insure the increase of the owner's personal beauty, an important factor in the acquisition of *kula* valuables. Just before arriving at the island

41. A Wahgi boy wearing a *geru* board. Wahgi people, Highlands, Papua New Guinea.

The boy has a section of bailer shell across his forehead, and his headdress is largely of Pesuet's parrot and cassowary plumes. The *geru* board is the geometrically decorated board projecting above the feather headdress. The motifs on *geru* boards have names such as "lizard's foreleg" and "bird's foot."

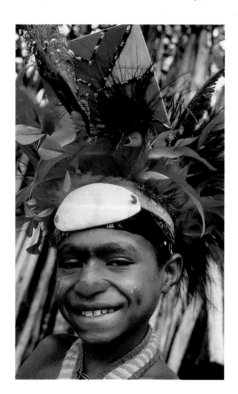

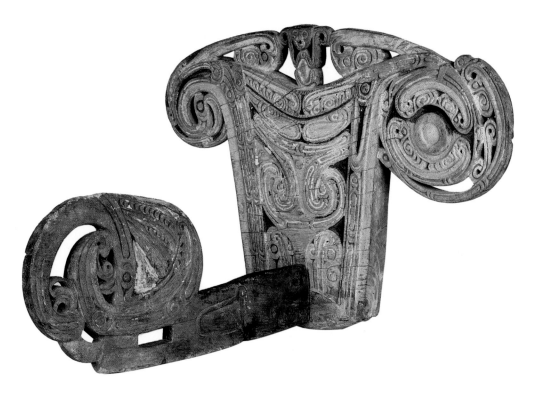

of their trading partners, the expedition leader takes hold of the prow and recites a spell: "fish hawk, fall on thy prey, catch it. My prowboard, oh fish hawk, fall on thy prey, catch it," and repeats it for each part of the canoe. Immediately before landing, the voyagers stop to repeat these spells and adorn themselves. *Kula* voyagers assert, "Our partner looks at us, sees our faces are beautiful; he throws the *vaygu'a* [shell valuables] at us." For Trobrianders, beauty means strength and immunity from danger, and in *kula* lore, physical ugliness disqualifies a man from possessing shell valuables.

This Trobiand notion of the power of aesthetics resonates with many art traditions on the island of New Guinea. It is the dazzling display of figures in the ceremonial house that convinces the Abelam initiate of the spirits' power, even before the elders explicate the meaning. On New Guinea's north coast, a woman's tattoos make her beautiful, testify to her strength and, today, proclaim her ethnic pride. The dynamic curve of a Papuan Gulf *bioma* figure evokes the power-laden canoe plank from which it was carved. Whatever particular visual form the aesthetic takes in New Guinea's art traditions, it can enhance the status of the artist, ensure victory in warfare, assist individuals from one stage of life to the next, transform a dancer into a spirit, and make ancestors present in this world once again.

42. Canoe prow and splashboard. Trobriand Islands, Milne Bay Province, Papua New Guinea. Wood, paint, height 15½" (39 cm), length 23" (59 cm). Musée de l'Homme, Paris.

Among the Trobiand Islanders, a master carver is not only a skilled artist but also someone who has mastered the meanings of the graphic signs carved on the prowboards and especially their relationship to *kula* mythology.

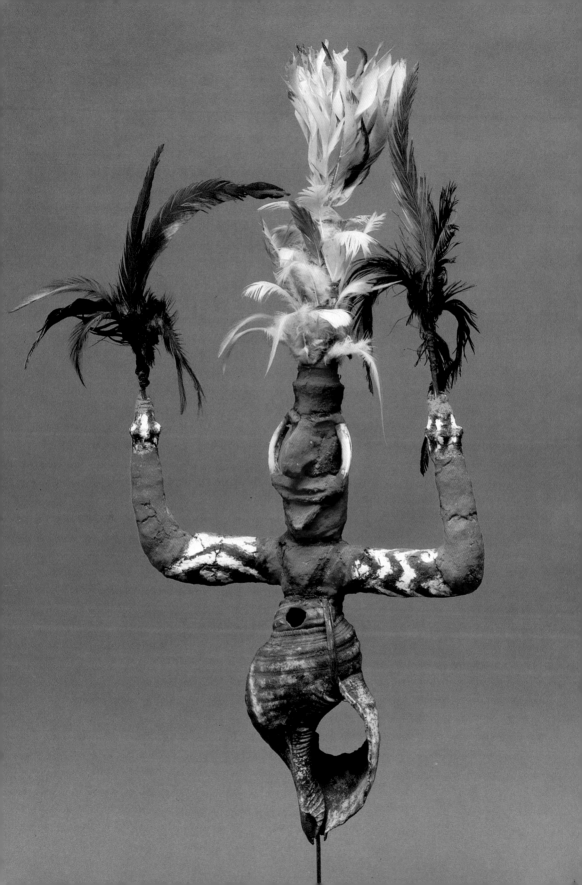

Island Melanesia: The Path of Peace

D espite numerous variations in form and meaning, perhaps the most unifying, as well as the most striking, characteristic of Melanesian art traditions is a focus on the artwork's visual impact, its effect on the viewer. The sculptor Alberto Giacometti remarked on the sense of power emanating from Melanesian art, a power that he believed was embedded in the object's own gaze: "The sculpture of the New Hebrides [Vanuatu] is true to life, and more than true, because it has a gaze. It is not the representation of an eye, it is well and truly a gaze. All the rest reinforces the gaze." Contrasts of color, line, form, texture, and pattern, and the use of dramatic elements such as oversized eyes all contribute to the aesthetic impact of these artworks. This dazzling visual impact evokes the profound spiritual, emotional, and political power of the spirits, ancestors, and ideas these artworks represent, and convinces the beholder of the power of those who have the right to display and perform them.

Most discussions of Melanesian art and culture emphasize the diversity of these islands rather than their unity, finding only a few cultural traits that connect these large island groups, which do indeed, by and large, have their own diverse populations. In general, and with the notable exception of several Solomon Islands groups and southern Vanuatu peoples, Melanesian cultures do not have hereditary political structures, as are found in Polynesia and Micronesia. Rather, the social hierarchies are relatively open to those who have the talent, wealth, and personal force to attain titles or advance through the levels of the grade societies (initiatory societies, sometimes called "secret" societies), thereby accumulating political and spiritual power. These power structures are not completely open, however, for those

43. Grade society figure. South Malekula, Vanuatu. Shell, pigment, feathers, fiber, height 21¾" (54 cm). Collected by Felix Speiser in 1912. Museum der Kulteren, Basel.

Small figures like this one may have been carried by dancers or displayed in the grade-society house during feasts. Its dynamic gesture, with arms raised, contrasts with the more composed, hieratic posture typical of large-scale grade-society figures.

whose fathers or uncles are powerful figures have an advantage in their access to wealth and influence. These powerful individuals are usually men – sometimes called "big men" in the anthropological literature – but in some cultures women can serve in these roles as well.

Most cultures emphasize the importance of the chain of ancestors, and so the importance of lineages and of the clans as a moving force in society. Artistic production focuses on the clans and the grade societies and on the relationship of the community with spirits and ancestors. In northern Ambae, Vanuatu, the origin myth of the Malauhi lineage identifies the grade society, *hungwe*, as "the path of peace," the way that people can overcome their differences and move to a higher order and level of civilization. This myth recounts how the Malauhi ancestor Gasinamoli learned that greater prestige and wealth were to be accumulated through the peace and trade fostered by the grade society than through warfare.

Although the culture area of Melanesia incorporates the island of New Guinea, the designation "Island Melanesia" distinguishes the other islands in this area from New Guinea to acknowledge its size and unique cultural history. Island Melanesia includes the Admiralty Islands, New Ireland, New Britain, the Solomon Islands, Vanuatu, and New Caledonia, which are strung out in a line running roughly northwest to southeast between the equator and the Tropic of Capricorn. Smaller island groups, including Matty-Wuvulu, Hermit and Anchorite Islands, cluster near the Admiralties and their culture shows the influence of both Micronesia and island Southeast Asia. Relatively recently, Polynesian peoples migrated back westward to settle some of the smaller island groups, creating distinctive cultural and artistic traditions that show affinities with Melanesian as well as their own Polynesian traditions (FIG. 44).

Most Melanesian islands are large and mountainous, the result of their volcanic origin. Like New Guinea, they include a range of environments, from mountainous interiors covered with rich tropical rainforests to grasslands and low-lying swamps and river basins. Island Melanesia and New Guinea share similar animal and plant life, especially birds, marsupials, small mammals, and reptiles. Austronesian languages predominate in Island Melanesia, although many Papuan languages are also spoken.

The current political situation in the region reflects its colonial history. Europeans began exploring this area in the sixteenth century. In 1568, Medaña anchored at Santa Ysabel and Guadalcanal and one of his ships visited Malaita, Ulawa, and

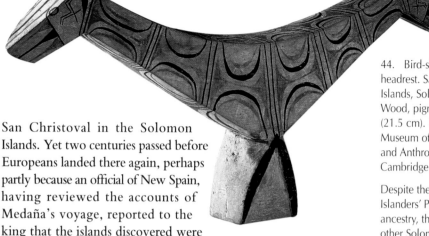

San Christoval in the Solomon Islands. Yet two centuries passed before Europeans landed there again, perhaps partly because an official of New Spain, having reviewed the accounts of Medaña's voyage, reported to the king that the islands discovered were "of little value" – at least to those who sought gold and spices. Other European voyages touched at various Melanesian islands in the seventeenth and eighteenth centuries: Quiros landed on Espiritu Santo in 1606, and in the 1760s and 1770s Vanuatu was explored by both de Bougainville and by Cook, who also visited New Caledonia. However, it was only in the nineteenth century that sustained contact developed and in the 1870s Great Britain, France, and Germany began to stake out colonial possessions in the region. Today, the Admiralty Islands, New Britain, New Ireland, and the northern Solomon Islands form part of the nation of Papua New Guinea. The islands south of Bougainville comprise the nation of the Solomon Islands, which achieved independence in 1978. Vanuatu, formerly known as the New Hebrides, is also an independent nation. New Caledonia is a territorial protectorate of France.

44. Bird-shaped headrest. Santa Cruz Islands, Solomon Islands. Wood, pigment, width 8½" (21.5 cm). University Museum of Archaeology and Anthropology, Cambridge.

Despite the Santa Cruz Islanders' Polynesian ancestry, their art relates to other Solomon Islands' artistic traditions in its style of geometric patterning and bird imagery.

Grade Societies

Grade societies were and remain centrally important in organizing the spiritual, political, and social life of many Melanesian peoples. Advancement through the grades or levels of the society is by gifts of valuables and currency, sponsorship of feasts, the demonstration of leadership, and mastery of esoteric knowledge. The arts, including body ornamentation, sculpture, and architecture, are a vital part of creating the prestige and demonstrating the status of the different grades of these societies (see FIG. 43). The houses of the grade societies are analogous to the men's houses of New Guinea, serving as centers for the spiritual, social, and political life of communities. Like New Guinea men's houses, they

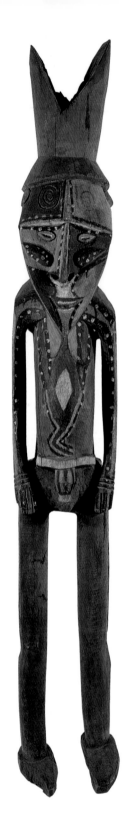

are often the largest and most imposing structures in the villages.

Perhaps the best-known of the Melanesian grade societies are those of the northern islands of Vanuatu, including Malekula, Ambrym, Pentecost, and the Banks Islands, and sometimes known as *suque*. Most men belong to the grade society and advance through the ranks by making offerings of pigs, mats, and shell money. Promotion to the next grade brings a man into a sphere of denser spiritual power by means of communion with others of the same grade, both living and dead. He acquires spiritual power himself and enjoys greater prestige not only on earth but also in the afterlife as he ascends through the ranks. These ranks often outweigh clans in organizing village affairs. Unlike the men's houses of New Guinea, the interiors of *suque* houses are divided not according to clans but according to the grades of the society, and it is a serious offense for a man of lower rank to approach the fireplace of a higher rank.

Art work was essential to the functioning of these societies to indicate grades, honor members, and form appropriate gifts. In Ambrym and Malekula, members of the grade society often commission large figures carved of wood or tree fern. These figures serve simultaneously as representations of ancestral spirits and as symbols of the power of their owner, for they express the grade of the living rather than the deceased (FIG. 45). The patterns painted on the figures' surfaces are composed of the *suque* symbols that indicate the rank of the owner. Nonetheless, statues are usually made for ancestors of high grade only. The patrons are nearly always men of high rank, since only they can be intimately acquainted with such powerful ancestral spirits and undertake such an expensive project. The statues are usually male, because the members of the *suque* are men. At least in the past, the grade society also sponsored the sculpting of female figures, but these were used in specific rituals about which little is recorded in the scholarly literature.

The ancestral figures most often stand near the grade-society houses. There they are sometimes hidden in the undergrowth, though those of the highest rank stand against the exterior walls in prominent positions. In front of the house they may be grouped with large-scale wooden figures that represent the different grades of the society. Figures may also adorn the entrance to the house

45. Grade-society figure. Malekula (east coast), Vanuatu. Wood, pigment. Musée et Institut d'Ethnographie, Geneva.

The elongation and angularity of the figure emphasize its skeletal structure, the substance of relics, rather than the flesh.

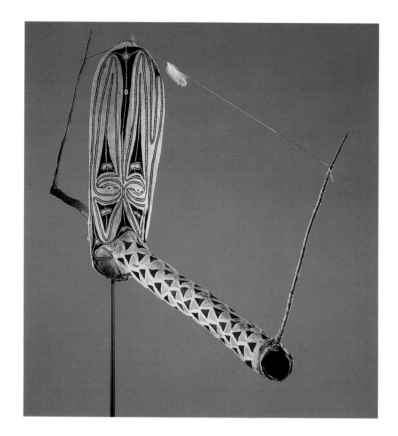

46. Mask (*vungvung*). Baining, New Britain, Papua New Guinea. Barkcloth, cane/wood, fiber, pigment, length 3′7″ (1.1 m). Museum der Kulturen, Basel.

Only the senior men understand the full range of the mask's symbolism. The audience of mostly uninitiated women and children would be unaware of many of the esoteric meanings of the masks, and might not in the darkness of the night dances even be able to see clearly the highly symbolic painted patterns.

of an important man. In the Banks Islands, high-ranking men clear terraces in front of their houses to accommodate large numbers of male and female figures. These figures probably originally represented ancestors but now function primarily as signs of their owner's wealth and prestige. As long as the ancestor is remembered, a statue retains its potency and so must be carefully tended. However, once its painted surface has worn away and the memory of the ancestor fades, the patron may sell the statue. Men of lower rank often buy such statues to acquire the protection of their spirits.

Although masks play little role in the grade societies of Vanuatu, the men's societies of the Baining of New Britain sponsor two types of masked dances, associated with day and night. The making and performance of the masks is connected to age-grade initiation, as the older men teach newly initiated young men the meanings of the different masks and how to make them. The initiates first learn to make and understand the meanings of the headdresses, then the helmet masks, and finally the large trumpet masks (FIG. 46). The symbolism of the day dances and masks refers mainly to women's activities and products, especially

those of the garden. Although men wear the masks at the day dances, women provide the orchestra. The men's night dances present a confrontation between the spirits of the forest, represented by the masked performers, and the civilized village, represented by a male orchestra. The symbolism of night dance masks refers to flora and fauna associated with men's production activities, including hunting, gathering, and cutting.

The night-dance performances begin at sunset, when the orchestra begins to sing and chant, beating lengths of bamboo or short poles on the ground or on logs or flat stones to mark their rhythm. One by one, the masked dancers approach the orchestra from the forested side of the dance ground. They dance in place before the orchestra and then line up on one side until all the dancers are assembled. The orchestra increases the tempo and the dancers begin to move around the dance ground. At this point, the smaller headdresses and masks dance into and through a bonfire. Large masks move about the dance ground more slowly, guided by assistants. While the smaller masks represent wild and sometimes nearly uncontrollable spirits, the large masks represent beneficent spirits. Mothers sometimes hold their babies up to a large mask so that it can blow on the children and endow them with the strength to grow to adulthood. As dawn approaches, the orchestra drives the spirits back into the forest, demonstrating their mastery over the spirit world.

Although missionaries and the colonial government discouraged these performances, causing their decline, the present Papua New Guinea government actively encourages the preservation of cultural activities. The Baining also perform night dances for tourists, thus providing another venue by which senior men can pass on their knowledge of maskmaking and symbolism to young men.

The materials, forms, and decoration of the masks are closely tied to their spiritual power. The red pigment is understood as male, and is connected to the flames of the ritual bonfire, the flowing of animal and human blood in hunting and warfare, ritual self-sacrifice in ceremonial contexts, and the blood-red saliva produced in chewing betel nut. The performers prick their tongues and spit blood on the masks to activate their spirits before a performance, further enhancing this connection. Black, in contrast, is a female color, associated with the ashes and soot of cooking fires, the fecundity of earth and mud, and the dark, wet places where powerful spirits live. The white of the barkcloth is the color of the spirits, associated with wet and cloudy days, misty watering holes, the foam that sometimes occurs on the beaches and streams and that is itself associated with afterbirth and the primordial slime.

The patterns painted on the masks represent various natural elements: fern leaves, bird tracks, the trails of caterpillars or snakes. The masks themselves may represent pig vertebrae, tree forks, or leaves. Nowadays masks may represent the spirits of a new range of important and powerful cultural and natural elements, including guitars, cats, dogs, mosquitoes, and spades.

Although women throughout Melanesia generally do not have access to men's grade societies, nor do they usually have their own, there are significant exceptions. Among the Kove of northern New Britain, each men's house is headed by a *mahoni*, a wealthy and powerful man full of esoteric knowledge and skilled in warfare. In the past, a *mahoni* could bestow his title on a first-born daughter. Her father revealed to her all the rituals associated with the men's house and taught her important masculine activities such as weather control and sorcery. Although female *mahoni* sometimes did marry, many did not, focusing their energies instead on supervising male activities, including warfare or artistic endeavors such as the construction of men's houses. As the role of the *mahoni* has changed, more men claiming a title that nevertheless bestows fewer privileges, women take on the role less frequently.

Fully institutionalized grade societies for women exist in Malekula and the Banks Islands of northern Vanuatu. The women of the Banks Islands have grades of honor to which they gain access through the payment of fees and sponsorship of a feast. In this way they become *tavine motar*, "women of distinction." Certain artistic privileges accompany their advancement, for they gain the right to wear tattoos, shell bracelets, and ornamented garments, and to decorate their faces with red earth. *Tavine motar* often use their wealth and status to help their husbands advance through the ranks of *suque*. On Malekula, some groups have women's grade societies called *lapas* or *langambas*. Like the men's societies, the women's is divided into a series of successive grades, each of which has a name and a distinctive title for its members. Women have a quality of sacredness, *igah*, which is opposed to men's sacredness, *ileo*. *Igah* not only confers power and prestige on women but can also counteract and destroy the *ileo* of men and men's ritual objects. While the men's house is located prominently in the center of the village, the women's *lapas* ceremonies of Seniang village, for example, take place in a house built in the forest. This house contains as its most sacred objects painted basketry headdresses that none but the fully initiated can view. Women accompany their dances with small bamboo gongs that they beat themselves, rather than the large slit gongs used by men's societies in the villages.

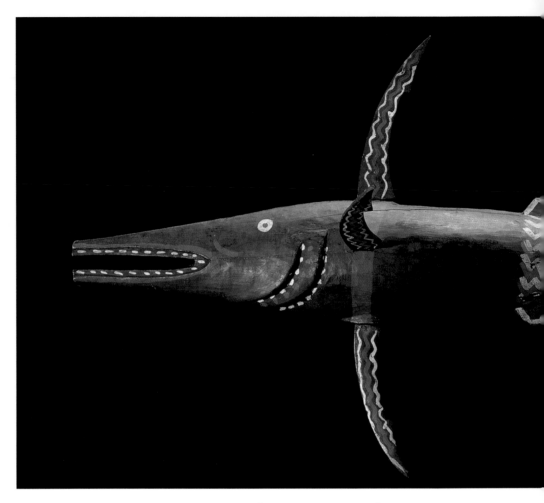

Ancestors and Funerary Rituals

Vast numbers of Melanesian artworks are recorded as represent-
ing ancestors, a term that has been used so often it is both full
of meaning and meaningless. The records unfortunately rarely
indicate exactly which ancestors are depicted, their relationship to
other spirits, or how they may gain or lose efficacy. In many
cultures it seems that artworks make visible and powerful in
this world the unseen presence of the ancestors and the intangible
forces they activate for the good of the community. Both clans
and the initiatory societies play a role in the organization of funer-
ary rituals and in developing continuing relationships between the
community and the ancestral spirits who are its protectors and
benefactors. Often, as in most parts of the Solomon Islands and
New Caledonia, there is no belief in a supreme deity or of great
gods that outrank the ancestors.

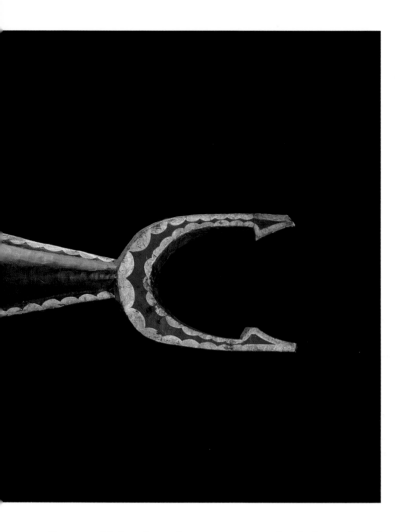

47. Skull reliquary. Santa Ana Island, Solomon Islands. Wood, paint, human skull, length 4'7½" (1.41 m). Collected by Admiral Davis during the cruise of HMS *Royalist* in 1890–93. British Museum, London.

Although the Solomon Islanders also preserved the long bones of the deceased, the skull was the most important relic because it contained the individual's power. It was placed in a small cavity in the body of the fish-shaped reliquary.

In many Melanesian cultures, mortuary rituals focused, and sometimes still focus, on the skull of the deceased. As in New Guinea, the skull was conceived as the most powerful part of the body, the seat of the soul and so of the individual's spiritual power. Often the symbolism surrounding the skull connected it to other aspects of the community's prosperity and continuity. On Santa Ana Island in the Solomon Islands, the skulls of important male ancestors were preserved in containers shaped like sharks or bonito, depending on the man's totem, while the long bones were stored in model canoes (FIG. 47). The clan members kept these reliquaries in the *tapu* house, which also housed the war and headhunting canoes. The conjunction of fishing, headhunting, and warfare, and the veneration of the ancestors celebrated the abundance, prosperity, and productivity of the natural world and the human community, and the spirit world that mediated relationships between the two.

Traditionally, Admiralty Islanders preserved the skulls of deceased male patrilineal relatives in hemispherical, wooden bowls with spiralling handles hung just inside the entrances to houses. Those who lived in the house regarded the deceased relative as a protective spirit. However, the death of the male head of the household discredited the spirit and the householders discarded the skull, for it had failed in its duty. The deceased householder then became the new protective spirit, watching over his male heir and the household. A female medium who had a dead male child interpreted the will of the skull spirit. The spirit brought messages to the medium in the form of whistles, which she translated for the household. Although protective toward the residents of their own houses, these spirits could be malevolent toward others.

The grade societies of southern Malekula, in Vanuatu, created dramatically painted statues, *rambaramp*, to preserve the skulls of the deceased (FIG. 48). On the death of a man of high *suque* rank, typically a warrior or leader, his body was buried and then exhumed when the flesh had rotted from the bones. A specialist then created an image of split bamboo and wood, plastered over with clay, to represent the deceased. The skull itself was modeled with clay and painted to recall the appearance in life of the deceased. For those of lower rank, the entire body is not re-created but the overmodeled skull is set on a pole representing the body more schematically. Set up inside the *suque* society house, the skull statue ensured the continuing presence of the protective ancestor spirit in the community. On important occasions, descendants offered food to the figures. The preservation of skulls in this way clearly relates to the Sepik River custom of preserving the skulls of important members of the community and slain enemies by coating them with clay to model flesh and painting them with patterns.

Perhaps the best known mortuary rituals in Melanesia are the *malangan* celebrations of northern New Ireland. Matrilineal clans sponsor these feasts to honor the dead, and they bring relatives and visitors to the village for performances, orations, feasting, and the exchange of pigs and shell ornaments. The climax of the ritual is the display of works of art specially commissioned for the occasion (FIG. 49). These are mounted on the façade of a ceremonial house built for the purpose and covered with fresh green foliage, providing a striking backdrop for the painted sculptures. The ceremonial payment of obligations is an important part of the proceedings. The bones of the deceased wrapped in bundles of leaves are temporarily placed in front of the carvings; more recently Western-style tombstones are erected

Opposite
48. Skull statue (*rambaramp*). Southern Malekula, Vanuatu. Wood, human skull, clay, boar tusks, feathers, fiber pigments, height 5'10" (1.78 m), width at shoulders 22" (56 cm). Musée des Arts Africains et Océaniens, Paris.

The patterns painted on the body and face corresponded to the deceased's *suque* rank. Figures often hold the insignia of the high *suque* rank, a pig's jaw and shell trumpet.

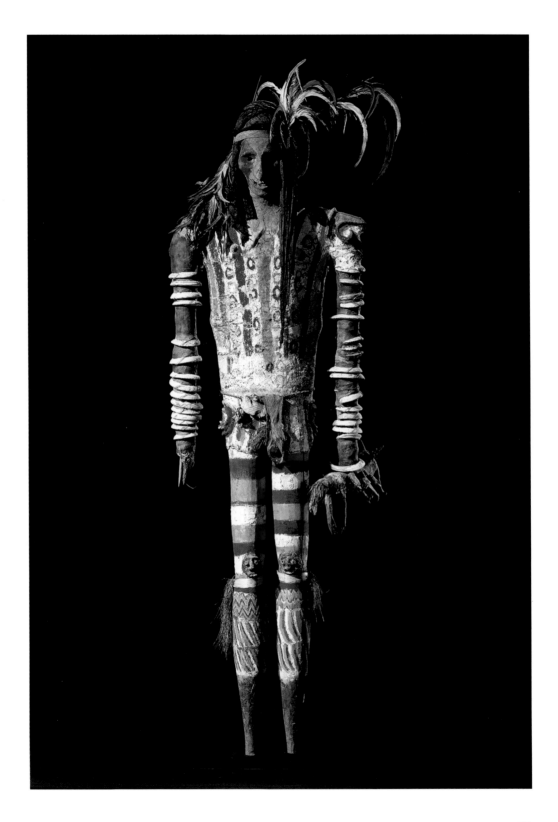

in front of the *malangan* display. *Malangan* may also be made and presented for the initiation of boys as well as mortuary rituals. There is a kind of balance here, for the ceremonies usher new adults into the community even as the dead depart. At the end of the display, the clan burns the *malangan* sculptures or allows them to rot away to prevent others from using their spiritual power for sorcery.

The sculptures themselves are complex, full of esoteric meanings and references to clan history and ancestors and spirits. Each connects to a specific story, one that can be told

49. Sangis Lamot, master Malagan carver, 1986 (now deceased). Mapua Island, Tabar Islands, Papua New Guinea.

in all authenticity only by the owner of the rights to the *malangan*. This richness of meaning is paralleled by a visual complexity, for the sculptures are often composed of multiple openwork figures and covered with a variety of painted patterns (FIG. 50). Anthropomorphic figures usually represent other ancestral or mythic beings and are often named after them. During the presentation, the deceased person or the mythic or ancestral spirit represented by the sculpture is believed to dwell in it, so they are treated with care.

50. Horizontal *malangan* frieze. Northern New Ireland, Papua New Guinea. Wood, pigment, snail opercula, length 35″ (89 cm). Acquired in 1881. British Museum, London.

Great feasts and performances accompany the display of the *malangan* sculpture. The sponsoring matrilineal clan asks others related through marriage and male descent to support the occasion by contributing dances or sculptural displays. Often, someone will bring "a line of *tatanua*," masked dancers who perform on one of the last days of the feast and represent an idealized image of manhood (FIG. 51). The striking crested hairstyle of the mask

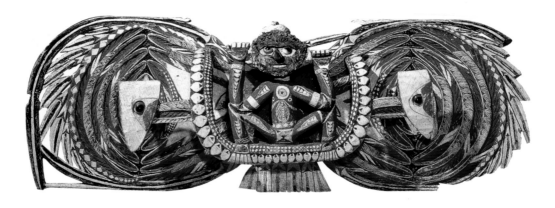

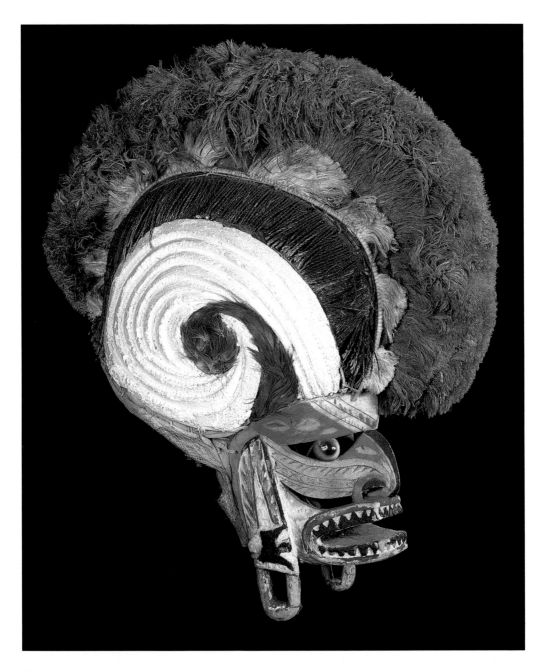

51. Mask (*tatanua*). New Ireland, Papua New Guinea.
Wood, fiber, shell, lime, feathers, height 17½″ (44 cm).
Otago Museum, Dunedin.

The person who organizes a *tatanua* performance must
select the music and dancers, assemble a male chorus,
and acquire the masks. The masks are usually rented
from one of the sculptors who makes them.

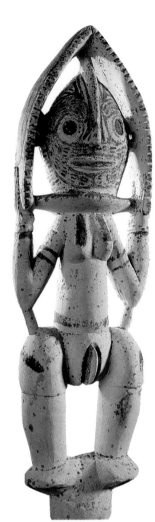

Left

52. Mortuary figure (*kulap*). Southern New Ireland, Papua New Guinea. Chalk, paint, height 18″ (46 cm). Collected by the Reverend George Brown in 1878. Auckland Institute and Museum, Auckland.

Chalk figures often incorporate simplified openwork elements that are reminiscent of the more compositionally complex *uli* and *malangan* mortuary images. After the funerary rituals, the figure was broken and the spirit then departed from the living to join the ancestors.

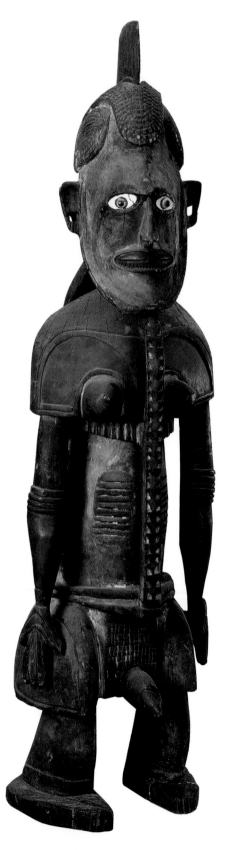

Right

53. Figure (*nalik*). New Ireland, Papua New Guinea. Wood, pigment, height 3′9¾″ (1.16 m). Presented to the British Museum in 1936 by Mr A. Lockwood. British Museum, London.

The head is emphasized visually because this is where the individual's power lies.

imitates a traditional hairstyle worn by young men to signify bereavement, when the sides of the head are shaved and the head covered with a plaster of lime dust. The mask's red, black, and white coloration recalls warfare, powerful forms of magic, sorcery, and the spirits of those who have died from violence. The men who wear the masks often live together for several weeks in the sponsor's men's house to practice and guard their spiritual strength. On the day of the dance, they don the masks while reciting protective rituals and spells. As the lead dancer ushers the *tatanua* into the compound one by one, they present a vision of the host village as a wellspring of vitality and male strength in spite of death, sorcery, and other misfortunes.

Two other great New Ireland mortuary traditions are no longer practiced. In southern New Ireland, there were mortuary rituals based on relatively small-scale chalk figures, *kulap*, which served as a temporary dwelling place for the deceased's spirit (FIG. 52). In the central part of the island, among the Mandak people, mortuary rituals known as *uli* focused on wooden figures, *nalik*, that embodied the spiritual energy of the deceased (FIG. 53). Following the death of a leader, the village staged a series of commemorative pig feasts every month for a year. In preparation for the final feast, a sculptor carved a wooden figure to represent the deceased, and people from neighboring villages were invited. The visitors brought with them their own *nalik* figures, freshly painted and furnished with new fiber beards, which they installed in small shrines for the duration of the feast. With the help of a shaman, the spirit of the deceased entered the newly made *nalik* of the host village. After the ceremony, the figure stayed in the men's house to provide assistance to the new leader and to the people of the village.

Nalik figures exhibit much of the visual and symbolic complexity that characterizes *malangan* carvings. Each *nalik* wears ceremonial dress, including bracelets, leg bands, and a crested headdress. The head is emphasized visually because it is the seat of spiritual power. The figure is hermaphroditic, endowed with both a phallus and breasts, and so has the ability both to create and to nourish. This may indicate the need in the community for a feminine element, which can nourish children and raise taro, and a masculine element, which can control ritual energy and direct the affairs of society, and the importance of fertility in both sexes. Once the figure has been installed in the men's house, the women stage a procession in which they bring taro roots to the men's house and place them in a special enclosure outside its walls, thus underscoring the interdependence of male and female skills in society.

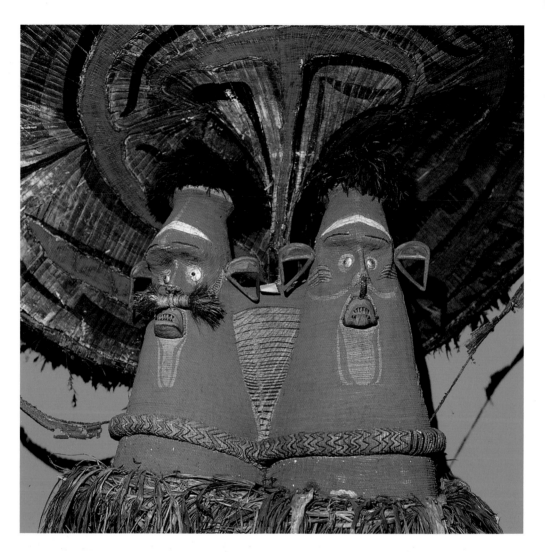

54. *Hemlaut* mask. Sulka people, New Britain, Papua New Guinea. Bamboo, wood, pith, cassowary feathers, pigments, height 8'½" (2.45 m). Collected 1908–10. Museum für Völkerkunde, Hamburg.

The patterns painted on the mask are called *mla* or sometimes *riteak,* "writing." The masks can include depictions of praying mantises, flying foxes, and phalangers (small marsupials).

Among the Sulka and Maenge of New Britain, masks appear not only during funerary rituals for prominent men and women, but also for births, initiations, and marriages (FIG. 54). These rites of passage are intimately connected, just as they are in the New Ireland *malangan* ceremony, when deaths and initiations balance each other out in the life of the clan. Sulka artworks depend on the aesthetics of "brilliance" to connote their spiritual effectiveness: the greater the visual impact of a work in its play of line, form, and color, the greater its spiritual power. The double-headed *hemlaut* mask, named Lopela, represents a powerful spirit and takes an unusual and striking form. Its two heads are anthropomorphic and wear the nose and ear ornaments of a Sulka adult. A circular piece painted underneath with a vibrant pattern surmounts

the masks. The dancers perform two basic gestures: jumping up and down in place or bending to reveal the patterns painted on the underside of the mask's superstructure and thus reinforce viewers' perception of the mask's spiritual power. A voluminous leaf costume conceals the identity of the dancer and focuses attention on the mask itself.

Ceremonial Gift-giving and Exchange

The process of exchange can invest artworks and other objects with value that is not only economic but social and political as well. Exchange may be a way of gaining prestige or power for an individual or community as well as wealth. This is even true of objects that Westerners perceive as having primarily aesthetic or spiritual value. When the American anthropologist Hortense Powdermaker (1903–1970) was leaving New Ireland in 1929, she asked the village elders what she should tell others about the *malangan* sculptures she was taking. The elders, to whom the objects primarily represented embodiments of wealth and ritual exchanges, instructed her to "tell these people who would look at the *malangans* that they were not just carved painted pieces of wood … make the people understand all the work and wealth that had gone into the making of them – the large taro crops, the many pigs, all the shell money, the cooking for the feast, and other essentials of the rites." The exchange value of the carvings and the human investment in them were thus as potent as their spiritual value.

The intertwining of exchange, prestige, and spiritual value is also characteristic of the striking greenstone axes that leaders exchanged ritually in New Caledonia (FIG. 55). Greenstone was particularly valuable, significant deposits being found in the center and south of the island only. The greenstone axe blades formed part of a cycle of exchange that included women's necklaces of greenstone beads, shell necklaces and money, and braided cords of flying-fox fur. The name of this exchange, *la-ni*, means "the road of riches," and, like the *kula* exchange of the Trobriand Islands, the trade in greenstone followed a set path. Peoples of the north

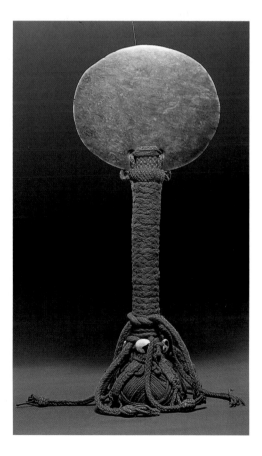

55. Ceremonial axe (*o kono* or *boulaibi bounbout*). New Caledonia. Greenstone, wood, fiber, flying-fox fur, height 18" (46 cm), diameter 10½" (27 cm). Collected by the anthropologist Fritz Sarasin (1859–1942) in Oubatche in 1911. Museum der Kulturen, Basel.

Although called ceremonial axes in the West, the New Caledonian names for these objects, *o kono* or *boulaibi bounbout*, actually mean "stone club" or "green club." They served primarily as symbols of the power of the clans that owned them rather than as weapons.

traded with the south and the Isle of Pines, who in turn traded with the Loyalty Islands, Mare, Lifou, and Ouvea. They completed the cycle by trading with the north. The French navigator Antoine de Bruni, Chevalier d'Entrecasteaux (1737–93), and other early observers thought these greenstone axes were used to cut open the bodies of victims, but it seems clear that they served primarily as symbols of their owners' prestige. Orators sometimes flourished these axes to emphasize their points and elders used them to indicate how the corpse of an enemy was to be divided.

56. Canoe and canoe house. Vella La Vella, Solomon Islands. British Museum, London.

The tradition of building this type of canoe is quite ancient. Medaña admiringly described canoes with raised prows and sterns in the sixteenth century, and Solomon Islands rock paintings dating to 1300–1100 BCE include canoes of this form. Pressure from the British navy and colonial officials caused headhunting – and the arts associated with it – to decline at the end of the nineteenth century. Many *mon* canoes were burned or destroyed at that time.

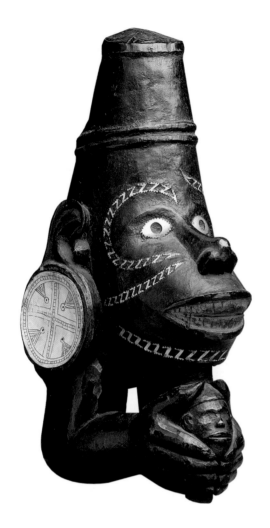

57. Canoe figurehead (*nguzunguzu*). Roviana, New Georgia group, Solomon Islands. Wood, shell, paint, height 11½" (29.5 cm). Collected in 1895. Barbier-Müller Museum, Geneva.

The shell-inlay designs accentuating the eyes, cheeks, and chin of this image imitate the face paint worn by warriors in this region. This figure holds a small head in its hands, a clear reference to headhunting. Headhunting raids accompanied the launching of a new canoe, the completion of a canoe house, marriages, and yam harvest celebrations. As elsewhere in Melanesia, headhunting linked the viability and continuity of the community to an abundance of food, the fertility of its members, the happiness and well-being of ancestors, and dominance over enemies.

The *mon* canoes of the Solomon Islands demonstrate the close connection between symbols of exchange and the most important spiritual activities of the community, headhunting and funerary rituals (FIG. 56). The canoes are quite striking, with their towering prows and sterns elaborately decorated with rows of pearl shell inlay and set with small figures to ward off water spirits, *kesoko*, that might try to capsize the canoe (FIG. 57). *Mon* canoes were used in headhunting and funerary rituals and were kept in special houses along with the skulls and bones of the deceased, as noted above. When a leader commissioned a canoe he requisitioned one or two thousand pieces of shaped inlays, which artists then set into the parinarium-nut paste in a variety of patterns. The patterns are mainly geometric but also depict birds, fish, stars, and clouds. The patterns feature shell rings that represent the larger shell rings frequently used as offerings and exchanges in rituals

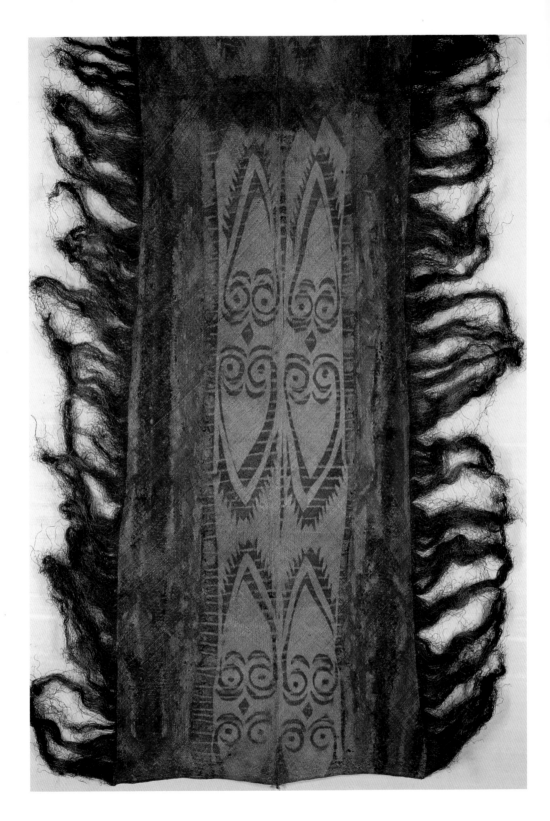

involving bonito fishing, headhunting and funerals. These shell rings also adorned ancestral skulls and offerings made to ancestors.

Textiles often figure prominently in ceremonial gift-giving and exchange throughout Melanesia. They are valued as a form of wealth with richly symbolic associations. On Pentecost Island in the Banks group of northern Vanuatu, large and small mats serve as a form of currency (FIG. 58). While now supplanted by money for most transactions, mats are still exchanged to mark ritual occasions, such as birth, death, marriage, the taking of rank, or circumcision. Value is partly determined by size – one large mat, *sese*, equals ten small ones, *tsip* – but aesthetics play a part too. Large ones have more value if they have fringes along their breadth, complicated perforated patterns in the weaving, or perfectly executed dyeing (FIG. 59). Women undertake the time-consuming and delicate task of attaching the stencil to the mat and dyeing it. Nowadays the stencils are created by male design specialists but in the past they were probably made by women as well.

The quality and nature of the design are related to its efficacy, and these designs are clearly spiritual in nature and have a supernatural authority and effect. Working entirely from memory, these specialists may drink a herbal potion to open the spirit and allow them to remember the designs. The mats' geometric motifs bear the names of plants and animals and are closely related to tattoo designs. Both tattoos and mat designs now incorporate modern and foreign images, such as hearts, personal names, arrows, and crosses. The relative lack of secular motifs in mat design may reflect their continuing importance as ceremonial objects, while tattooing has become a more secular activity, less closely tied to cultural identity and other community values.

Although the art of barkcloth was once widely practiced in Vanuatu, it has ceased to be important in the twentieth century and only survives to any significant degree in Tanna. On the island of Erromango, the decorated barkcloth made by women was once a prestige item and an object of ceremonial exchange (FIG. 60). Decorated barkcloth formed an important part of ritual payments such as bride-wealth. Dozens of these barkcloths were hung from the bamboo or wooden poles that radiated from a tall tower built to celebrate alliance rituals. The display of textiles was sometimes burned in an awe-inspiring act of consumption, especially at the funerals of chiefs. Women wore decorated barkcloth across their shoulders or draped over one shoulder and across the breasts. The production of decorated barkcloth gave women status, and a woman who wore an exceptionally beautiful example was a *fah nahiven*, "a woman of substance."

Opposite

58. Ceremonial mat. North Pentecost Island, Vanuatu. Fiber, pigment, 166½ x 33½" (400 x 85 cm). Museum der Kulturen, Basel.

The images on this mat include schematic anthropomorphic faces with large, staring eyes.

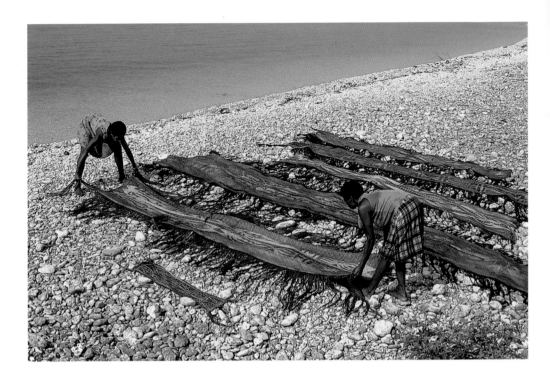

59. Dyed mats drying on the beach. Pentecost Island, Vanuatu.

Of course, utilitarian as well as ritual objects are used for trade. The Matankor people of the Admiralty Islands trade in sculpture, woodwork, and obsidian blades for weapons with other peoples in the Admiralty group. They produce furniture such as headrests and house ladders, household utensils such as scoops and ladles, and large slit gongs. The carvings the Matankor produce often bear figurative decorations. Figures that appeared on beds, bowls,

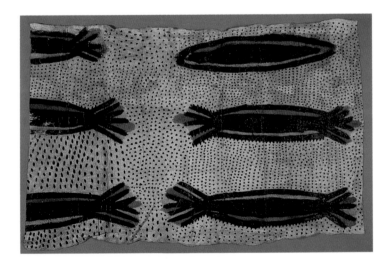

60. Decorated barkcloth (*nimah neyoruri*). Erromango Island, Vanuatu. Barkcloth, pigment, length 26⅜" (67 cm). British Museum, London.

Decorated barkcloths were called *n'mah neyorwi*, "decorated (beautiful) cloth." Although the designs may seem abstract, they depict animals, fish, birds, plants, people, spirits, or heavenly bodies.

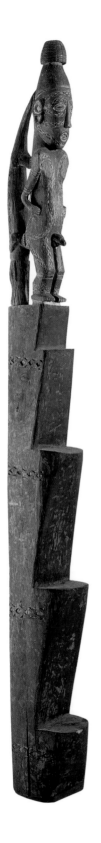

ladles, and other utilitarian objects probably depicted generic ancestor figures, rather than specific ancestors, as many free-standing figures or house supports probably did (FIG. 61). Their identity as trade items would support this surmise: if the carvers did not know the families and their specific ancestors well, it may have been more appropriate to make a generalized figure. As in this example, ancestral figures are often combined with crocodiles, a motif that may refer to clan history. Despite the fact that the human/crocodile combination is the most common motif, its meaning is not fully clear. In some areas the crocodile is a clan totem, and in these villages it is not harmed. Fish, birds, and insects are also sometimes depicted.

The art form for which the Matankor are perhaps best known is the spectacular wooden feast bowl (FIG. 62). The openwork handles cannot support the weight of the massive bowl and their role is symbolic rather than functional. The bowls may represent a spirit ship, the handles representing the spiral prow and stern that ornament ceremonial canoes in many Melanesian cultures. The Admiralty Islanders used small bowls of similar shape to house the skulls of male ancestral spirits, as noted above. These spiritual associations may have been so generalized, like the generic ancestor figures,

Left

61. Ladder. Matankor, Admiralty Islands, Papua New Guinea. Wood, paint, height 5'7½" (1.72 m). British Museum, London.

Ladders were used in the village men's house or bachelor's house, buildings that frequently incorporated images of male and female ancestors.

Below

62. Feast bowl. Manus Island, Admiralty Islands, Papua New Guinea. Wood, height 20" (51 cm), diameter 45" (114 cm). Collected by Alfred Bühler in 1929. Museum der Kulturen, Basel.

This type of large, hemispherical bowl is carved of a single piece of wood except for the dramatic, spiraling handles which are attached separately.

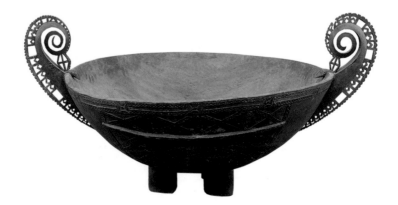

that these bowls were able to function as trade objects not controlled by the restrictions governing esoteric knowledge.

Among the Tolai people of New Britain, mortuary canoes used in the funerary rituals of powerful men were also objects of trade (FIG. 63). In the late nineteenth century, Tolai clans of the Duke of York Islands made these canoes and then transported and sold them to Tolai living on the Gazelle Peninsula. The canoes apparently were not functional, although they sometimes were launched and set afire at the end of the mortuary rituals. The prow and stern are large, detachable ornaments, with openwork carving of fine parallel lines. The central motif terminates in a spiral at either end, thus reproducing the form of the canoe though it stands on human legs. With their tall prow and stern ornaments, these mortuary canoes are related to the tradition of canoe building in the Solomon Islands as well as the Hermit Islands, Kaniet, and other Austronesian-language speakers throughout Melanesia (see FIG. 6). The spiritual significance of this canoe form is suggested not only by the ritual nature of the vessels, but also by the appearance of this canoe form in other ritual artworks, including the feast bowls and skull reliquaries of the Admiralty Islands.

One of the best known Melanesian art objects, the shell-inlaid shields of the Solomon Islands, may have also been produced for trade (FIG. 64). The people living in the interior of New Georgia Island may have made these decorated shields for they also manufactured wicker shields of this shape, which were used also in Guadalcanal, Florida, and Santa Isabel. Decorated shields are far fewer in number than the wicker shields and only about twenty exist in collections today. Their fragility and elaborate ornamentation suggest a ceremonial rather than battle use, and, unlike the plain wickerwork shields, they were never viewed in use by nineteenth-century visitors to the islands. The designs of all the extant shields are closely related, focusing on a central, elongated anthropomorphic figure, which is often bordered by bands of shell inlay that incorporate small, anthropomorphic faces. It has even been suggested that the New Georgians made these shields exclusively for trade with Europeans, especially since all the extant examples

63. Ceremonial canoe prows. Tolai people, Blanche Bay, New Britain, Papua New Guinea. Wood, paint, width 5′5½″ (1.66 m). The Field Museum, Chicago.

The fine, openwork carving is sometimes called fish bones. The open spaces appear to be black, making the work a subtle play on positive and negative space, black and white.

were collected in a relatively short period in the mid-nineteenth century. However, the shields may simply have belonged to high-ranking individuals and been used in ritual exchanges, and these exchanges may have been extended to European visitors.

Art, Leadership, and Social Control

Art plays an important role in enforcing social control in many Melanesian societies with open leadership hierarchies. Grade societies often play various roles in this process, enabling individuals to accrue spiritual authority and influence as they progress through the ranks. In most Melanesian communities men traditionally played the most important roles in public life. Spirits and ancestors are important supports for the authority of the leadership. The arts enable political authority and spiritual power to intersect and reinforce each other. Masking traditions, which make spirits present in the community in active, physical form, are often essential to governance.

One of the primary examples of the role of masked spirits is the *duk duk* society of the Tolai people of New Britain. This society serves as a sort of regulatory body that punishes those who transgress against a village leader's edicts and rules. The performance of masked dancers helps to establish social control and reinforce the power of the leadership (FIG. 65). The dancers represent both male and female spirits. The female masks, *tubuan*, are painted barkcloth or net cones surmounted by a tuft of white feathers. The costume consists of large reddish and green leaves set in circular rows that envelop the torso of the dancer, leaving only the legs visible; combined with the dramatic staring eyes and elongated shape of the mask, it creates the image

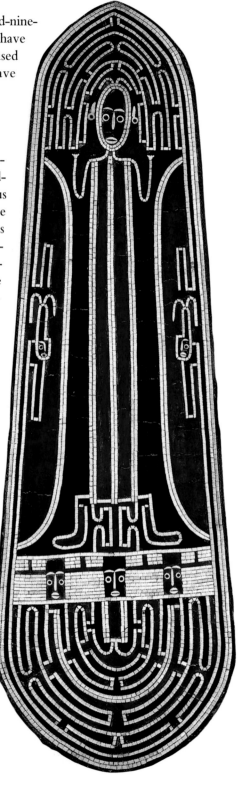

64. Shield. ? New Georgia, Solomon Islands. Wood, fiber, resin, shell, pearl shell, height 36½" (93 cm). National Museum of Scotland, Edinburgh.

The small heads in the border decoration may refer to headhunting.

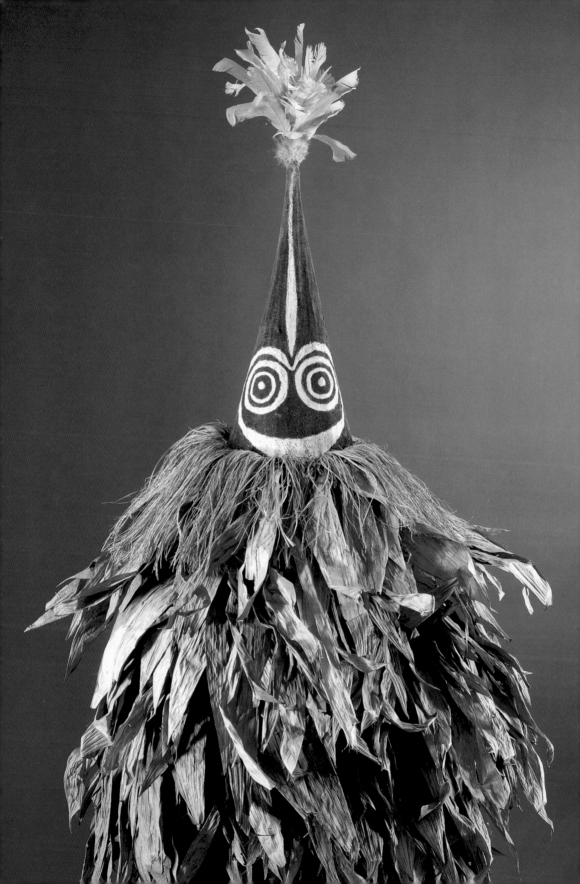

Left

65. *Duk duk* society mask (*tubuan*). Tolai people, Gazelle Peninsula, New Britain, Papua New Guinea. Cloth, paint, fiber, feathers, height 4'11⅞" (1.52 m). Collected by Felix Speiser around 1930. Museum der Kulturen, Basel.

In this mask, commercial sackcloth is used instead of barkcloth or netting to form the headpiece.

Right

66. Mask. New Caledonia. Wood, feathers, human hair, fibers, height 37¾" (96 cm). Acquired in 1896. Muséum d'Histoire Naturelle, Le Havre.

The eyes of these masks are never perforated for the wearer looked through gaps in the teeth. A feather mantle completely enveloped the body of the performer.

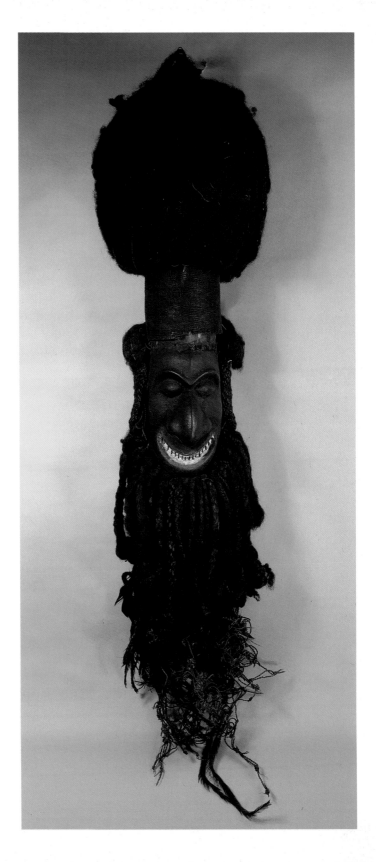

of an otherworldy being. The female spirit is immortal and each year gives birth to the male spirits, *duk duk*, who are also represented by masked dancers. The different clan moieties sponsor the female masks, which are often named for an ancestor or the owner's mother. Even though the masks (*tubuan*) are worn only by men, myths acknowledge that women were their original owners. Often, women help their sons buy the rights to a *tubuan* and they participate in the ceremonies in which male novices purchase these rights with shell valuables. The spirit of the *tubuan* is powerful, difficult to control, and potentially very disruptive. A measure of the community's leader is his ability to domesticate the wild spirit of the *tubuan*.

In New Caledonia, too, masks played a part in reinforcing the power of the village leaders (FIG. 66). Like the bird gable ornaments, the great houses, or the ritual axes, the masks symbolized the leader's authority. In the northern part of the island, the mask appeared during mourning rituals for leaders, as a substitute for the deceased leader and symbol of the continuity of power. The meaning of the mask in southern New Caledonia is less clear. There, the mask appeared in theatrical performances, invoking both terror and joy. Masks seem to have fallen out of use at the time of increased contact with Europeans, at the end of the nineteenth century, possibly because the power structures on the islands shifted in response to the colonial regime.

The mask could represent simultaneously the deceased leader, the father-creator of the clan, and the spirit who leads the spirits of the dead to the underworld. The striking appearance of these New Caledonian masks suggests the spiritual and political powers they embodied. The coiffure is made from hair taken from the heads of male mourners, although they do not cut their hair until the mourning period ends. Its spectacular domed shape recalls the shape of mourners' coiffures. The masks are sometimes also associated with forest spirits represented by birds. The name of the mask in several New Caledonian dialects of the north is composed of the words *da*, a generic term for "bird," and *ak/ac*, meaning "person." In the south, the name of the mask means "bird feather," appropriately for the long, curving nose evokes the form of a beak. The performer sometimes also carried a wooden club with a bird-shaped head.

In New Caledonia the name of the masks applies too to the great houses that also symbolize the leader's power and are a continuing tradition in many parts of the island (FIG. 67). The house is a particularly potent image, the sign of the person whom the clans have chosen as their leader, the metaphor for the social

relations that connect these groups to him and to the clans who live outside the village. It exists in the power and image of the ancestors, and ancestral imagery is interwoven throughout the structure. The house is constructed around a central post, which is its most important part, both functionally and symbolically. Two massive figurative panels representing ancestors flank the entrance to the house and symbolize the reemergence of the ancestors into the community (FIG. 68). The figure's body is schematically rendered by the lower part of the panel, which is covered with geometric motifs. The face, with its large, imposing features, would be just visible below the thatched roof. An ancestor figure usually surmounts the roof, and smaller figures are lashed to the interior post. So total is their identification with the

67. Ceremonial house and dance ground, 1970. New Caledonia.

The house sits at the end of a broad avenue where the community holds its celebrations. Nowadays, great houses are often less richly decorated than in the past. This house preserves the imposing form of the nineteenth-century great house.

68. Door jamb figure. New Caledonia. Wood, pigment, height 70" (177 cm), width 23½" (60 cm). Musée Nationale des Arts Africains et Océaniens, Paris.

New Caledonian sculptors were specialized artists who had to have full command of both technical and ritual knowledge. The massive door jamb figures required trees more than two meters in diameter, which were difficult to shape and carve without splitting. The acquisition of suitable trees was dangerous, for the bodies of the dead were left in the forests and their spirits often lingered there.

leader that at his death the sculptures and the house itself are usually destroyed.

The impressive public display of the New Caledonian great house, distinguished by its size and sculptoral program, is typical of the visual impact of the arts of Island Melanesia. Often, the arresting forms – the masked dancers of New Britain, the *malangan* carvings of New Ireland, the *suque* society figures or painted barkcloth of Vanuatu – are most meaningful in the context of public display and performance. The aesthetic power of these artworks can serve as a declaration of political authority, spiritual strength, or social status that speaks both to the community and to the world at large.

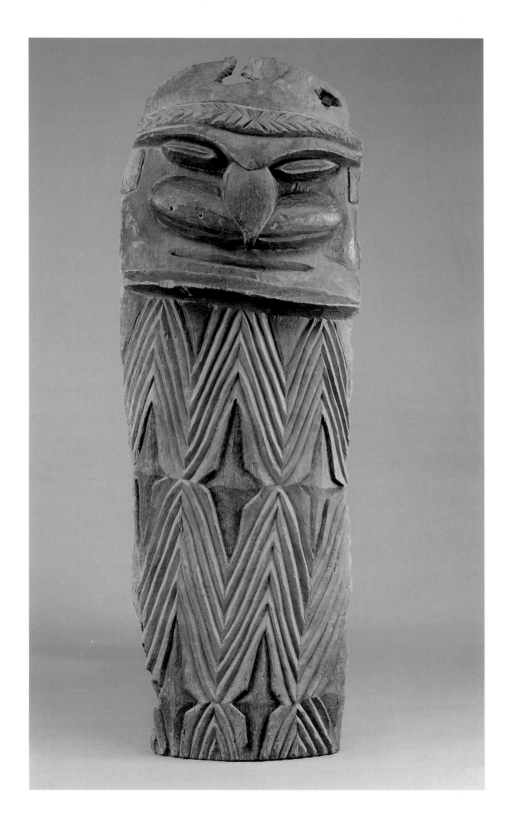

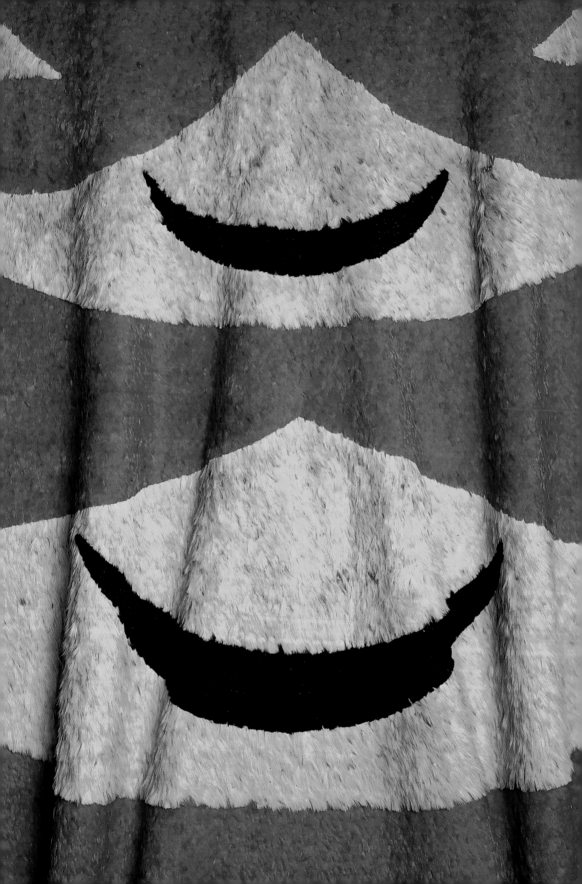

Polynesia: Where Sharks Walk on Land

S ince the eighteenth-century voyages of exploration opened Polynesia to Europeans, Westerners have greatly appreciated the art of this region. The naturalist George Forster (1754–94), a member of Cook's second Pacific voyage of 1772–1775, noted of wooden Easter Island figures that, "there was something that was characteristic in them, which showed a taste for the arts." Although certain aspects of Polynesian artistic production, such as the emphasis on the virtuosity of the artist and the careful preservation of objects, coincide with those of the West, in Polynesia these traits arise out of a rather different set of social, spiritual, and artistic concerns.

In Polynesia, artworks are made primarily for the hereditary elite, called *ari'i* (*ali'i*, *ariki*), who are powerful social and political leaders, themselves imbued with *mana*, a spiritual power derived from the ancestors. Hawaiian and Tahitian histories and proverbs frequently refer metaphorically to the *ari'i* as sharks that walk on land or as the descendants of sharks to convey a sense of their awe-inspiring power. In these highly stratified societies, where most titles are hereditary, genealogy is of paramount importance, and objects passed down as heirlooms create connections between the living and the dead. Artworks can embody *mana* and make it active in this world, facilitating the transfer of *mana* from one generation to the next. As artworks are used by succeeding generations, they gain more *mana*, prestige, and luster, characteristics that also accrue to the lineage and the individuals that own

69. Feather cloak (*ahu'ula*; detail). Hawaii. Feathers, fiber, height 3'11½" (1.2 m), width 8'10" (2.29 m). Pitt Rivers Museum, Oxford.

them. Artistic refinement helps make this possible, as a contemporary Maori proverb suggests: "Where there is artistic excellence/There is human dignity" (*He toi whakairo/He mana tangata*).

Anchored at its corners by Hawaii, Easter Island, and New Zealand, the Polynesian triangle includes island groups that show a great deal of similarity in both environment and culture. Most are mountainous volcanic islands covered by rich forests populated by numerous species of birds and reptiles. Polynesian settlers typically brought with them dogs, pigs, and chickens as well as breadfruit and mulberry trees. Polynesian cultures recognize their similarity, and there are many legendary accounts of long, open-ocean voyages in search of new islands.

A basic cultural division exists between western Polynesia, which includes Fiji, Tonga, Samoa, Wallis, and Futuna, and eastern Polynesia, including Easter Island, New Zealand, Hawaii, the Society Islands, the Cook Islands, Pitcairn, and the Marquesas Islands. This division points up both social and artistic differences: western Polynesia, for example, has less figural sculpture and places greater emphasis on certain cultural institutions, such as the sacred sister of the paramount titleholder and the ceremonial consumption of kava, a mildly narcotic drink made from the *Piper methisticum* plant. Within this division, Fiji presents a paradox, for its languages and cultures are clearly a mixture of what scientists identify as Melanesian and Polynesian traits. However, since the thirteenth century, Fiji, Tonga, and Samoa have maintained strong ties, and many Tongans have visited and settled in Fiji, especially the Lau Islands, to work as artists for high-ranking Fijians.

Until the eighteenth century, contact between Europeans and Polynesians was sporadic. The first Europeans to visit a Polynesian island group were the Spanish explorers Alvaro de Medaña and Pedro Quiros, who anchored at Santa Cristina in the Marquesas Islands and Pukapuka in the northern Cook Islands in 1595. The first European to visit the Tongan islands was Jacob Le Maire, who found the island of Tafahi in 1616. New Zealand was named "Zeelandia Nova" by the Dutch explorer Abel Tasman in 1642, who also visited some of the Tongan islands. It was the great eighteenth-century voyages of exploration, especially those of Cook, de Bougainville, and Vancouver, that gave Europeans a more extensive knowledge of Polynesia.

Many Polynesian island groups, subject in the nineteenth century to colonial regimes, have now achieved independence. Western Samoa is an independent nation while American Samoa remains a protectorate of the United States of America. Tonga, Fiji, Niue,

and the Cook Islands are independent nations. The Society, Marquesas, Tuamotu, Austral and Gambier Islands are part of the protectorate of French Polynesia. Easter Island, also called Rapanui, is a protectorate of Chile. Hawaii has achieved statehood in the United States. In New Zealand the Maori have gained a large measure of internal self-government and political influence in the land they call Aotearoa.

Gods and Ancestors

The pantheon of creator gods, the spirits of deified ancestors, and the adventures of legendary, semi-divine heroes are central to spiritual life in Polynesia. Extant figures of gods and deified ancestors often bear scant resemblance to their original presentation, for they were frequently wrapped in barkcloth and ornamented with tufts of feathers as a sign of their *tapu* or sacred, restricted status. Some figures were kept hidden in god houses, or, in the case of ancestral spirits, in the homes of lineage heads; others were displayed prominently in temples. Many of the figures are richly layered in meaning, referring both iconographically and stylistically to concepts of power, history, time and space, the land, gods, and ancestors. These multiple allusions may be expressed by the concept of *kaona*, a Hawaiian word that means "veiled meaning or symbolism," which is a well-known feature of poetry, music, and dance.

All Polynesian cultures share a concern not only with their own genealogy and history, but also with understanding the nature of the creation of the earth and the beginning of time. Throughout Polynesia, elite lineages trace their ancestry to the gods. Among the Maori, tribal accounts of their history extend back to creation; these stories share similarities, and all are presented in art works, known as *taonga*, "the treasures of the people." Appropriately, given the *mana* of war canoes, the stern and prow ornaments depicted central themes in Maori cosmogony. Many prows depict the creation of the earth and sky (FIG. 70). The openwork spirals on the main panel may represent the entry of light and knowledge into the world when the god Tane separated his parents Papatuanuku and Rangi, Earth Mother and Sky

70. Canoe prow (*pīlau*). Maori, New Zealand. Wood, length 4'11" (1.5 m). Auckland Institute and Museum, Auckland.

The separation of the earth and sky was a subject common to war canoe prows and the door lintels of meeting houses, both *tapu* (sacred) spaces. Because the canoe was *tapu*, ways of entering and exiting the canoe were ritually prescribed. The warriors had to cross the canoes' side-strakes as if crossing a threshold, thus entering the body of the ancestor represented by the canoe.

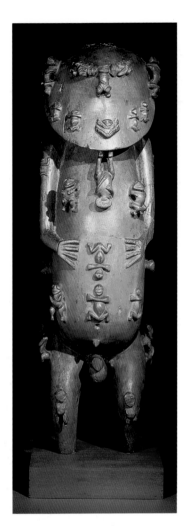

Father. The foremost figure depicts a male with aggressively protruding tongue. He may represent Tūmatauenga, the god of war and man. The stern carvings frequently incorporate two vertical ribs that may represent knowledge and life, which are simultaneously attacked and protected by *manaia* spirit figures. The canoe itself was *tapu* (sacred), especially when in action. Often over 65 feet (20 meters) in length, a war canoe was conceptualized as the body of the ancestor, the hull representing the backbone of the titleholder. Songs of mourning for dead titleholders often compare them to broken canoes awash in the surf. The imposing war canoe, *waka taua*, was the focus of intense pride and the source of community identity for Maori peoples, and continues to be so in the communities where it is still made.

On eastern Polynesian god images, the use of subsidiary figures, smaller figures incorporated into larger ones, is a characteristic motif and may also represent aspects of creation, particularly the creation of humans or of particular lineages. Perhaps the most famous example of this motif is the Austral Islands figure identified as the god A'a (FIG. 71). Members of the London Missionary Society collected the figure in the early nineteenth century as a "trophy of a bloodless conquest," namely, conversion. According to the missionary John Williams (1796–1839), the figure depicts the ancestor who first populated the island of Rurutu, where the figure originated, and who was deified after death. (Williams himself, who arrived on Samoa in 1830, was later murdered on Erromango and hailed as a martyr.) Smaller figures make up the eyes, nose, mouth, ears, and nipples, and others are scattered over the face and body. A cavity in the back originally held smaller figures in another variation on the motif.

71. Figure of the god A'a. Rurutu, Austral Islands, French Polynesia. Wood, height 3'8" (1.12 m). Collected by members of the London Missionary Society, c. 1820. British Museum, London.

The figure's stance, with flexed legs and hands on belly, is very similar to anthropomorphic *ti'i* images from Tahiti and the Society Islands that also represent deified ancestors (see FIG. 77).

Staff gods from Rarotonga in the Cook Islands present this motif in a visually rather different way (FIG. 72). The whole figure with its large head may represent the creator god Tangaroa, while the small figures that compose the body would be the generations of human ancestors he has created. The placement and position of the figures invokes the vertebrae of the spine, frequently a symbol of genealogy and genealogical continuity in Polynesian sculpture. They are interspersed with profile figures with erect penises, a further reference to genealogical continuity. Other figures from Rarotonga stand with hands on bellies and smaller figures ranged across the chest, an articulation of subsidiary figures much closer compositionally to the Austral Islands figure.

The Hawaiian god of war, Kūkāilimoku, was the special tutelary god of Kamehameha I (c. 1758–1819) and helped him consolidate control over the entire Hawaiian archipelago in an unprecedented centralization of authority in the late eighteenth century. Monumental figures of the god decorated *heiau*, or temple enclosures, on the Kona coast of the island of Hawai'i, Kamehameha's stronghold (FIG. 73). The *heiau* were composed of stone platforms, often terraced, enclosed by stone walls or wooden fences. Temple images were set into holes in the stone pavement or mounted on the walls or fence posts. A central image, such as this one from the British Museum, faced the altar and was designated the *akua mo'i,* "the lord of the god image" or *haku ohi'a,* "god of the *ohi'a*," the focus of ritual activities. The image conveys a remarkable sense of power. Its compact, muscular body stands with knees and elbows flexed, as if ready to spring into action. The

Left

72. Staff god. Rarotonga, Cook Islands. Wood, length 28½" (73 cm). Cambridge Museum of Archaeology and Anthropology.

The small frontal figures have remarkably large ears, leading some scholars to associate them with the ancestral figure Taranganui, whose name translates as "great ears."

Right

73. Monumental Kūkāilimoku figure. Late eighteenth century or early nineteenth. Kona coast of Hawai'i Island, Hawaii. Wood, height c. 7'7" (2.36 m). British Museum, London.

This figure projects a sense of contained energy, with its flexed knees and elbows, slightly turned rather than absolutely frontal torso, and expressive face.

head is proportionately large, emphasizing the figure's *mana*, for that is where *mana* resides. The open, grimacing mouth, with chin thrust forward, is a potent gesture of disrespect. In the hierarchical society of Hawaii, degrading others advanced one's own status. The object of war was often not to kill the opposition but to humiliate them and Kūkāilimoku's grimacing mouth may have been a visually compelling signal of this intent.

In addition to wood figures, wickerwork figures covered with feathers also represented the Hawaiian gods (FIG. 74). In many Polynesian cultures the bodies of gods were conceived of as covered with feathers and they were frequently associated with birds: in Tahiti and the Society Islands, bird calls on the *marae* signaled the presence of the gods. Hawaiian feathered god figures generally depict only the head and neck of the god. Although eighteenth- and nineteenth-century observers did not associate the feather heads with any particular god, they may have represented Lono, god of agriculture, fertility, and peace; equally, they may have represented Kūkāilimoku or others. Like their wooden counterparts, these feathered heads, also with large eyes and grimacing mouth, were probably used in processions and mounted on poles, some of which were notched, perhaps to represent the genealogy of the god. The crest is a further genealogical referent: it may represent the spine extended up over the head in a protective manner, or it may represent the hair, also a sign of *mana* and genealogical potency.

On Easter Island, in addition to the celebrated monumental stone figures and rock carvings, a variety of wooden figures represented ancestors and spirits. These depicted men and women as well as composite human-bird and human-lizard figures. According to Rapanui tradition, the legendary hero Tuu-ko-ihu carved the first wooden figures, called *moai kavakava* (FIG. 75). Tuu-ko-ihu climbed the crater Punapau and saw two sleeping spirits who were just ribs and had no bodies. Upon waking they questioned him, but Tuu-ko-ihu denied any knowledge of them, realizing that they would kill him if they learnt that he had seen their ribs. When he returned to the house, Tuu-ko-ihu took some discarded firebrands and made two statues representing these spirits, Hitirau and Nuku-te-mango. *Moai kavakava* figures share distinctive characteristics, which bring to mind these ribbed spirits. They have prominent, skeletal ribcages, skull-like heads, and emaciated, elongated bodies. They are always male, and usually exhibit clearly carved genitals and short beards. For other figure types, Easter Island sculptors employed more rounded contours and youthful faces, or flattened and schematic torsos.

74. Feather god figure. Hawaii. Fiber, feathers, dog teeth, pearl shell, height 18¾" (48 cm). Collected on Captain James Cook's third Pacific voyage, 1776–80. Institut und Sammlung der Kulturen, Göttingen.

Despite the difference in medium, this feather image shares many features with the large wooden Kūkāilimoku figure (see FIG. 73), including the oversized eyes and grimacing mouth.

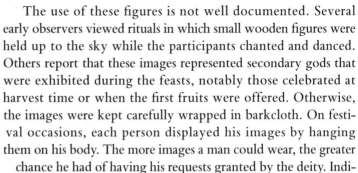

The use of these figures is not well documented. Several early observers viewed rituals in which small wooden figures were held up to the sky while the participants chanted and danced. Others report that these images represented secondary gods that were exhibited during the feasts, notably those celebrated at harvest time or when the first fruits were offered. Otherwise, the images were kept carefully wrapped in barkcloth. On festival occasions, each person displayed his images by hanging them on his body. The more images a man could wear, the greater chance he had of having his requests granted by the deity. Individuals thus sometimes carried ten or twenty images, which may explain why many Easter Island figures have perforated lugs at the back of the neck or through the spine.

The ritual context of Rapanui barkcloth figures is also unclear, but they too may have been associated with *mana* and the continuity of lineages (FIG. 76). They may have been used at *paina* feasts held to honor deceased relatives. The figures, like this example dating from the nineteenth century or earlier, exhibit large, skull-like heads, to emphasize the head's importance as the seat of the person's *mana* and to invoke the ancestors. That the figures may have had something to do with fertility is suggested by another barkcloth figure the erect penis wrapped in a strip of red cloth. Red was a sacred color throughout Polynesia; the act of wrapping made things *tapu* – set them apart in a sacred state – so that, on certain levels, the figure can be said to refer to the power, or *mana*, of the lineage, its potency and continuity. Both the ritual treatment of the phallus and the symbol of a vulva painted on that figure suggest a possible connection to a fertility cult that became important on Rapanui around the time of contact.

The double, back-to-back figure is a distinctive Polynesian motif that presents the image of an all-seeing, protective spirit. A canoe ornament from the Society Islands includes a pair of images

75. Male figure, (*moai kavakava*). Easter Island (Rapanui), Chile. Wood, height 18" (45.5 cm). From the estate of Sir Joseph Banks and probably collected on Cook's second Pacific voyage of 1772–75. Staatliches Museum der Kulturen, Munich.

The top of this figure's head bears a glyph that represents a lobster: the fan-shaped tail extends over the forehead almost to the eyebrows and could be mistaken for the figure's hairline.

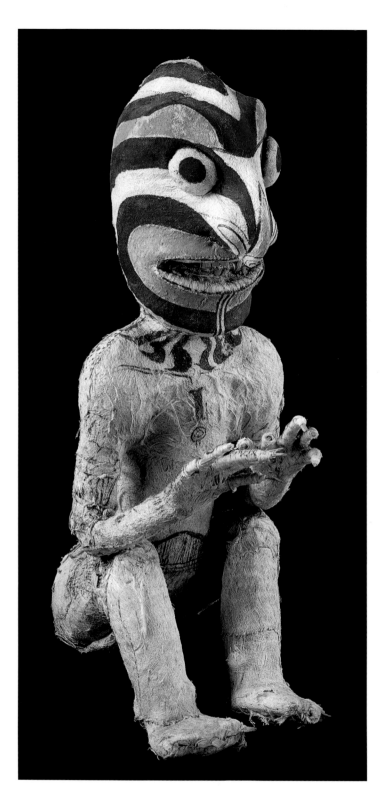

76. Barkcloth figure. Easter Island (Rapanui), Chile. Barkcloth, wood, pigment, height 16" (41 cm). Peabody Museum of Archaeology and Ethnology, Cambridge, MA.

Tattoo patterns and symbols cover the figure's face and body.

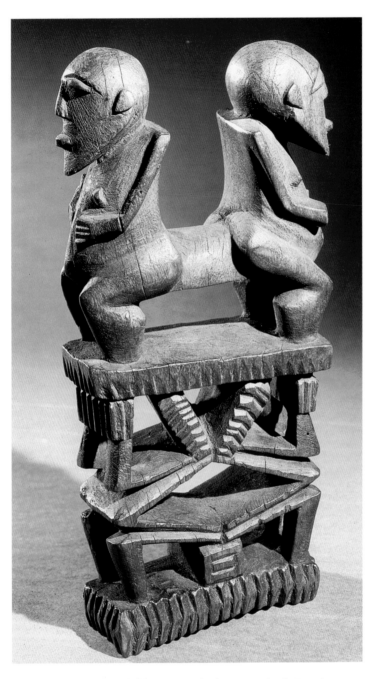

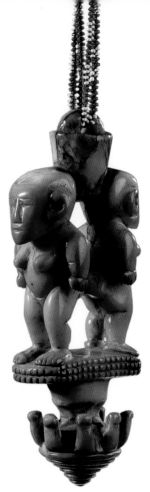

77. Canoe ornament. Probably Ra'iatea Island, Society Islands, French Polynesia. Wood. British Museum, London.

The two pairs of figures here provide a striking contrast in abstract and representational styles. Images made on Captain James Cook's voyages document Society Islands canoe ornaments composed of many stacked pairs of figures.

78. Ceremonial hook. Tonga. Ivory, glass beads, fiber, height 4½" (12 cm). Collected in Fiji. Cambridge Museum of Archaeology and Anthropology.

Despite their small size, these figures convey a sense of strength and monumentality through their composed facial expressions, frontal posture, broad shoulders, and flexed legs.

of deified ancestors, *ti'i*, standing in this way (FIG. 77). The openwork support repeats the motif, for it depicts back-to-back figures of more abstract form. The stacking of figures may also allude to the generations of ancestors, much like the stacked figures of the Rarotongan staff god. The figures are not clearly male or female, but androgynous, possibly because the creative force of the universe was not interpreted as sexed. They may thus represent generalized ancestor figures. Possibly, too, this androgyny was intended to give the viewer a certain flexibility of interpretation analogous to the flexibility exercised in tracing genealogies upward through various lines to particular important ancestors to justify certain claims and prerogatives.

The back-to-back motif reappears in a Tongan suspension hook carved of ivory (FIG. 78). Wooden hooks, sometimes painted with images but not figurally carved, were used in households to suspend bags of food, safeguarding them from rodents. Both the material and the figural decoration of this hook suggest that it had a ceremonial function. Single female figures of similar form are thought to represent ancestors or possibly Hikule'o, goddess of the afterlife. In this hook, the protective nature of the image is doubled, as the figures look in both directions, a stance that also enhances its visual impact. Fijians, who acquired these small ivories from Tongans, regarded them as ancestor figures. All the double-figure hooks were collected in Fiji, suggesting that Tongans may have made them specifically for Fijians. These hook figures dwelt in miniature spirit houses kept within the main spirit house and priests hung small offerings from their hooks.

Often, gods and ancestors appeared not only as free-standing figures but also as images incorporated into ritual paraphernalia. In the Austral Islands for example, large drums, *pahu*, kept on the *marae* to play on ceremonial occasions, include rows of alternating male and female figures that may be dancing (FIG. 79). Although the identity of these figures is unknown, both their postures and the associated motifs suggest that they may represent ancestral figures. Dance was and is an important sacred activity throughout Polynesia, relating stories of the ancestors and legendary heroes. This drum has a resonating chamber encased in plaited fiber binding that features a zigzag pattern that may be

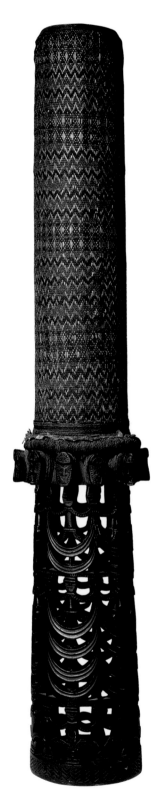

79. Ceremonial drum. Ra'ivavae, Austral Islands. Wood, shark skin, fiber, pandanus, height 4'4" (1.32 m), diameter 10" (25.2 cm). Private collection, New York.

The base is carved with alternating figures of men and women. The women's skirts split to form crescents that connect with each other and encircle the base.

a genealogical symbol. In Hawaiian art, this zigzag motif evokes the spine, which is itself a symbol of genealogy, the ancestors being likened to the column of vertebrae. The zigzag motif is also found on Society Islands fly whisks surmounted by ancestral *ti'i* figures, which were reserved for elite usage. If these drums were reserved for rituals staged for the elite, then clearly the figures and geometric motifs included would be those that underscored the genealogical pre-eminence of their audience.

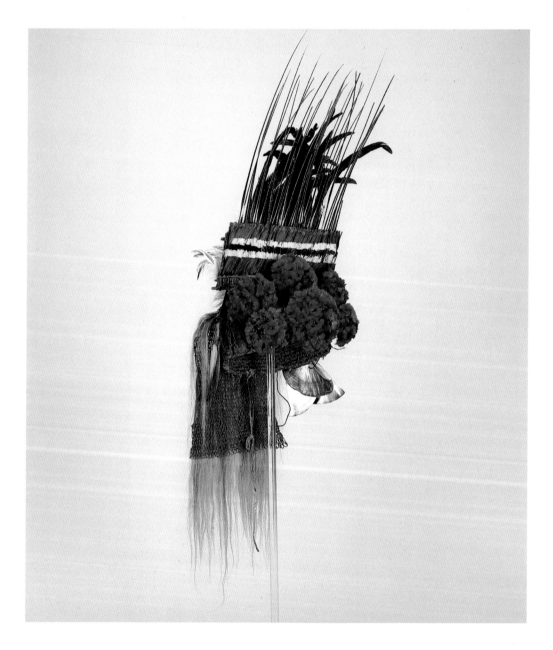

Status and Display: The Decorated Body

Feather garments and headdresses signaled high status throughout eastern Polynesia, for to wrap the body in feathers was to liken it to the feathered bodies of the gods (FIG. 80). Perhaps the most impressive feather garments are the majestic cloaks, 'ahu'ula, worn by the highest-ranking Hawaiian men on state occasions or when going into battle (FIG. 69). Executed in brilliant red and yellow feathers, the sacred colors of Polynesia, the cloaks were treasured heirlooms and ceremonial gifts of the highest value: when the paramount titleholder of Hawai'i met Captain Cook in 1779, he took off his own cloak and wrapped it around Cook's shoulders. The feathers were gathered as part of the tribute paid by the common people to the elite each year during the *makahiki* season. Although barkcloth, mats, and other textiles were made by women, the cloaks were made by high-ranking men. As they worked on garments so imbued with *mana*, the men were surrounded by a variety of *tapu* objects. They chanted the genealogy of the cloak's owner, capturing it and its protective power in the knots of the garment's foundation.

The feather cape was often paired with a crested feather helmet, *mahiole*, which provided spiritual protection for the head in dangerous or sacred situations. It reproduced the form of the crest often incorporated in feathered god figures, and probably with many of the same associations (see FIG. 69; page 000). In addition, a *lei niho palaoa*, an ivory or bone hook ornament suspended from bundles of finely braided human hair, was occasionally worn by the high chiefs and by high-ranking women. These women did not wear the feather cloaks or helmets but they did wear smaller feather capes as well as other ornaments (FIG. 81). During Cook's third voyage (1776–80), the surgeon's mate David Samwell described the attire of one aristocratic Hawaiian woman: "An old woman called Oheina [Kaheana or Naheana], who is an Eree [*ali'i*] or

80. Headdress. Rurutu, Austral Islands, French Polynesia. Coconut fiber, barkcloth, feathers, pearl shells, human hair, height c. 23¼" (59 cm). Presented to the museum in 1882. British Museum, London.

This headdress was the privilege of an elite warrior, *po'ena*. Although the red feathers are perhaps its most striking feature, the long, thin tropic-bird features signify the wearer's high status. Throughout Polynesia, human hair makes precious ornaments imbued with *mana*, for the head is the seat of *mana*.

Overleaf
81. Feather cloak (*ahu'ula*). Hawaii. Feathers, fiber, height 5'9" (1.75 m), width 9'6" (2.89 m). British Museum, London.

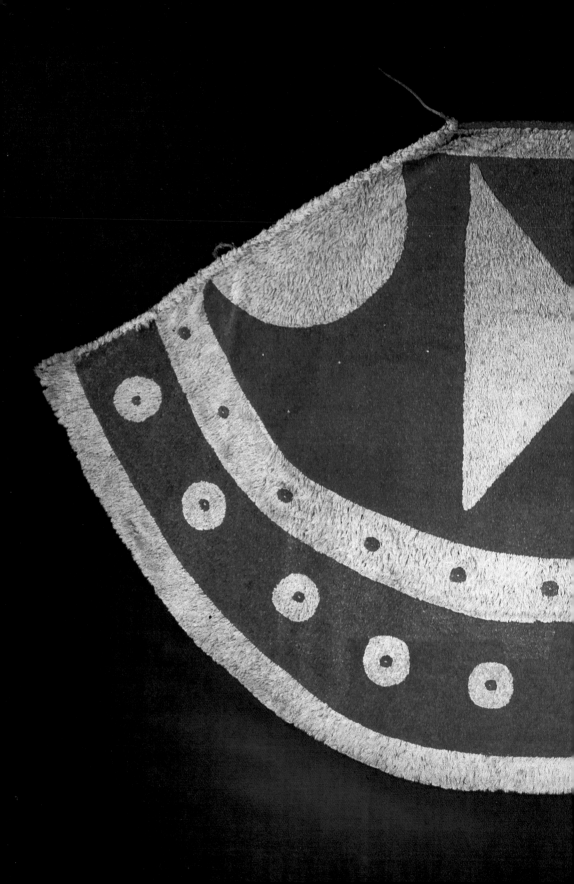

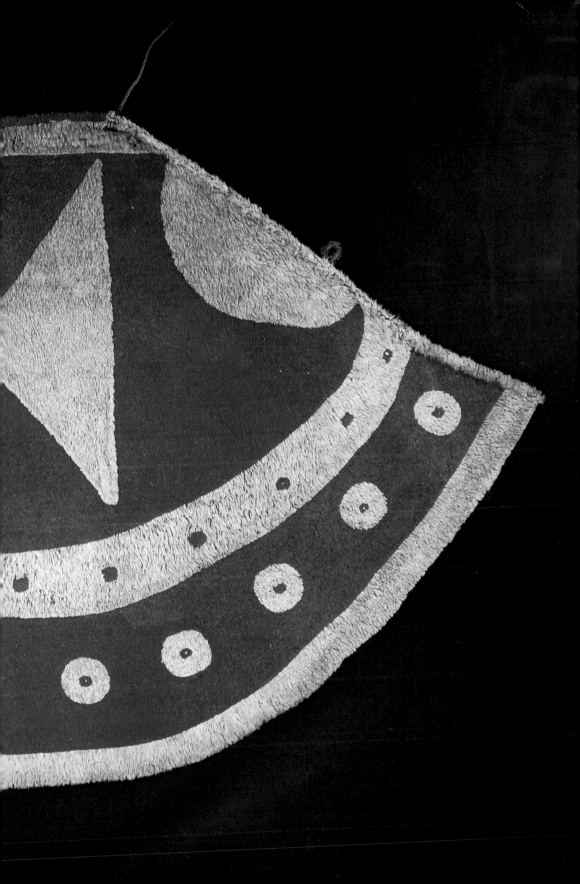

82. Bowl with support figures. Hawaii. Wood, pearl shell, bone, length 18" (45.7 cm), height 9⅞" (25 cm). Probably collected on Captain James Cook's Pacific voyage of 1776–80. British Museum, London.

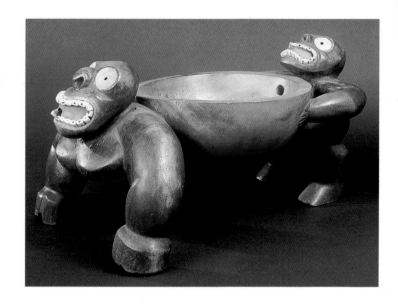

Hawaiian titleholders used bowls like this for *awa*, called kava elsewhere in Polynesia, which was their exclusive privilege. Like all elite possessions, bowls had to be finely made. The artist rubbed the dish smooth both inside and outside, first with a piece of coral or with rough lava (*oahi*), then with pumice or a stone called *oio*. Then it was further treated with charcoal and bamboo leaf, and lastly it was polished with breadfruit leaf and small sections of barkcloth.

poss[ess]ed of the authority of a Chief, came on board of us in some State this morning. She had a great Quantity of new red & white striped Cloth wrapped round her Waist, on each arm large bracelets made of boar's Tusks of an enormous Size, & round her neck a thick bunch of human hair platted in fine strings with a bone ornament called Parawa [*palaoa*] depending from it."

The possessions of the Hawaiian elite also included beautifully carved bowls for a variety of uses that were often passed down to succeeding generations as treasured heirlooms (FIG. 82). The squat and muscular bodies of the figures and their playful gestures on this bowl differ markedly from the temple figures and suggest that they were not meant to represent gods. They have

83. Bird-shaped dish. Fiji. Wood, shell, 5 x 15¾ x 9½" (13.3 x 40.2 x 24.6 cm). Fiji Museum, Suva.

Such ritual utensils began to enter collections only in the mid-nineteenth century as priests began to convert to Christianity and handed over their sacred utensils to Methodist missionaries. The more social kava ritual adapted from the Tongans survived conversion, for missionaries did not see it as a threat like the religious *yaqona* rituals.

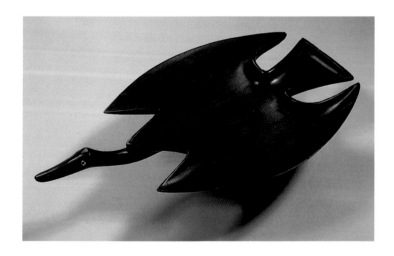

frequently been associated with the *menehune*, a legendary race of small people who loved to work hard and play at all the games the elite enjoyed. The figures on this bowl may be engaged in an acrobatic movement, as many support figures are, or possibly copulation. The front figure balances on hands only and the vessel represents the body, which the rear figure grasps from behind as if holding the other's hips. Though inventive and light-hearted in spirit, such bowls are also relevant to issues of *mana* and *tapu*: figures that support refuse bowls or spittoons often bear the teeth of enemies, in order to dishonor them. Likewise, as a token of respect, food bowls often incorporate the teeth of ancestors or other honored people. Even after Western clothing, customs, and religion had established themselves in the islands, these high-status accessories and their associated notions of *tapu* continued to be important. Kuakini (1791–1844), the governor of Hawai'i in the 1820s, may have sat on a chair and worn European clothes to view a hula performance, but, as described by the English missionary William Ellis (1794–1872), he was accompanied by "a servant, with a light *kihei* of painted native cloth thrown over his shoulder, [who] stood behind his chair, holding a highly polished spittoon, made of the beautifully brown wood of the cordia in one hand, and in the other a handsome *kahiri* [fly whisk] …"

In the Fijian islands, too, special accessories signaled the high status of leaders and priests in both spiritual and secular life. A corner of the spirit house was reserved for the priest's sacred paraphernalia, which might include a human image carved of whale ivory or wood, a club, shell trumpet, whale tooth, fossil, or anything else that the spirit chose to enter. A priest's possessions always included dishes for oil and *yaqona*, or kava, for they were essential to his rituals. These were usually beautifully carved in a variety of forms and highly polished. Only priests could use the *yaqona* dishes, *iBūbūraunibete*, shaped like flying ducks or humans, and, in fact, images of animals or humans could be reproduced on religious artefacts only (FIG. 83). Priests drank *yaqona* from these special dishes when possessed by their ancestor spirits or gods, who spoke to the community through the priest. The priest drank the *yaqona* through a straw, probably because it was forbidden to touch food or drink with the hands during ceremonies. The priest positioned himself on hands and knees to drink from the vessel, which stood on the ground. The *yaqona* rituals were not public affairs, unlike the more social kava rituals that Fijians had adopted from the Tongans. *Yaqona* rituals took place exclusively within the spirit house, and only the priests, village leaders, and clan elders attended.

Throughout Polynesia, ornaments made of rare and precious materials expressed the *mana*, prestige, and genealogical strength of the elite. In general, ivory and whale-tooth ornaments became more widespread as a form of elite adornment in the nineteenth century as a result of trade with whaling ships and the introduction of metal tools. In Fiji, ivory and shell breastplates, *civavonovono*, were a sign of high status (FIG. 84). The artists who made these breastplates were Tongans who had settled in Fiji. In the Marquesas Islands, headdresses of turtleshell and ivory were worn by high-ranking men, of porpoise teeth by women. Both sexes wore a variety of ivory ear ornaments that depicted *tiki*, ancestral figures. Similarly, the Maori elite wore greenstone ornaments, *hei-tiki*, that depicted ancestors, as well as cloaks with finely plaited geometric designs on their borders (see FIG. 8).

In the Marquesas Islands, the human body served as a source of artistic motifs, for the body symbolized the important relationship between the living and the deified ancestors, *atua*, who could bring prosperity or misfortune. Clubs called *u'u*, which were the privilege of warriors, repeatedly used the head motif to enhance the warrior's *mana*, for the head was considered the most sacred part of the body (FIG. 85). The top portion of the club represents a face on each side, another example of the Janiform motif discussed above. A projecting crossbar extends horizontally below the large eyes, and three bands of low-relief carving, which frequently incorporate both eye and tattoo motifs, decorate the club below this bar. The two principal faces contain faces within them, for the eyes and nose are fashioned as human heads, and the image of the faces reappears in the relief carvings below the crossbar and in a simple incised motif at the top. With the repeated imagery of face and eye, the *u'u* makes rich allusions to skulls and genealogy, ancestors and sacrifice. Tufts of gray hair fashioned from old men's beards frequently adorn the handles, reaffirming the link with ancestors.

Many Polynesian cultures expressed this concern with the body, status, and *mana* by means of tattooing, which wrapped the body in protective images and served as a marker of social status and gender identity (FIG. 86). In Hawaii, before the decline of tattooing in the mid-nineteenth century, high-ranking men

84. Breast ornament, nineteenth century. Fiji. Whale ivory, pearl shell, diameter 9½ x 9½" (24.5 x 24.5 cm). The Baltimore Museum of Art, Baltimore.

The pieces were butt-joined and lashed at the back through small, oblique holes so that no joinery or binding is visible from the front.

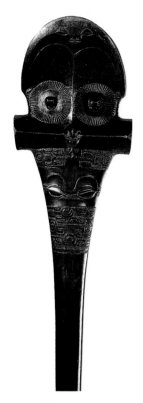

85. Club, or *u'u*.
Marquesas Islands, French
Polynesia. Wood.
Collected by William Low
in 1813–20. British
Museum, London.

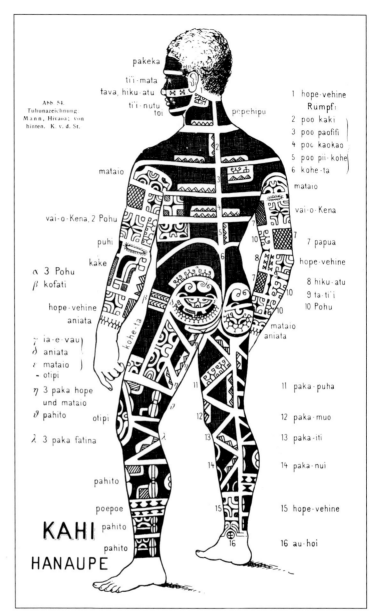

Abb. 54.
Tuhunazeichnung
Mann, Hivaoa; von
hinten. K. v. d. St.

pakeka
ti'i-mata
tava, hiku-atu
ti'i-nutu
toi
popehipu

mataio

vai-o-Kena, 2 Pohu
puhi
kake

⋏ 3 Pohu
β kofati

hope-vehine
aniata

γ ia-e-vau
δ aniata
ε mataio
- otipi
η 3 paka hope
und mataio
θ pahito otipi

λ 3 paka fatina

kohe-ta

pahito

poepoe
KAHI pahito

pahito
HANAUPE

1 hope-vehine
Rumpf:
2 poo kaki
3 poo paofifi
4 poo kaokao
5 poo pii-kohe
6 kohe-ta

mataio

vai-o-Kena

7 papua
hope-vehine

8 hiku-atu
9 ta-ti'i
10 Pohu

mataio
aniata

11 paka-puha

12 paka-muo

13 paka-iti

14 paka-nui

15 hope-vehine

16 au-hoi

86. Diagram of Marquesan tattoos from von den Steinen, 1925.

In the late nineteenth century, Karl von den Steinen (1855–1929)
traveled to the Marquesas to document its art traditions.
Compared with early nineteenth-century images, von den
Steinen's drawings suggest that Marquesan tattoo styles changed
in the course of the nineteenth century. His drawings of tattoo
patterns include a number of motifs based on solid bars and
patches of black, a departure from earlier illustrations showing
tattoos that were more linear in style.

87. Teve Tupuhia performing at the Fifth South Pacific Arts Festival, Townsville, Australia, 1988.

As a Marquesan, Teve Tupuhia was inspired to have tattoos to reinforce his sense of cultural pride after seeing images of Marquesan warriors in Tahiti's Musée de Tahiti et des Iles. A Samoan tattoo artist, Lese li'o, performed the work.

Opposite
88. Mourning dress. Society Islands. Barkcloth, wood, shell, turtleshell, coconut shell, feathers, fiber, pigment, 76¼ x 36¼ (194 x 92 cm). Collected on Captain James Cook's second Pacific voyage of 1772–75. Pitt Rivers Museum, Oxford.

The mourning dress incorporates many valuable and rare materials. The large pearl shells forming the mask and decorating the breastplate made important gifts between high-ranking people and were highly desirable trade goods. The mask also includes turtleshell plaques; turtles were eaten only by the elite and were considered a very acceptable offering to the gods. The mask is supported by a turban of fiber cords bound with very finely braided human hair, one of the most sacred ornaments in Tahiti. These long, smooth, unbroken braids served as a reminder of the unbroken chain of ancestors who gave the elite their *mana*, or power.

were tattooed on their faces, chests, legs, and hands. The motifs included zigzags, stepped triangles, and chevrons that made reference to spines and to genealogy. When these high-ranking men went into battle, their feather cloaks and helmets protected their backs and heads, and their tattoos protected their faces and chests. The gender differentiation of tattoo was quite marked in New Zealand. Elite men wore a full facial tattoo; elite women wore tattoos on the lips and chin only, unless they were the highest-ranking members of their lineages, in which case some wore full-face male tattoos as a sign of their unusual status.

In the present day tattoos usually indicate cultural identity rather than social status or gender (FIG. 87). Many Society Islanders, for example, have adopted Marquesan-style tattoos, partly for their aesthetic appeal and also because both island groups are now part of French Polynesia and so share a sense of political and cultural connection. Because the Society Islands tradition of

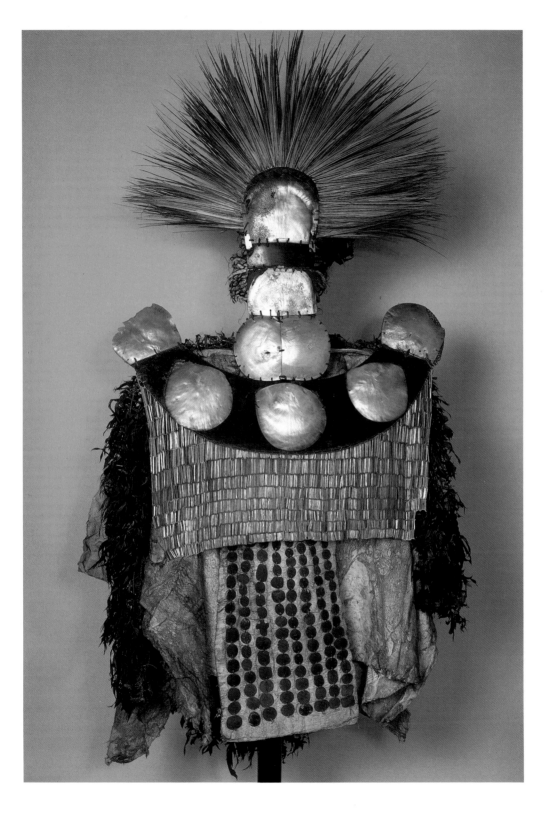

tattooing largely died out in the mid-nineteenth century due to missionary pressure, Marquesan tattoos may also have a greater appeal as a more or less continuous tradition. In French Polynesia, tattooing is particularly prevalent among young people, especially among members of dance troupes, who may feel a heightened appreciation of the continuity of their traditions. Indigenous designs now coexist with, and are even more popular than Western-style "sailor" tattoos.

In the highly stratified societies of Polynesia, rituals of birth, marriage, and death for the elite were often more elaborate than for commoners and involved a variety of exclusive artistic practices. One remarkable elite tradition was the funerary ritual for very high-ranking men and women in the Society Islands, in which the costumed chief mourner appeared (FIG. 88). The mourner paraded through the district after the mummified body had been displayed on a special bier for some time. All fled before him, for the chief mourner carried a shark-tooth weapon and had license to harm anyone he caught. His attendants, covered with soot and body paint, raced through the village, attacking everyone they met. The procession of the chief mourner marked the end of the mourning period, when the bones of the deceased were removed from the funerary bier and buried or preserved as relics.

Early sources do not record the meaning of this distinctive costume. Parallels with other Pacific art traditions and Tahitian petroglyphs suggest that the mask and breastplate together may represent the ancient "ship of the dead" motif. Found in the arts of the Southeast Asian mainland, Indonesia, and the Philippines, this motif depicts the soul of the deceased traveling to the spirit world by ship. On the mourning dress, the curved breastplate represents the ship, while the vertical shell mask represents an abstract human figure surrounded by a halo. The mask and breastplate of most mourning dresses are attached to each other, suggesting that they were meant to be seen together. In the nineteenth century, the missionary William Ellis noted that Society Islanders considered the mask and breastplate the most sacred part of the costume.

Textiles and Ceremonial Gifts

The ceremonial exchange of textiles has long been a primary means by which Polynesians create and reinforce social relationships. In the nineteenth century and earlier, when adopting someone into the lineage, a Tahitian titleholder would wrap that person in a tunic and several additional pieces of barkcloth. Similarly,

to create an alliance, a Fijian leader would wrap himself in vast quantities of white barkcloth and dance before the leaders of the corresponding clan; when he cast off the cloth, they took it and dressed their followers in it. Gifts of barkcloth and mats often formed part of systems of exchange that included other valuables as well. In Fiji, barkcloth and large, well-patinated whale teeth, or *tabua*, were presented together as marriage tokens, marks of esteem or atonement, and in quest of favors. By accepting such gifts, a leader bound himself morally and spiritually to the giver and the desired course of action.

In the early nineteenth century, the women of the Society Islands and Hawaii were justly famed for the decorated barkcloth they produced (FIG. 89). It was an art form that flourished in the early contact period. When Europeans first arrived in Tahiti in the eighteenth century, they received gifts of both plain white and colored barkcloth. Some barkcloth bore circular and geometric motifs made by dipping a length of bamboo in red dye and stamping on the textile. Soon, possibly influenced by the printed cotton textiles they received in exchange, Tahitian women began incorporating fern and flower printed motifs in their work and began to execute patchwork pieces cut with scissors. They created printed images by trimming ferns or flowers to the desired shape, dipping them in ink, and pressing them on to the cloth. By the early nineteenth century, these fern-decorated barkcloths were large and dramatic, and were still presented as ceremonial gifts for sea captains and other important visitors. Society Islanders recognized and appreciated differences in individual style, and each woman tried to make her work as distinctive as possible. The more beautiful a cloth, the more valuable a gift it made.

In many island groups of eastern Polynesia today quilts have supplanted decorated barkcloth as a women's art form and as highly valued gifts (FIG. 90). The wives of missionaries introduced the art of quilting in the nineteenth century as a useful and appropriately civilized pastime for elite women. Cook Islanders have transformed

89. Tunic (*tiputa*). Society Islands. Barkcloth, pigment, width 3'8" (1.12 m), length 8'¾" (2.46 m). Collected in the 1820s. Collection Norman Hurst, Cambridge, MA.

The original color scheme would have consisted of brilliant crimson prints on a bright yellow background, a repetition of the sacred Polynesian colors seen also in the Hawaiian feather cloak. The plant dyes used by Society Islanders to color barkcloth fade with time.

90. GRACE NGAPUTA
Quilt with Christmas Lily pattern (*Riri Iotepa*). Cook Islands.

This is a *tivaevae manu,* an appliquéd quilt, in which a top layer is cut into a pattern in a single piece and sewn on to the bottom layer of a contrasting color. It is executed in red and white, the traditional colors for quilts of this type. Women of the Cook Islands also make *tivaevae taorei,* piecework quilts.

it into a unique cultural expression and medium of gift-giving that perpetuates many of the traditional values and customs that the missionaries, in other ways, tried to replace with their own. Like the decoration of barkcloth, the making of *tivaevae* is a communal activity. Groups of women in local communities gather to cut and piece the designs but parties also travel between islands to share design ideas and techniques. Patterns reflect the environment, especially plants and flowers, but also turtles, sea life, and butterflies. Most women do not sell their work because of its personal nature and the time it requires; some even believe that they would lose their ability to design and sew if they did so.

Tivaevae are displayed at public events and given as gifts on special occasions. They mark those times when it is important to stress the power and continuity of the community and the family. When boys are aged between five and twenty-one they have their hair cut for the first time. Hair is the locus of *mana* because it grows from the head, and boys' hair is allowed to grow to enable them to increase their *mana.* Cutting the hair thus puts the *mana* at risk, so at the hair-cutting ceremony quilts are given as gifts and decorate the chair on which the boy sits in order to reinforce the strength of the boy, his lineage, and his community. Like barkcloth in former times, *tivaevae* may be presented to departing min-

isters or visiting dignitaries. They are highly desirable wedding gifts and after the ceremony the couple may sit on chairs draped with *tivaevae*. At funerals, quilts may wrap the body, drape the coffin, or line the grave.

Western Polynesia has its own highly developed tradition of barkcloth that is both closely related to and yet different from eastern Polynesian traditions. The decorative techniques comprise freehand painting, and printed and rubbed patterns. The latter are created using *upeti*, rectangular tablets covered with designs carved into the surface, or executed in sticks of split bamboo, folded pandanus leaf, or sennit cord. The cloth is laid over the tablet and then rubbed with dye to produce the pattern. These are subdued patterns usually subsequently enlivened with bold, geometric motifs painted on the surface. The design principles governing the decoration of Tongan barkcloth, similar to those of Samoa, have been identified as a fundamental aesthetic principle applied to music, dance, and carved patterns as well (FIG. 91). The principle comprises three structural components: melody (the essential features), drone (the space definers), and decoration (the

91. Club with incised patterns and motifs. Tonga. Wood, length 34″ (86.5 cm). Collected on one of the three Pacific voyages of Captain James Cook (1769–80); formerly in the collection of the Leverian Museum. Royal Albert Memorial Museum and Art Gallery, Exeter.

Tongan clubs often incorporate small human and animal motifs. The designs here include a turtle and a shark, both closely associated with the elite. The use of such figural motifs did not come into barkcloth design until the nineteenth century.

92. Newlyweds Selala and
Kotisoni Ufi, and
attendants. Pangai, Tonga.

The attendants wear
barkcloth (*ngatu*), while the
wedding couple wear
layers of fine mats. The
bride also wears an open
flower lei (*kahoa*) across
her shoulders and a festive
pendant floral decoration
(*sisi*) around her waist.

elaboration of specific features). Thus in barkcloth, the straight
lines are the drone, the named motifs are the melody, and the elab-
oration of those motifs are the decoration. Similarly, on a club,
the lines dividing the surface into panels function as the drone, the
patterns filling these panels are the melody, and the small figures
and other elements that elaborate these patterns are the decoration.

In Samoa, barkcloth is used as bedding or to make parti-
tions in the large, open houses. Today, people throughout west-
ern Polynesia continue to exchange barkcloth and mats on rit-
ual occasions, especially to mark rites of passage such as marriages
and funerals (FIG. 92). Even since the introduction of the cash econ-
omy, hundreds of pieces of barkcloth and fine mats are exchanged
to mark births, deaths, marriages, and the inauguration of title-
holders. In Samoa, both barkcloth and finely woven pandanus mats,
'ie toga, are exchanged by the bride's family at marriages for canoes,
pigs, fruits, and foreign goods, and by the groom's family to
seal the bonds between them. Each mat has its own rank, deter-
mined by its age, quality, name, and history, which enables it
to authenticate claims to titles and to *mana*. The work of mak-
ing and decorating barkcloth and mats is itself sacred, and, as in
eastern Polynesia, it is executed and supervised by the highest-
ranking women. Women's own *mana* infuses the mats as they
work. Women have a great deal of control over the exchange, for
they not only exchange mats and barkcloth themselves but
direct exchanges on behalf of their brothers and their brothers'
sons. Even though early twentieth-century colonial administra-

tors in Samoa tried to outlaw the exchange of mats and barkcloth, reckoning it a waste of resources that undermined the newly developing cash economy, these practices continue to be strong today.

Architecture and the Social Organization of Space

Architecture marks and elaborates on the special relationship of the people to their neighbors, to the land and the world around them, to the ancestors and the gods. Most Polynesian cultures built, and many continue to build, *marae* or ceremonial centers, where images of gods are kept and rituals take place that reinforce good relationships between this world and the spirit world. Architecturally, a *marae* can be simply a clearing delimited by a boundary wall of some sort, as in Samoa, where the form is called a *malae*. It can also be an elaborate open-air temple structure with a paved courtyard incorporating platforms, backrests, and walls, as in Easter Island and the Society and Marquesas Islands.

The meeting houses of the Maori, *wharenui* or *whare whakairo*, stand on the village *marae*, an open space where public debates took place and where both men and women perform the *haka*, sacred chants accompanied by dances that demonstrate the strength and fearsomeness of the performers. Under European influence, the Maori meeting house probably evolved from the decorated chief's house some time in the late eighteenth or early nineteenth century (FIG. 93). Meeting houses are the most important emblems of community identity, a focus of local pride and prestige, surpassing even the community storehouse and the war canoe. Used for funerals, religious and political meetings, and for entertaining visitors, the meeting house marks the relationship between the people, their ancestors, and the land they occupy.

93. View of the Maori house (*whare*), prior to restoration by Maori carvers and artists. Clarendon Park, Surrey, England.

Much like the war canoe, the house itself is identified with the body of the chief and his ancestors and imbued with their *mana*. The proper names of the houses often referred to particular ancestors, and orators would address the house as a living person during speeches given on the *marae*.

Ancestral motifs permeate the meeting house and create a sense of community identity. The ridgepole is identified with the chief's lineage and a figure of the founding ancestor surmounts the bargeboards of the roof. Additional ancestor figures provided supports within the

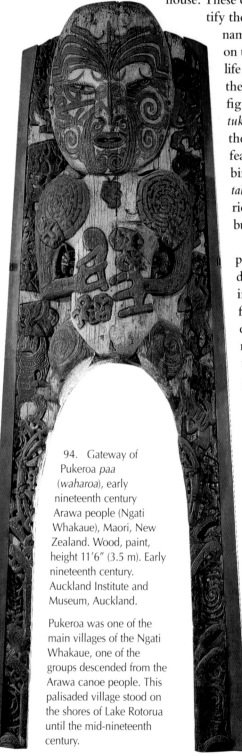

house. These often carried characteristic attributes to identify them, and by the mid-nineteenth century their names were carved on them. The scroll patterns on the rafters, *kōwhaiwahi*, symbolize the eternal life spirit that flows along the descent lines. Along the walls, panels depicting additional ancestral figures alternate with panels of woven *tukutuku* design. Woven by high-ranking women, the patterns of these panels reflect the natural features of the area: the footprints of a swamp bird, seeds, or stars. The master architect, the *tahunga whakairo*, has a total picture of the interior in mind and advises the weavers so that the building will have aesthetic and conceptual unity.

The Maori *paa*, or village (often fortified), provided not only defensive structures but divine protection as well, for the gateways incorporated ancestral motifs. Most *paa* are found on New Zealand's North Island, especially in the rich agricultural regions that experienced high population density and intensive warfare. A system of palisades and trenches protected the village, which was often strategically situated on a hill or cliff. The imposing gateway of Pukeroa *paa*, carved by the Arawa people at Rotorua, incorporated the protection of a powerful ancestor figure into these defensive structures (FIG. 94). The central ancestral figure wears the full facial tattoo of an elite man. As additional signs of his high status, the figure holds a club and wears a greenstone pendant, *hei-tiki*, around his neck. The smaller figures that stand under his arms and flank him on either side represent his descendants. Resplendent in his status and the strength of his lineage, the ancestral figure is truly impressive.

On Samoa, the organization of space provides a conceptual map of the community's social hierarchies (FIG. 95). Varying in size from a few dozen to several hundred inhabitants, Samoan villages, or *nu'u*, are dispersed along the coastlines while inland are situated the gardens for

94. Gateway of Pukeroa *paa* (*waharoa*), early nineteenth century Arawa people (Ngati Whakaue), Maori, New Zealand. Wood, paint, height 11'6" (3.5 m). Early nineteenth century. Auckland Institute and Museum, Auckland.

Pukeroa was one of the main villages of the Ngati Whakaue, one of the groups descended from the Arawa canoe people. This palisaded village stood on the shores of Lake Rotorua until the mid-nineteenth century.

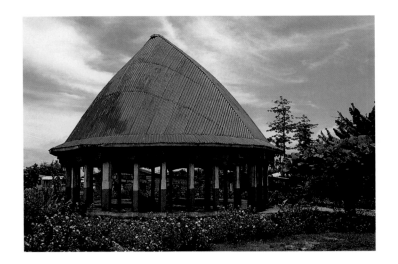

95. *Faletele* belonging to Galuvdao family, Avao village, island of Savai'i, Western Samoa. Recently, Samoan architects have begun to build ceremonial houses with tin rather than thatch roofs, which are more vulnerable to storms.

taro and other crops and behind these the forests. Each modern village consists of a number of landholding extended families, the *aiga*, each of which elects one if its members to the governing council, *fono*. The family houses are situated around the common ceremonial ground, *malae*. The houses of each *aiga* cluster together and frequently share the same earth oven to prepare food. The traditional-style houses, *fale*, are oval, open-sided buildings with thatched roofs. The open sides may be screened by mats to keep out the sun or winds. The openness of the houses, blurring the distinction between public and private space, insures that people behave with a degree of social decorum at all times. Families now also build Western-style rectangular houses with closed sides, a form of architecture that promotes a very different style of community relations. Similarly, the community house today is often, as a practical matter, roofed with tin rather than time-consuming thatch; this sometimes necessitates the change to a square rather than circular floorplan.

Throughout Polynesia, it was often the place itself that had significance, as the spiritual home of ancestors or legendary figures. The continuing ritual activity and artistic elaboration of such places increased their *mana*. One such place in Rapanui is the ceremonial center of Orongo and its sacred precinct, Mata Ngarau, located dramatically on the rim of Rano Kau crater, nearly 1000 feet (300 meters) above the surf (FIG. 96). The natural rock formations at Mata Ngarau are quite distinctive, and probably enhanced its attractions as a ceremonial site, for large boulders comprise a "court" area surrounded by upright stones. Orongo was the site of the birdman ritual, a yearly contest to obtain the first egg of the *manutara*, the sooty tern, from the offshore islet of Motu Nui. As documented

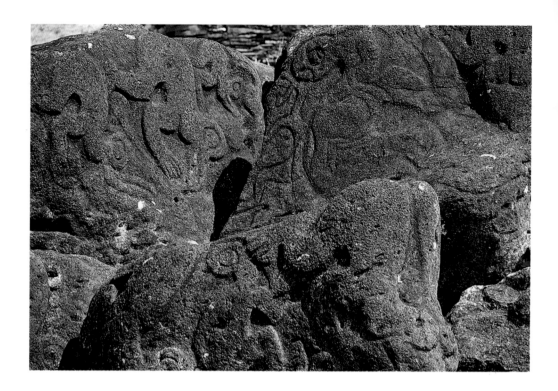

96. Bird-man petroglyphs, Orongo. Easter Island (Rapanui), Chile.

Stone faces were often not ornamented with petroglyphs all at once but carved over time, accounting for the profusion and overlapping of images.

in the nineteenth century, the contestants were high-ranking men who selected servants or proxies to compete for them. The proxies swam out to the islet and lived there in caves until the first sea birds arrived. Onshore, priests kept watch and chanted from the sacred *rongorongo* tablets. When the first egg had been brought back from Motu Nui, the winning titleholder became the next bird-man, *tangata-manu*, a position that carried material, moral, and religious privileges. The rites honored the gods and insured a good food supply in the coming year.

Not surprisingly, Orongo and Mata Ngarau contain the highest concentration of rock art on Easter Island, perhaps to mark this area as a sacred precinct. The numerous examples of superposition suggest that the petroglyphs were carved over time, perhaps on a yearly basis in conjunction with the bird-man ritual. Many motifs are present, including the famous one that combines the head and beak of a frigate bird with a human body. An aggressive bird that snatches food from other birds on the wing, the frigate bird was associated with warriors and the nobility. Other motifs include human faces, vulvas, terns and other birds with multiple heads or fingerlike feathers. The vulva motifs seem to have been added later, perhaps reflecting the development of a fertility cult around the time of Western contact, as noted above.

The ceremonies and images central to Easter Island's bird-man ritual exemplify the ways that Polynesians activate the *mana* of the elite through the intertwining meanings of artistic form and action. Whether it is the ceremonial wrapping and unwrapping of a Cook Islands staff god, the performance of a *haka* before a Maori meeting house, the gift of barkcloth in Tahiti or Samoa, or the playing of an Austral Islands drum, artworks put *mana* into action, making it present in this world. Essential to this process is the fine work of the object itself – the intricate plaiting of a mat, the polish of wood and stone, the dynamic contours of a sculpture – that expresses in visual terms the impact of *mana* and of the individuals and communities that make these works and participate in these events.

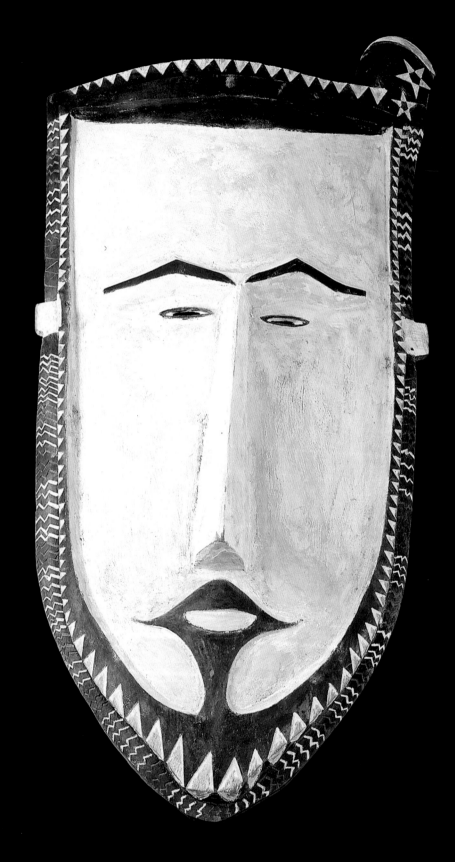

FOUR

Micronesia: The Path of the House

M icronesia is perhaps defined as much by its unique geography as by its culture. It is the only Pacific culture area in which most of the inhabited islands are coral atolls, which consist of a low, circular belt of coral surrounding a central lagoon. The atoll environment tends to be limited, presenting artists with a much narrower range of materials than volcanic islands. Coconut, pandanus, banana, and hibiscus trees dominate the low island flora, and many fewer species of birds and other animals are present than in Melanesia or Polynesia. In the western part of Micronesia, several major islands, including Belau, Yap, and the Mariana Islands, are volcanic in origin. Not surprisingly, the inhabitants of these western islands make pottery, stone tools, and other art forms not seen on the coral atolls.

For the peoples of Micronesia, the relationship with the sea is paramount, and Micronesians often consider navigation and canoe-building to be their greatest art forms. Other important art forms include textiles, basketry, tattoo and body ornament, bowls and containers of various sorts, and architecture. Micronesians do not make the range of figural sculpture that characterizes arts of New Guinea, Island Melanesia, and Polynesia, and, with a few notable exceptions, figures tend to be small. This may be due in part to the environment of the small coral atolls, where wood is relatively scarce. Nonetheless, many Micronesian cultures demonstrate an explicit concern with aesthetics. In the Mariana Islands, for example, the word *oogis* describes an object that is supremely functional or attractive in design. Vessels, textiles, and other personal accessories often combine simple, visually dramatic forms with finely executed, complex surface patterns. Figural sculpture tends to be geometric and spare in form, with facial features either absent or schematically rendered.

97. Mask. Satawan Atoll, Mortlock Islands, Caroline Islands, Federated States of Micronesia. Wood, paint, height 45¼ x 22" (115 x 56 cm). Museum für Völkerkunde, Hamburg.

Most Micronesian cultures are highly stratified, and the arts frequently reinforce and mediate social status. In this sense, sculpture, body ornament, and architecture serve both to connect and differentiate individuals and communities. This idea is perhaps best expressed through the Belauan phrases "paths of the house" (*rolel a blai*) and "paths of the person" (*rolel a bedengel*). These terms distinguish between the way a principal *bai*, or men's house, relates to its satellite *bai*, whether through institutionalized relationships of long-standing or through the less-established personal relationships of those who are associated with them. The metaphor of the house is not static, for, as discussed below, the *bai* not only serves as a blueprint for the organization of the community but also as a way for groups to change their relationships within the community.

Micronesian artistic traditions demonstrate connections with Melanesia, Polynesia and the islands of Southeast Asia, reflecting in part not only the widespread trading networks that extended through this area but also the processes of migration and settlement. Archaeological evidence suggests that the first inhabitants arrived in the Mariana Islands directly from Indonesia and the Philippines as early as 1500 BCE; later migrations originated in the Solomon Islands, Vanuatu, and Polynesia. The communal houses of Belau and the Mariana Islands show the influence of Indonesian prototypes, and other traditions, such as the art of loom weaving, were introduced by Indonesian traders in the historic period. The Polynesians who settled Nukuoro Atoll brought with them a tradition of monumental figural sculpture, while the tradition of the western Caroline Islands of three-dimensional wood sculpture depicting humans and birds may derive from Melanesian sources.

Magellan was the first European to visit Micronesia when he anchored at Guam in 1521. In 1528, Álvaro de Saavedra Cerón anchored at Pohnpei or one of its neighboring atolls, and named it "Barbudos" in reference to the beards of the inhabitants. Contact with the West was sporadic until the early nineteenth century, when whaling and trade with Asia brought many vessels into the region; missionaries began to arrive in the mid-nineteenth century. Great Britain, Spain, the United States, and Japan all established colonial territories in the region in the nineteenth century, preceded by the Spanish in the Mariana Islands in the seventeenth century. Independence from colonial regimes came relatively late to this area of the Pacific, for it was not until the 1980s that the process began in earnest. Nauru is now an independent nation, as are the Marshall Islands and Kiribati, for-

merly known as the Gilbert and Phoenix Islands. Most of the Caroline Islands have joined the Federated States of Micronesia, an independent nation in free association with the United States, except for Belau, a republic whose status is as yet undetermined. Guam remains a territorial protectorate of the United States, as do the northern Mariana Islands.

Gift-giving, Trade, and Exchange

Micronesians have always been great seafarers, frequently engaging in long, open-ocean voyages. On the coral atolls, such voyages were undertaken for fishing and warfare, but frequently one of the goals was the establishment of trading networks and diplomatic relations between island groups. The volcanic, high islands were often divided into several politically autonomous regions, and gift-giving was an essential means of fostering cooperative relationships among them. Of course, gift-giving practices within lineages and families also serve to reinforce social bonds. On Yap, vessels in the shape of white gulls serve either as food bowls or containers for canoe paint and are highly prized heirlooms passed down from mothers to daughters.

Yap was also the center of a far-flung system of tribute and exchange that extended throughout most of the western Caroline Islands. As in the *kula* exchange of the Trobriand Islands, gifts and offerings flowed in specific directions. The participants exchanged cloth, mats, coconut oil, chants, and dances. On Yap itself, the most extraordinary symbols of wealth are stone discs fashioned of aragonite quarried on Belau and imported to Yap (FIG. 98). The discs were displayed on the dance ground in front of the men's community house. Some of the disks served as backrests for important individuals and stood in a circle around a stone table used for the ceremonial distribution of fish. Both the size of the stones and the medium itself connote permanence, strength, and stability, while the stone's origin in Belau testifies to the power and extent of Yap's tribute network.

Among the textiles that formed part of this exchange system were large rolls of woven banana-fiber cloth, *mbul*. Relatively coarse in texture, the cloth was woven on special looms by men, unlike other forms of cloth woven by both men and women

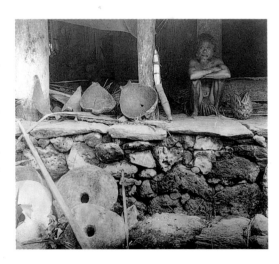

98. Stone money. Yap, Caroline Islands, Federated States of Micronesia.

Yap stone discs measure up to twelve feet (3.66 m) and have central holes by which they can be transported on carrying poles.

on ordinary back-strap looms. Bales of this cloth hung in the men's house, where they were stored for safe-keeping. When a village raised a new men's house, neighboring villages provided these bales of cloth as gifts. According to Yap tradition, this cloth covered the ground on which a leader walked when entering the men's house on ceremonial occasions. Other textiles played an important role in the Yap exchange network. For example, the *machiy*, a highly decorated textile (see FIG. 10), was often presented by the paramount leader of Fais to the Yapese "overlord."

On Belau, women as well as men participate in ceremonial exchanges. Women wear necklaces of glass beads acquired from Philippine or Chinese traders. These necklaces are a sign of the family's wealth and prosperity, especially during pregnancy and after the birth of the first child. Although worn by women, these pieces are considered the property of men and are exchanged by them. Men's money also includes pieces of pottery and porcelain received in trade. The transfer of men's money from the male to the female side of the family validates events such as births, marriages, and deaths. Only high-ranking leaders and specialists know the different grades and classes of money, and they guard this knowledge carefully. In a series of exchanges parallel to the men's, Belauen women exchange turtleshell plaques among themselves to mark these rites of passage (FIG. 99). Made by specialists, the plaques are highly valued but subsidiary to the men's money.

Powerful Belauan titleholders used shell-inlaid containers to present gifts of food to each other. The tradition was extended to Europeans upon their arrival and was one way to establish relationships with these newcomers in a way that was sensible and

99. Women's currency. Belau, Caroline Islands. Turtleshell, length 7⅛" (17.8 cm). The Metropolitan Museum of Art, New York.

The simple, oval shape highlights the beautiful pattern of the turtleshell. The tabs carved around the tray's perimeter may represent abstract images of birds with spread wings.

familiar. Two of the earliest Micronesian objects extant in museums are a bird-shaped bowl and a covered vessel inlaid with pearl shell, which the leading titleholder of Belau presented to Henry Wilson, an English captain shipwrecked there in 1783 (FIG. 100). The vessels contained a fresh drink, coconut sweetmeats, and oranges. In such exchanges, it was not the foods themselves but the gesture that had value, underscored by the fine quality of the bowls in which the gifts were offered. Trays with figural supports and shell inlay were also used for this purpose.

As cash economies have both supplanted and supplemented traditional forms of exchange and trade, the arts can provide an important source of income. In the Marshall Islands, for example, women are fine and prolific basketmakers, and in many areas

100. Lidded vessel. Belau. Wood, shell, height 8¾″ (22 cm). Collected by Capt. Henry Wilson in 1783. British Museum, London.

The fine shell inlay on this bowl is reminiscent of the intricate patterns of Caroline Islands textiles.

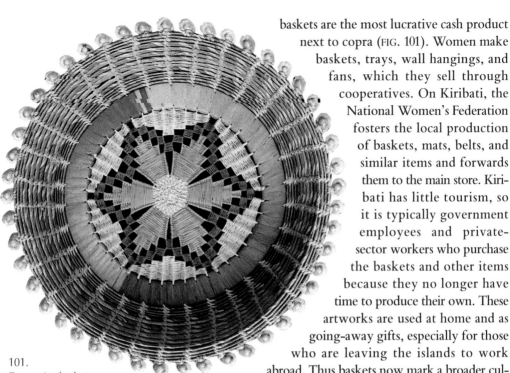

101.
Decorative basket.
Ailuk Atoll, Marshall
Islands. Coconut palm,
pandanus, dyes, diameter
11¾" (30 cm). Private
collection, Los Angeles.

The intricately woven
central designs, called
teneriffe, were introduced
in the first half of the
twentieth century, either by
Japanese traders or
patterned after the lace that
ornamented church linens.
The basketmaker warps the
area, and then uses a
needle-weaving technique
to create the pattern. While
the materials are local,
including coconut palm
and pandanus, the colors
are made from commercial
powdered food dyes.

baskets are the most lucrative cash product next to copra (FIG. 101). Women make baskets, trays, wall hangings, and fans, which they sell through cooperatives. On Kiribati, the National Women's Federation fosters the local production of baskets, mats, belts, and similar items and forwards them to the main store. Kiribati has little tourism, so it is typically government employees and private-sector workers who purchase the baskets and other items because they no longer have time to produce their own. These artworks are used at home and as going-away gifts, especially for those who are leaving the islands to work abroad. Thus baskets now mark a broader cultural identity than formerly, when they were made for use by members of the weaver's own family. Although basketmakers still recognize that individual designs belong to certain clans, the respect for this tradition is lessening as the conditions of production and use change.

Protection and Power

As elsewhere in the Pacific, images of humans, animals, and birds are often believed to serve a protective function, to help establish and maintain positive relations between the human and the divine, and to ensure the prosperity and continuity of the community. The goddess Ko Kawe, from Nukuoro Island, is represented by a monumental wood figure that projects both serenity and strength (FIG. 102). Ko Kawe is the protective goddess of the Sekawe clan and the wife of Ariki Tu Te Nato Aki, the god of the underworld. Though located in Micronesia, Nukuoro is inhabited by peoples of Polynesian origin. The figure of Ko Kawe may represent a link to the Polynesian tradition of monumental sculpture – the Easter Island stone figures and the Hawaiian temple figures are perhaps the most famous examples – that is otherwise unknown in Micronesia. This massive figure of Ko Kawe, created on a coral atoll with few large trees, testifies to the

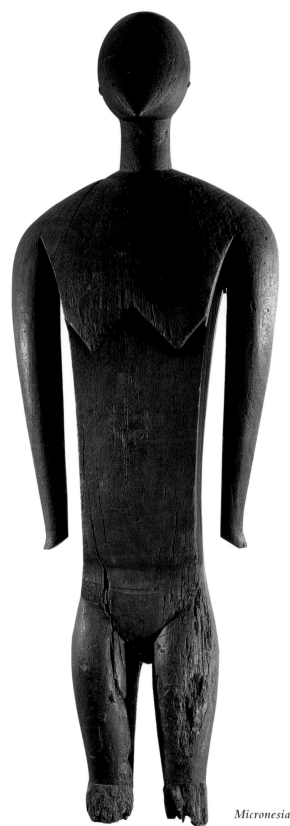

102. Figure of the goddess Ko Kawe. Nukuoro, Caroline Islands, Federated States of Micronesia. Wood, height 7'2½" (2.2 m). Auckland Institute and Museum, Auckland.

This figure's frontal posture has an air of dignity and composure, enhanced by the reduction of the facial features. The massive shoulders and chest, and the sheer size of the figure, convey a sense of power and authority.

103. Canoe prow ornament. Chuuk, Caroline Islands, Federated States of Micronesia. Wood, paint. British Museum, London.

Although at first glance this work seems abstract, it may represent two sea swallows facing each other or a stylized human figure.

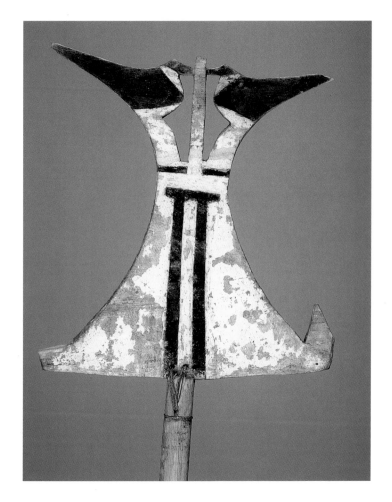

persistence and adaptability of important artistic practices even under unfavorable conditions.

On Nukuoro, each of the five original lineages has its own special god whose image resided in the *amalau*, a community spirit house used by the entire island. Both men and women could enter this building, a long rectangular structure with three open sides hung round with mats. On the short side of the house the god images, ornamented with flowers and crownlike headdresses, stood against the wall. The priests sat in front of them and the people ranged along the open sides. The main ceremony took place at the time of the breadfruit harvest, when people followed ritual restrictions, renewed the god images, and tattooed the young women.

Other sculptures from Nukuoro depict ancestral figures called *tino*. Some are life-size and, like the monumental figure of Ko Kawe, would have been kept in the spirit house. Others are portable; their use is not entirely clear although the early sources indicate

that they, too, were associated in some way with the *amalau*. These small figures generally stand on circular bases, some of which are grooved and retain their fiber bindings. Many of them are distinctly female, with carved breasts and genitals, although others are not clearly gendered. This, too, is characteristic of many Polynesian ancestral figures, such as the Society Islands canoe ornament (see FIG. 72).

Given the difficulties of long-distance ocean voyages and the central importance of sailing to Micronesians, canoes often incorporate protective devices that appeal for supernatural help. On Chuuk, large, paddled war canoes, *waa faten*, bear removable prow ornaments carved by master canoe builders (FIG. 103). Fashioned from a single plank of wood, the ornament incorporates geometric elements and two sea swallows facing each other. The form can also represent a stylized human figure: the projecting tails of the birds are the arms, the central vertical element is the hip, the bottom projections are the legs. Removed from the canoe when not in use, these ornaments are lowered to signal peaceful intentions when approaching another vessel.

Throughout the western Caroline Islands, small anthropomorphic figures serve as weather charms to protect canoes (FIG. 104). The knotted palm leaves attached to the figure may be a protective device designed to ward off evil spirits, analogous to the Polynesian tradition of wrapping a person or object to establish sanctity and spiritual power. Navigators also use weather charms to appeal to beneficent water spirits, sometimes called *yalulawei*, to divert storms. The navigator takes the image to a coconut tree near the canoe house and chants a request for protection; he then takes the charm along in the canoe. He may place the figure in a small spirit house lashed to the outrigger booms, or he may attach it directly to the booms. The navigator can also function more generally as a sorcerer, using the charm to appeal to spirits, alter the weather or perform divination, or to direct evil spirits against particular individuals.

On Satawan Atoll in the Mortlock group of the Caroline Islands, protective ancestral spirits appear as masked dancers in the only masking

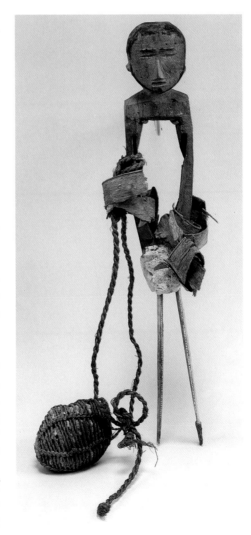

104. Wind charm. Puluwat, Yap, Caroline Islands, Federated States of Micronesia. Wood, fiber, coral cement, pigment, length 16″ (40.7 cm). Fine Arts Museums, San Francisco.

The wind charm exhibits the spare sculptural style typical of Micronesian figures. The negative space between the squared arms indicates the torso, while sting-ray spines indicate legs.

tradition indigenous to Micronesia (FIG. 97). The name for the masks, *tapuanu*, is a combination of two words, *tapu*, meaning "sacred, full of *mana* or power," and *anu*, meaning "ancestral spirit." These spirits are able to ward off hurricanes and typhoons and protect the breadfruit crop. Secret societies called *soutapuanu* organize the performance and the creation of the masks. They occupy a large ceremonial house, *falefol*, where the performances and their accompanying feasts take place in March or April. Miniature images of the masks sometimes decorate the support beams of both the *falefol* and the boat houses, thereby extending their protection to the two most important ceremonial structures in the village. The meaning of the performance itself is not entirely clear. The masked dancers were divided into two groups that engaged in a stick dance, a stylized battle, all the while calling out to each other, "Who are you?", and replying in the affirmative.

Patterns of Power

Textiles and body ornaments are a primary focus of artistic activity throughout Micronesia, and they are often visually spectacular, despite the limited resources of many islands. The intricate patterns incorporated in clothing and tattoo provide ways to distinguish family identity, rank, and social status. The knotted coconut fiber armor of Kiribati, which enveloped the wearer from head to foot, is a good example, for its effectiveness lay as much in its psychological and visual impact on the viewer as in the sense of spiritual and physical protection it provided to the wearer. Most Micronesian cultures traditionally practiced tattooing; specialists tapped a small, toothed, bone implement with a wooden mallet and inserted black pigment from soot in the punctures. In addition to textiles and tattoos, Micronesians have traditionally worn and still wear a large variety of shell, bone, and feather ornaments to indicate social status (FIG. 105).

105. Pendant. Marshall Islands. Shell, turtleshell, fiber, length 4" (10.5 cm). Linden-Museum, Stuttgart.

Caroline Islands' textiles are particularly significant because they include the most highly developed loom-weaving tradition of the Pacific. This technique was probably introduced by Indonesian traders but is believed by Micronesians to be a gift from the gods. Barkcloth, the primary textile medium in Melanesia and Polynesia, is relatively unimportant in these islands, perhaps because most atolls could not support the groves of mulberry and other trees necessary to make barkcloth in quantity. Women are the weavers everywhere in Micronesia except on Kapingamarangi, where only men weave, and on Yap, where only men weave the coarse, banana-fiber cloth used in ritual gift-giving and exchange, as noted above. Textiles are produced on back-strap looms, in which the warp threads are anchored by pegs at one end and by a board tied with cords around the weaver's waist at the other. This loom limits the width of the cloth to the width of the human body. Even though Micronesians learnt the art of weaving from Indonesian traders, they do not practice the characteristically Indonesian *ikat* technique, in which the yarns are dyed according to the final pattern before weaving.

In highly stratified Micronesian societies, special textiles were often reserved for the elite. On Pohnpei, for example, the right to wear certain kinds of woven sashes, plaited belts, and dyed grass skirts belonged to the nobility. Designs for woven sashes and plaited headbands belonged to specific lineages exclusively (FIG. 106). Executed in warp-striped patterns, the geometric designs are characterized by their fineness, precision, and symmetry. Pohnpei weavers often use warp-float, which entails passing the lengthwise threads without interweaving them, and supplementary-weft techniques, in which additional threads are added or manipulated to create more complicated and visually striking motifs. Pohnpei tattoos incorporated plaitwork motifs that relate directly to the

106. Woven sash. Pohnpei, Caroline Islands, Federated States of Micronesia. Banana fiber. British Museum, London.

This sash, from the Henry Christy collection, was acquired by the British Museum after his death in 1865. Its label bears a rare attribution to its original owner: "Belt of Chief Ometha belonging to Ascension Island South Pacific." Similar geometric motifs appear on wooden dance paddles and hair combs as well as in tattoo.

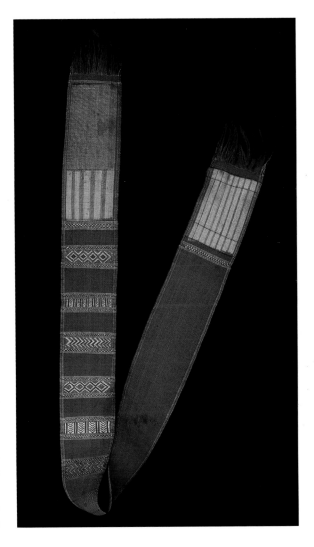

107. Pohnpei tattoo motifs.

designs on woven textiles (FIG. 107). Women wore these tattoos on their abdomens, buttocks, and legs, while only the men wore sashes. The underlying concept of both cloth and tattoos may have been to wrap the body in protective images, although little is known of the significance of particular design motifs.

Square mats from the Marshall Islands served as clothing for both men and women (FIG. 108). Called *in* or *nieded*, they are plaited, not loom-woven, and are typical of the intricately patterned and finely woven mats produced on a number of islands. Women wore a skirt of two mats, one each at front and back,

while men wore a single mat as a loincloth. The borders are composed of bands of intricately woven geometric motifs. Like the Pohnpei sashes, the mat designs seem to relate closely to tattoo patterns. Both sexes also wore tattoos, which included motifs of barbed, crenellated, and zigzag lines. Only elite men had the right to the facial tattoos that signified high status and to the special plaited cords that were worn as belts.

On Nauru, maternity mats served as emblems declaring the strength and continuity of a woman's lineage (FIG. 109). The designs on these plaited mats were similar to family crests for they identified her family and clan. From her fifth month of pregnancy an expectant woman and her husband would abstain from sexual activity and both would wear similarly patterned mats. The infant was laid upon a mat that was a smaller version of the mother's mat,

108. Mat. Marshall Islands. Fiber, length 35″ (89 cm). British Museum, London.

and displayed the same pattern. The geometric patterns appear entirely abstract to a Western observer, yet their names are quite evocative: "morning star," "blood spot," "lizard tail," "roof beam," or "tree of life with gifts."

Throughout Micronesia, distinctive forms of dress are also worn for dance and on special occasions (FIG. 110). On Kiribati, dance costumes have changed in response to the introduction of new materials and innovations in dance and music. There is little tourism in Kiribati, so these changes take place within and for the community. Dance troupes appear mainly at weddings, community socials, and government functions, although some troupes now travel overseas to perform at arts festivals. Just as the dances meld traditional Kiribati dances with other Pacific traditions, especially from Hawaii and Tahiti, so the costumes also incorporate traditional Kiribati regalia and elements borrowed from other Pacific cultures. Both aesthetics and functionality govern the substitution of materials: armbands that formerly incorporated fresh flowers now use flowers fashioned from durable plastic or shiny wrapping paper that glint as the dancer's arms move.

109. Family emblem/ maternity mat. Nauru. Fiber, shell, seed, feathers, 15½ x 7¼" (39.4 x 18.4 cm). The Metropolitan Museum of Art, New York.

Architecture and Community

If sculptural traditions are not as well developed in Micronesia as elsewhere in the Pacific, the traditions of monumental architecture are fully as impressive as any found in New Guinea and the other island groups. The concern with the social construction of space is not surprising in cultures that have severely restricted land resources. For many Micronesian cultures, the relationship between land, sky, and ocean is a primary concern, one that architecture mediates visually, physically, and symbolically. Monumental

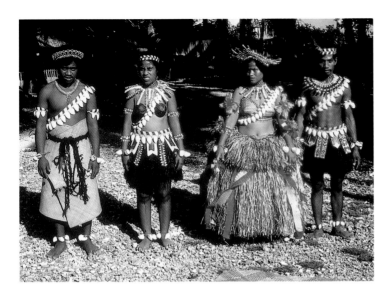

110. Costumed dancers. Kiribati.

111. Mortuary enclosure. Nandauwas islet, Nan Madol, Pohnpei Island, Caroline Islands, Federated States of Micronesia.

The massive stone blocks convey a sense of the importance of this enclosure.

architecture, whether spirit house, men's house, or community house, is part of a wider system of spatial demarcation articulating social, spiritual, and political relationships within the community.

The administrative and ceremonial complex of Nan Madol on the island of Pohnpei demonstrates that the construction of monumental architecture is a long-standing tradition in Micronesia (FIG. 111). Although the earliest construction at the site dates to the eighth or ninth century CE (common era, or AD), the distinctive megalithic architectural style came into use around 1200–1300. Around this time, a ruler called the *saudeleur* unified Pohnpei and Nan Madol is associated with his ascendancy. This political system came to an end in the early 1600s, when the island was divided into three autonomous political units. One of these units, founded in legend by the son of the thunder god, was centered at Nan Madol, which therefore continued to be actively used, though not expanded, at least until the early eighteenth century. By the 1820s, Nan Madol was no longer a residential center but was still used occasionally for religious observances.

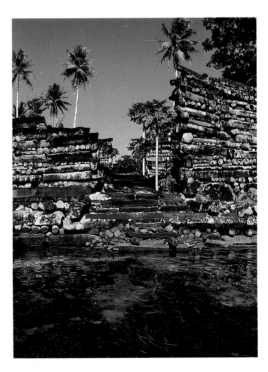

Nan Madol's location offshore from the main island of Pohnpei may have both reflected and reinforced the unique character of the

people who lived there and their ritual activities. The complex consists of ninety-two artificial islets built in a shallow lagoon and surrounded by retaining walls to protect them from the ocean waves. Some of the islets have sides more than a hundred yards (91.5 meters) long and many have orthogonal plans. They are covered with loose coral pavement. The buildings included residences, meeting houses, and tombs, divided roughly into two sectors by a central canal. One part is administrative, containing the rulers' residences and large public spaces, the other is ritual, encompassing the priests' residences and the mortuary centers. Many of the original structures were pole and thatch constructions, although ceremonial structures were also built of stone. Enclosures provided privacy for the dwellings of high-ranking people or established sacred zones for the tombs or religious activities. The walls throughout the complex are built of alternate courses of basalt boulders and naturally formed prismatic basalts.

The royal mortuary compound on the islet of Nandauwas is perhaps the most magnificent part of the structure. The main entry landing on the central canal has a monumental quality, its steps leading to interior courtyards and tombs. It is situated near the edge of the lagoon, and faces east. The outer sea wall is fifteen feet (4.6 m) high and thirty-five feet (10.7 m) thick in places, and the sound of waves breaking against the wall is continuous. The blocks of stone are massive: one basalt corner stone is estimated to weigh more than fifty tons. The wall of the outer courtyard incorporates ledges that may have been used to display corpses before burial. The inner courtyard contains a square central tomb that must have been reserved for a *saudeleur*. The tomb contained adzes, beads, needles, necklaces, pearl shell fishhooks, and other valuable objects, including fragments of iron.

The men's house, or *bai*, of Belau in the Caroline Islands is one of the great architectural traditions of Micronesia (FIG. 112). These men's houses closely resemble men's houses in Indonesia, also called *bale* or *balai*. *Bai* serve as ceremonial centers, gathering places, and reception halls. Women do not normally enter the *bai*, although sometimes they use it for their own meetings and gatherings, even for several months at a time. Today, with the decline in the number of *bai*, this separation is not strict. In the past, women sometimes had their own, smaller *bai*, to which men's access was restricted. The Bai-ra-Irrai (*bai* at Irrai) is one of only two *bai* that currently exist on the island (a third, built near the museum in Koror in 1969, burnt down in 1978). It rests on a stone platform that once was the site of three *bai*. Irrai was the village of a regional leader who exercised authority over a

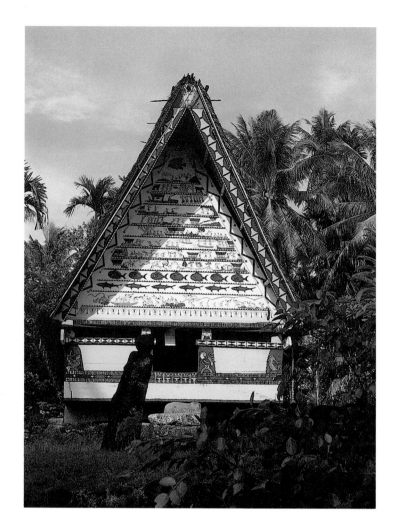

112. Bai-ra-Irrai, a modern men's house (*bai*). Irrai, Belau Islands.

A men's club within a village that wished to have a new *bai* constructed would approach another club to which a master builder of notable reputation belonged. The men's house was actually constructed on a site near the builder's village and then disassembled and moved to the chosen site by new owners. Once reassembled, the figures and gable boards would be carved and painted. These buildings are made entirely without nails, screws, or lashings. All pieces are cut to interlock in complex joinery systems and with removable pegs, a method that allows the buildings to be moved easily during the construction process.

number of lower-ranked villages. Because of Irrai's political prominence it may have had more numerous and prestigious works of architecture than other villages.

The Bai-ra-Irrai was originally erected about three hundred years ago, and has been continually refurbished. Six portals, two on each long side, one on each short side, provide access to the building. No one must touch these portals, nor can men without rank enter them. An image of a bat, painted on the underside of each lintel, enjoins all those who enter to respectful behavior. The ideal village has six *bai* arranged into two groups, as was the case in Irrai, and the buildings in each group are assigned junior, middle, and senior status. On a larger scale, the *bai* are the corner-posts of the village, while the four most important villages are the corner-posts of the island. Within the building itself, a man's seat reveals his rank and privileges and the four leading

titleholders sit at the four corner-posts in recognition of their central role in the community.

The gables bear numerous symbols of fertility and productivity associated with the sun god. Not only are there food animals, fish, and plants, but also sun discs ringed by both rays of light and penises. Images of roosters are common, for they appear in the legend that recounts the creation of the first *bai* and the placing of the sun in the sky. Rows of heads may refer to headhunting, a practice associated with spiritual renewal, fertility, and the ancestors, in Belau as in many Melanesian and Southeast Asian cultures. Apparently, the heads of enemies slain in battle were hung on stakes outside the *bai* or placed under the threshold. Rows of circles with crosses are money symbols that connect exchange to these ideas of fertility and natural production.

On the gables, story boards, carved in low relief and painted, depict important events from spiritual traditions and clan history, including typhoons, important visits, and battles. The story boards of the *bai* built in Airai village just after the end of World War II commemorated the battles between American and Japanese forces. Older *bai* frequently included images of Western sailing ships. The ten story boards on the façade of the Bai-ra-Irrai represent legendary events in the history of the village. They include animals and humans, as well as images of several other *bai*. When a board depicts more than one scene in a story, the events are represented from left to right; when a single scene is depicted, the most important figures are central and flanked by less important figures and elements. The boards rely on the viewer's prior knowledge of the basic story, but reach their full meaning through the interpretation of the storyteller, who gives it depth and character. Story boards suggest the influence of outside narrative traditions, for they do not appear on the earliest *bai*. Since the 1930s, these story boards have been created in portable form to sell to tourists.

Women are central to the *bai* and to the community. The senior women of each clan elect the four most important leaders, the "corner-posts" of the *bai*, and have the right to depose them as well. In recognition of their importance, the portal jambs of the west façade of the Bai-ra-Irrai represent two of the four leading women, *ourrot*, of the village. In this way they are analogous to the four corner-posts that represent the four clans, and to the clan leaders, the conceptual corner-posts elected by the women. The *bai*'s gable ornaments frequently include a sculpted or painted figure of Dilukai, a young woman with legs spread wide (FIG. 113). Dilukai is a symbol of both protection and fertility,

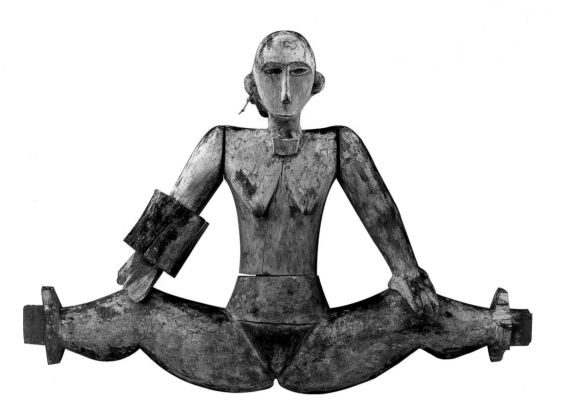

for she safeguards the taro fields and heals the sick. More recent stories interpret her as a reminder to women to be chaste. Incised and painted images of young men with erect penises may flank the figure of Dilukai. Their name is *bagei*, a word which both means "married" and is the name of Dilukai's brother. Legends tell how Dilukai's promiscuity embarrassed her brother Bagei, who carved her image on the *bai* to shame her.

The tradition of monumental architecture is not exclusive to the high volcanic islands: indeed, the *maneaba* meeting houses of Kiribati are the largest buildings erected anywhere in Micronesia (FIG. 114). The thatched roof of the *maneaba* can soar to over fifty feet (15 m), creating a striking visual effect amidst the long line of green coconut trees that defines the landscape of these low, coral atoll islands. The site for a *maneaba* is selected with great care to insure its visibility from the lagoon approach to the village; it must also be within a *gange*, a plot of land that serves as a sanctuary, where any man beaten in battle or otherwise ostracized from the community is safe. The smaller village houses cluster around the *maneaba*, which is the spiritual, social, and political center of the community. The *maneaba* serves as a community's council chambers and is regarded as the home of the principal deities.

113. Dilukai, represented on a men's house (*bai*). Belau Islands. Wood, pigment, fiber, height 23⅝" (60 cm). Linden Museum, Stuttgart.

The image of Dilukai is sometimes painted on the men's house façade rather than sculpted.

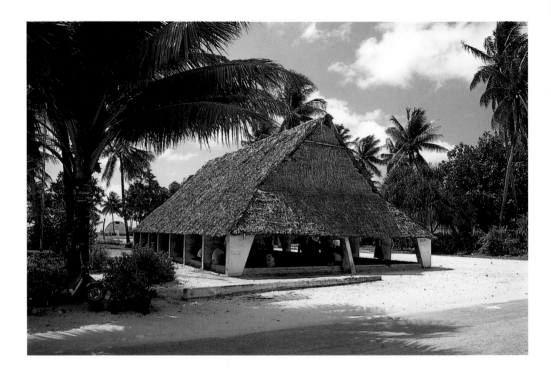

114. Meeting house
(*maneaba*). Kiribati.

The open-sided *maneaba*,
silhouetted against the
trees, expresses the close
relationship between
people, nature, and the
built environment. The
soaring roof creates a vast
interior space, the
monumentality of which
encourages appropriately
dignified behavior.

It is the place for the arbitration of disputes, the trial of offend-
ers by village elders, and the discussion of peace and war. Feasts,
initiations, marriages, funerals, and ceremonies honoring the patri-
lineal ancestors all take place under its roof.

Not surprisingly, social and spiritual considerations govern
each aspect of the *maneaba*'s construction, as well as appropriate
conduct within the building. For example, the rafters cannot be
placed directly over the pillars that support the roof but must
be positioned a little to one side, or misfortune will fall on the
community. All behavior in the *maneaba* has to be seemly, deco-
rous, and in strict conformity with custom, or the offender will
be cursed. Children are never allowed in because their behavior is
potentially inappropriate. The only people who customarily enter
the building are adult males, although women and young adults
also sometimes attend community functions there. Any adult male
has the right to speak, but given the large numbers of people who
attend these gatherings, the lineages usually choose spokesmen.

Although there are several styles of *maneaba*, each charac-
terized by its own history and distinctive proportions, all share
a basic spatial division into three zones. The ground on which the
building sits forms part of the *maneaba* and is covered with a layer
of coral gravel within a low stone border. This stone border marks
the ground as sacred space, distinct from the surrounding earth.

The name for this sacred space, *te marae*, is a Polynesian word for "ceremonial center" and was probably introduced by Samoan invaders who arrived on the island between 1200 and 1400. The other two spatial zones exist within the building itself. The perimeter provides seating for the villagers. The central space, marked by a low stone border much like the low stone wall surrounding the *te marae* pavement, is a ceremonial space reserved for ritual performances.

The division of space within the *maneaba* provides a social map of the community, and the building itself is a source of both individual and corporate identity. The patrilineal clans, *boti*, govern seating within the *maneaba*, and the arrangements reflect the relationships among the *kainga*, ancestral estates held by the clans as corporate possessions and communal residences. The location of a man's seat within the building indicates his totem and ancestors, his ceremonial duties and privileges. The eastern half of the building is allied with the deity Tabakea, the western half with Tebakoa. The two gods represent the opposition of land and sea, expressing the triumph of land over sea, and of human civilization over the pre-human undersea kingdom. The opposition may also reflect the dominance of clans that descend from the Samoan invaders over clans that descend from the first inhabitants, who probably arrived from southeastern Melanesia.

The Kiribati *maneaba* makes clear the vital role that Micronesian art plays in establishing connections between people and the spiritual realm and between communities. This is as true of the Belauan *bai* as it is of the massive stone discs of Yap or the textiles of the Caroline Islands. Through these arts, an area that Westerners might consider as isolated small islands, reveals itself as a place of dynamic historical and cultural relationships, traversed by far-flung trade routes, the crossroads of regional influences. In this sense, the Pacific Ocean serves as much to connect as to separate, just as Micronesian art both distinguishes and unifies individuals, clans, and communities across space and time.

DISPELA MERI
I RINGIM BOI
PREN BLONG EM
LONG PABLIK TELEPHONE.
. OSCAR TOWA.
(1995.

Tradition and Power in Contemporary Pacific Art

Many art traditions, including architecture, sculpture, masking, tattooing, and textiles, continue as vital aspects of Pacific Islands culture. To be sure, there have been great changes especially over the past two hundred years, stimulated in part by colonialism, market economies, and missionary activity. Change is certainly indigenous to Pacific cultures and their artistic traditions, but the pace of change has accelerated. It is this dynamic of change and continuity that both challenges and sustains contemporary Pacific artists. As the celebrated Samoan writer Albert Wendt has observed, "I am interested in the arts of our region not only for their own sake but in how they can be used to heal and restore our pride, self-confidence, and self-respect; in how they can reshape, redefine, discover and rediscover our cultures and help give birth to new cultures and a new Oceania."

As part of this process, some Pacific artists have adapted Western-style media, including painting, sculpture, and printmaking. This development spans regions and island groups, from Micronesian atolls to the highlands of Papua New Guinea. These artists often have strong ties to urban centers where they explore Western art traditions in museums, cultural centers, schools, missions, and mass media. Along with the new media, they frequently blend indigenous symbols and artistic styles with Western-inspired depictions of the human body, narrative, and symbol structures. Their focus remains largely on Pacific subjects and experiences as they celebrate cultures and traditions, give expression

115. OSCAR TOWA
A Girl Rings her Boyfriend,
1995. Gouache on paper,
25 x 20" (64 x 51 cm).
Private collection.

to individual, ethnic, and national identities, reclaim traditions lost in urban relocation, missionary fervor, and colonial regimes, and explore the social and political issues that Pacific Islanders face in the contemporary world.

The Role of the Artist

The Hawaiian artist Herman Pi'ikea Clark does not see this turn toward new media as a radical break with tradition, arguing that the role of the artist as communicator is the same no matter what material is used to make the image. Clark trained as a traditional artist – he has carved a canoe – and then evolved as a graphic artist. For Clark, the contemporary artist is still a *kahuna*, a Hawaiian ritual specialist and artist who serves as a spiritual counselor and repository of cultural knowledge. The *kahuna* interprets the past, present, and future, explaining the will of the gods and ancestors through both words and visual representations. Graphic art provides Clark with an effective way of communicating with the native Hawaiian community in keeping with the spirit of the *kahuna*, even if he works within a radically altered native society, which is now a minority population fighting its dispossession and no longer governed by the strict social hierarchies of the past.

116. HERMAN PI'IKEA CLARK *Na Ola Makou — We Have Survived*. Computer graphic.

The combination of words and images effectively encapsulates the tragic post-contact history of Hawaii and points to the survival and resurgence of Hawaiian culture.

Clark's *Na Ola Makou – We Have Survived*, a computer graphic, succinctly expresses this role of the artist as communicator and interpreter in the way it addresses the history of native Hawaiians (FIG. 116). It is an image that presents the tragedies of the past as well as hope for the future. The names of diseases introduced into Hawaii by Westerners float on the screen in large type as if emerging from the microbes pictured behind them. These words threaten to overwhelm the bright red lines of a genealogical chart,

which bears the names of Clark's own ancestors and terminates on the right in a circle superimposed over his portrait. The names of diseases are limited for the most part to the left side of the screen, as if Clark is putting a stop to them. Behind the genealogical chart, another line plots the native Hawaiian population over time, showing its precipitous decline and its resurgence, which also occurs on the right.

117. ERENORA PUKETAPU-HETET *Kokiri,* 1982. Hanging of feathers and fiber.

A similar sensibility is shared by Erenora Puketapu-Hetet, one of the greatest traditional Maori weavers alive today. She also works as a contemporary textile artist, her medium remaining closer to the traditional work than Clark's does. Growing up at Waiwhetu among her people, Te Atiawa, she spent time amusing her women relatives, enticed by their laughter and encouraged to help with small tasks, and from them she learnt weaving. She continues to weave feather cloaks, flax cloaks, baskets, and other forms that they taught her. Puketapu-Hetet affirms the sacred status of weaving, for the *mana* and skill of the weaver imbue her creations with lifeforce. She notes that Maori weaving is full of symbolism and hidden meanings. Her feather hangings are also richly allusive even though they do not take the form of traditional garments or accessories. The shape, size, and technique of her hanging, *Kokiri,* evokes the cloak, even though it is hung from a single point, like a fine-art textile (FIG. 117). Its stripes symbolize the multifaceted advancement of the Maori people, strengths that will give the Maori people the kind of physical and spiritual protection traditionally provided by feather cloaks. Other hangings, such as the triangular *Tu Tangata,* are also richly symbolic. In this work, inspired by her wish for greater Maori autonomy, the apex of the triangle represents powerful bureaucratic hierarchies, while the broad base represents the "flax roots" of the community, the weavers. The name derives from the Tu Tangata policy introduced by the Bureau of Maori Affairs in the 1980s that promotes Maori dignity and self-determination.

Like Solomon Islands artists in the past, Eddie Daiding Bibimauri feels that his true inspiration comes from the land where he

118. EDDIE DAIDING BIBIMAURI
Custom Images, 1974.
Plastic housepaint mural on copra shed. Point Cruz Wharf, Honiara, Solomon Islands.

Bibimauri's ravenous shark derives more directly from pop-culture images of sharks than the wood carvings of the past (see Chapter Two).

119. TEKIRAUA URIO
Mural on side of Routakarmi Store, Tarawa, Kirabati, 1983.

Urio's shop murals are designed to attract the attention of the passerby and encourage them to shop, but do not necessarily depict the goods for sale inside.

grew up, on the island of Malaita. He works as a graphic designer, landscape artist, and muralist in the capital city of Honiara, where his interest in traditional art and graphic design came together in a series of murals he executed on the cargo sheds at Honiara's Point Cruz wharf in preparation for Queen Elizabeth II's 1974 visit (FIG. 118). To prepare for this mural, Bibimauri spent time studying the collections of the National Museum. The mural juxtaposes the ancient form of the war canoe, with its upswept prow and stern, with the image of a shark totem. The images show his careful observation of traditional forms, but the crisp, geometric lines of the canoe are indebted to the eye-catching shapes and rhythmic repetitions of graphic design.

In Kiribati, the artist Tekiraua Urio also works within a Western idiom (FIG. 119). Urio had no training before working as an artist, but later spent a ten-week period as artist-in-residence at the University of the South Pacific in Fiji. His energetic figural style contrasts with the fine geometric patterning much more typical of Kiribati art traditions, especially two-dimensional design. He finds visual inspiration in films, advertisements, and other Western sources. Urio paints murals for a variety of patrons, including churches, the government, and merchants, and also paints gravestones with scenic images of fruits and flowers. Recently, he has begun to make easel paintings.

Patronage and Power

Like Tekiraua Urio, many artists working in Western-inspired media now look for patronage to governments, tourists and

foreigners, art collectors, museums, and cultural centers rather than to village leaders and traditional societies. Governments throughout the Pacific have been especially active as patrons of contemporary art, perhaps because of their need to build national identities out of myriad local identities and foster pride in Pacific nations and cultures in the wake of colonialism. This process is perhaps most evident in Papua New Guinea, with its hundreds of languages and cultures, where the challenge of creating a national identity is greater than anywhere else. In order to embody these ideals of nationhood, the government sponsored an ambitious building program in Port Moresby, the national capital, in the 1970s (FIG. 120). Located at the administrative center of Waigani, the capital complex includes Independence

Hill, the National Museum and Art Gallery, the Supreme Court, the National Library, and, as its centerpiece, the Parliament House. At the opening of the Parliament House, the Honorable Timothy Bonga, Speaker of the House, expressed the government's vision of the building's symbolic function: "It is for Papua New Guinea a symbol of political independence ... Its sweeping lines impress, while signifying essential aspects and parts of our nation ..."

The design principle in all these buildings is *bung wantaim*, a *tok pisin* (pidgin English) expression made popular by politicians during the national election campaigns that means a "true coming together." In relation to the arts, *bung wantaim* signifies both the mixing of styles and also cooperation between artists from different regions on a shared project. The façade of the National Museum and Art Gallery, designed by the New Ireland artist David Lasisi and executed by students from the National Arts School, incorporates motifs from a wide variety of Papua New Guinea cultures (see FIG. 120). Similarly, the decorated façade of the Parliament House, coordinated by Archie Brennan, brought together artists from all over the country to provide designs. The soaring roofs of both the National Museum and the Parliament House evoke the form of the Abelam ceremonial house (*korambo* or, in pidgin, *haus tambaran*), an appropriate metaphor for national

120. Façade of the Papua New Guinea Museum and Art Gallery, Port Moresby, 1974. Designed by David Lasisi, executed by students of the National Arts School.

The widespread use of mosaic decoration on PNG government buildings may be another way to express *bung wantaim*, "a true coming together," a term that celebrates the multicultural richness of Papua New Guinea.

gathering places. The Parliament House, in an extension of the principle, contains the largest display of modern PNG art in the country.

Although the buildings are a source of pride for many Papua New Guineans, others have been more critical both of the complex itself and also of *bung wantaim* as a design principle. The allocation of resources to such projects is itself a problem in a country that faces a lack of infrastructure, urban drift, and widespread violence. This apart, some contend that, though the buildings are visually dramatic, they are a superficial expression of traditional styles, a pastiche of symbols taken out of their ritual and social contexts and away from their owners. Others, with perhaps less justification, have criticized the buildings for "Sepik centrism," alleging that the Abelam *korambo* and other East Sepik Province art forms have received disproportionate emphasis. This is attributed to the pre-eminence of Sepik people in the government at the time and also to the fact that Sepik styles are the most familiar to foreigners, whose investment the government courts.

While this may be an overly cynical perspective, it does raise an important issue by addressing the foreign presence in the Pacific and its impact on the arts. The role of foreigners in Pacific economies and politics has long been a matter of debate, but attention has turned, too, to the increase in foreign sponsorship of the arts, especially by international corporations and tourists. Some observers are concerned that such patrons may affect the ways in which issues of identity are explored in the visual arts and, therefore, in Pacific communities. The dialogue ranges across issues of authenticity, creativity, and political commitment in a post-colonial and increasingly global cultural and artistic environment. In a recent and controversial case, the largest art commission ever in New Zealand, the decoration of Harrah's Sky City Casino in Auckland attracted criticism and praise. Both Pakeha (New Zealanders of European origin) and Maori artists adopted the images of Maori culture and the vocabulary of Maori art to locate the casino culturally in Auckland. Some see this as an unacceptable appropriation of Maori culture, while others disagree, citing the participation of Maori consultants on the project.

The burgeoning number of museums and cultural centers that have opened in the past ten years attests to their ability to nurture the development of the arts in a way that meets with both popular and government approval. The Sir Geoffrey Henry Cultural Centre in the Cook Islands and the Vanuatu Cultural Center are among the most recent to open, and plans are under way

for a cultural center in Tonga. These institutions undertake a variety of activities: commissioning artworks, staging exhibitions, sponsoring research, and providing a place where artists and the community can gather to exchange ideas. In this spirit, the main buildings of the new Jean-Marie Tjibaou Cultural Center in New Caledonia are conceived as a series of great houses, the structures that symbolize the power of the traditional leader and his ancestors (see Chapter Two). In the Marshall Islands, the Alele Museum sponsors the yearly Folk Arts Festival. Its stated goals are shared by many such institutions: "to stimulate cultural identity; celebrate the traditional; provide an opportunity for contemporary expression and encouragement toward a national goal of self-reliance."

Pacific museums and cultural centers also exhibit historic art traditions, which often are a source of inspiration to contemporary artists. These institutions have become places for the repatriation of cultural property, as Pacific Islanders ask museums around the world for the return of sacred art and artefacts and human remains. Recently a number of cooperative ventures have developed in which major museums present artworks on long term loan to Pacific institutions. The Australian National Museum, for example, has placed a famous Erromango barkcloth from its collection on exhibition at the National Museum of Vanuatu. Another response has been to recognize the principle of cultural ownership in which Pacific Islanders serve as consultants and advisors to institutions about the works of art in their care.

The Pacific museums and institutions have often fostered the growth of individual artists as well as artistic movements by providing artists with training and studio space and by promoting their work. Perhaps the most famous example of this is the group of artists from the northern Central Highlands of Papua New Guinea, who moved to Port Moresby to work in various jobs and learnt painting at the Creative Arts Centre (which became the National Arts School in 1976). This group includes some of the most celebrated of that country's artists: Timothy Akis, Jakupa Ako, Ruki Fame, Cecil King Wungi, and Matthias Kauage. Like many artists working in Western idioms at the time, they had been raised in the villages and were adults before they became artists. All have maintained close ties with their villages, typically spending long periods there living with their families and tending the land and then returning to Port Moresby for intensive periods of artistic production. This fits the traditional pattern in which there was a burst of creative activity before festivals and also the way in which an image was conceptualized before it was

121. MATTHIAS KAUAGE *Okuk's Son at Port Moresby Airport*, 1987. Synthetic polymer on canvas, 5'4" x 6' (1.62 x 1.83 cm). Australian Museum, Sydney.

Highlands artistic traditions inspire Kauage's use of rich, contrasting colors and multiple patterns, including chevrons, checkerboards, and striations. This painting depicts the return of Okuk's son from the United States for his father's funeral. The use of red, white, and blue stripes on the plane and the American flag in the lower right-hand corner help to identify the event. On another level, the image addresses the relationship between humans and machines in the modern world.

executed. Many of the artists make small works for exhibition and sale as well as public commissions and other large-scale projects. Their subjects include reflections on village life, the urban scene, and important events in national history. Matthias Kauage, for example, executed an ambitious series of oil paintings commemorating the life and death of his clansman, the Deputy Prime Minister Iambakey Okuk (FIG. 121).

Artists themselves have often played an active role in the development of these institutions and the establishment of artists' groups. One of the most famous of these organizations is Hawaii's Hale Nau'a III, founded by the sculptor Rocky Jensen. An association of contemporary native artists, it is dedicated to their training and the promotion of their work. More recently, the fiber artist Maile Andrade has helped to form the Council of Contemporary Arts, or Aha Noeau'Oiwi (ANO), which will focus on education and outreach programs. In the Solomon Islands, a group of artists based in Honiara have recently banded together to form the Artists Association of the Solomon Islands. Their first exhibition, based on the theme "Our Environment," was held in the National Museum in 1994. The exhibition included paintings and drawings, prints, dyed cloth and T-shirts, representing a refusal to work within the media hierarchies of Western art traditions and an affirmation of the many arenas in which twentieth-century Solomon artists must and do work. The group's efforts have attracted the attention of the Ministry of Culture and Tourism, which has signaled its interest in greater support for contemporary artists.

Confronting the Past: The Genealogy of the Present

Many contemporary Pacific artists working in Western media share a concern with cultural traditions, seeking to understand their significance for the present and the future. No single image of tradition emerges from this visual exploration: the past is as multifaceted and open to interpretation as the present, and tradition is not fixed but contested. Although Western audiences may rightly

perceive a connection to a post-modern sensibility that values multiple interpretations and pastiche as strategies of representation, this is not a new process in the Pacific. In many ways this approach can be seen as a new expression of a long-standing Pacific practice of exploring the relevance of history and tradition through the visual arts. Polynesian peoples, for example, contest the genealogies that allow individuals to claim titles and their privileges, a process that often centers on images that make *mana*, power derived from the ancestors, manifest in this world (see Chapter Three). In the men's houses of the Sepik River, clan members gather to hear orators standing at the debating chair argue their history and the legacy of the legendary clan founders, the sacred names and totems that empower the living and enable them to succeed (see Chapter One). What is new today is that many artists working in urban settings and with Western-style media feel a self-conscious need to reconnect with traditions and to assert an identity from which they have been separated by urban migration, missionary activity, and the colonial legacy.

Jaqueline Fraser's work, for example, addresses the complexities of tradition and identity in post-colonial New Zealand. Fraser herself is both profoundly connected to her Maori heritage and descended from the first European settlers of Otago. *The Deification of Mihi Waka*, a sculpture executed in plastic-coated electrical wire, plays on the ironies of naming a sacred mountain after a colonial woman (FIG. 122). "Mihi Waka" is the Maori transliteration of "Mrs Walker," the name of a European woman who lived by a sacred mountain at Puakaunui, near the Otago Peninsula. The mountain itself was named Mihi Waka after her, perhaps to acknowledge that she, too, was connected to the land. Fraser, who is from this region, notes that upon entering the *marae*, or ceremonial center, the local Maori introduce themselves and address the mountain as Mihi Waka. *The Deification of Mihi Waka* is one of a series of portraits of this woman in which Fraser imaginatively re-creates the essential aspects of Mihi Waka's life, representing her in conjunction with images of her daughter,

122. JAQUELINE FRASER
The Deification of Mihi Waka, 1995. Plastic-coated electrical wire. Sarjeant Gallery, Wanganui, New Zealand.

At first glance this work seems playful in its lively silhouette and use of a common material, electrical wire, which children often use to make toys. However, the process of knotting, binding, and tying by which the sculptures are made relates to practices of wrapping and knotting used throughout Polynesia to establish *tapu*, the quality of being invested with power or *mana*.

her dog, a bell for summoning workers from the field, and her walking stick. All of these images highlight Mrs Walker's relationship to the land she owned, land that was taken from the Maori but that became her home, her sustenance, and her legacy.

Gender relations, too, are debated as part of the rethinking of traditional roles in the modern world. In the arts as well as in social life, the politics of tradition and gender are complex and intertwined, and many island women recognize that a call by island men for a return to traditional ways and values will not automatically mean a return to pre-contact patterns of gender relations. The Vanuatu poet Grace Mera Molisa writes eloquently of the dilemma,

"Custom"
misapplied
bastardised
murdered
a frankenstein
corpse
conveniently
recalled
to intimidate
women,

which is evident both in images of women and in women's artistic practice. New Zealand Maori women who carve and Papua New Guinea women who work as professional artists have begun to challenge the limitations of traditional gender roles in the arts. Many others explore through images of women and men the ways that gender roles, like other social roles, have changed. Among his paintings of twentieth-century Papua New Guinea, Oscar Towa creates images of women that are ambiguous commentaries on modernity and tradition. In *A Girl Rings her Boyfriend*, a woman who wears traditional dress, including a fiber apron and feather headdress, uses a payphone to talk with her boyfriend (FIG. 115). Closer examination reveals her polished nails and a bag that looks like a striped *bilum* but is worn like a Western-style handbag, signs of her boldness that are just as obvious as placing a telephone call to a man. The displayed posture in which she sits, often used to depict female ancestors as images of fecundity and prosperity, seems incongruous, perhaps underscoring Towa's perception of the inappropriateness of her behavior.

Nowhere is this sense of cultural blending, a Pacific modernity evolving in the presence of tradition, stronger than in Auckland, the largest Polynesian city in the world, populated

by Maori, Tongans, Samoans, Cook Islanders, and others. Pacific Sisters, a loose collective of performance artists based in Auckland, marks the intersection of the urban environment, the international art scene, and Polynesian culture (FIG. 123). Pacific Sisters performances are multimedia presentations incorporating music, dance, video, and spectacular costumes. Rosanna Raymond, a spokesperson for the group, says "Pacific Sisters is ever-evolving, it's never static, it's multi-disciplinary. We're like a Polynesian version of Andy Warhol's Factory: artist, designers, fashion, street, people." But unlike Warhol's Factory, Pacific Sisters has a serious interest in reconnecting with tradition, performing Polynesian legends and stories, and at the Seventh Pacific Festival of Arts held in Western Samoa in 1996, taking part in a kava ceremony. Their work is not only a play of fantasy, it is also an exploration of identity.

In the Pacific today, it is this continuing dialogue between tradition and change, past and present, that shows the strength of the arts. Artists work in villages and cities, for governments and clans, with media and images that have been used for thousands of years and that are a product of the moment. Pacific art today means women making *bilum* in the highlands of New Guinea, Pacific Sisters performing in Auckland, tattoo artists such as Lese Li'o working in Samoa, Tekiraua Urio painting murals in Kiribati. In all these places and within all these artistic practices, cultural traditions continue to evolve and to be contested, constantly creating and renewing meaning. A Maori proverb from the weaver and textile artist Erenora Puketapu-Hetet suggests that tradition can open a space for the multiplicity of artistic practice and that the visual arts, as a vehicle for tradition in its many forms, are a powerful expression of cultural vitality and renewal for Pacific peoples today:

Nau te rourou
Naku te rourou
Ka ora te tangata

With your basket [of knowledge]
And my basket [of knowledge]
The people will be assisted.

123. PACIFIC SISTERS Performance by the group at the Seventh Pacific Festival of Arts, Western Samoa, 1996.

The costumes worn by the Pacific Sisters juxtapose tapa and raffia with coconut-shell bras, lycra, and polyester. They are a form of body ornament that is hip and playful, but also full of meaning, helping to re-create the spirit of the Polynesian legends that the group frequently performs.

	New Guinea *(Papua New Guinea and Irian Jaya)*	Island Melanesia
BCE (before the common era, or BC)	**45,000** Papuan-language speakers settle New Guinea and Australia **25,000** Flaked stone tools present at Kosipe, central highlands **8,000** Beginning of stone sculpture traditions in highlands **4,000** Highlands people drain swamps, possibly for taro cultivation	**33,000** Papuan-language speakers settle New Ireland **27,000** Papuan-language speakers settle Solomon Islands **18,000** Evidence for exchange of stone resources between New Britain and New Ireland **3,000** Austronesian expansion into Island Melanesia begins; Vanuatu, New Caledonia settled **1,500** Lapita culture expands rapidly through Island Melanesia **500** Lapita pottery becomes increasingly plain
0–500 CE (common era, or AD)	**0–1200** Oposisi pottery and tool traditions along the Central Province coast show affinities to Lapita sites **700–1400** Pottery from the southeastern coast shows affinity with Philippine traditions, suggests presence of Southeast Asian traders	**0–100** Distinctive Lapita artifacts disappear from the archaeological record; Lapita possibly absorbed into surrounding populations **c. 500** Pottery disappears from archaeological record, New Britain; Monumental stone enclosures built on Mari Island, New Caledonia
501–1000 CE	**1000–1200** Inland Papuan speaking peoples expand toward coast, forcing coastal Austronesians into specializing in fishing and trading economy	**c. 600–1300** Sohano and Hangan cultures on Solomon Islands; emphasis on shell ornaments and tools
1001–1550 CE	**c. 1200** Comb-incised pottery appears around Port Moresby, precursor of contemporary Motu wares **1500s** Dutch begin to assert control over northern New Guinea through Tidore	**c. 1200** Comb-incised pottery in southern New Ireland, northern Solomons **c. 1350** The leader Roy Mata arrives in central Vanuatu; known through oral traditions, his burial is found 1967

Polynesia	Micronesia

Polynesia

300 Lapita settlers established in Fiji
200 Lapita settlers in Tonga
000 Lapita settlers in Samoa
00–300 Distinctive Polynesian culture begins to emerge
00 Settlement of the Marquesas Islands from western Polynesia

00–500 Settlement of Hawaii and Easter Island, probably from Marquesas

00 First known settlement of Society Islands
00–1000 Settlement of Cook Islands
000 Settlement of New Zealand from Society Islands
950 Traditional genealogical origins of the Tui Tonga dynasty, Tonga

1400 Beginning of intensive irrigation and building of large-scale temple structures on Hawaii
000–1550 Building of monumental *ahu* with statues on Easter Island

Micronesia

c. 1500 "Marianas Red" pottery on Mariana Islands suggests settlers of central Philippine origins
250 Possible settlement of Pohnpei by this date
50 Marshall Islands settled, probably from eastern Melanesia

0 Belau and Yap settled
0–500 Chuuk, Kosrae settled
0–1000 Plain ware ceramics manufactured on Yap

700 Earliest construction at Nan Madol, Pohnpei, Caroline Islands
800 Building erected on monumental stone pillars, Mariana Islands; plain ceramics appear
900 Nukuoro and Kapingamarangi settled
1000 Simple pottery of untempered clay supplants plainware on Yap

1200 Introduction of megalithic style at Nan Madol, Pohnpei, rise of the *saudeleur* leaders
1300–1500 Nukuoro settled by Polynesians, who adapt many aspects of Micronesian culture

1550–1800	New Guinea (Papua New Guinea and Irian Jaya)	Island Melanesia
	1595–97 Spanish explorer Luis Vaez de Torres sails through the Torres Strait between New Guinea and Australia **1642–43** Dutch navigator Abel Janszoon Tasman visits New Ireland, New Guinea **1769–1771** English navigator James Cook visits New Guinea on first Pacific voyage	**1567–69** Spanish explorer Alvaro de Medaña visits the Solomon Islands during his Pacific voyage **1605–06** Spanish explorers Pedro Fernandez de Quiros and de Torres visit Espiritu Santo, Vanuatu **c. 1650** Islanders of West New Britain resume importing pottery from New Guinea **1699–1701** English navigator William Dampier visits New Ireland, New Britain, New Guinea **1772–1775** Cook visits Vanuatu, New Caledonia on second Pacific voyage
1801–present	**1828** Northern New Guinea declared a Dutch possession **1884** Protectorates declared by Britain in Papua, Germany in New Guinea **1905** British New Guinea becomes Papua, administered by Australia **1921** League of Nations Mandate grants administration of German New Guinea to Australia **1962** Indonesia assumes control over Dutch New Guinea, later renamed Irian Jaya **1975** Papua New Guinea declares independence of Australia	**1854** France claims New Caledonia, later establishes penal colony (1864-1897) **1885** Germany annexes the Admiralty Islands **1893** Britain declares a protectorate over the southern Solomon Islands; Germany expands its influence to the northern Solomons **1975** Vanuatu gains internal autonomy, elects Representative Assembly **1978** Solomon Islands independence, member of British Commonwealth **1980** Vanuatu gains independence of the UK and France

Polynesia	Micronesia
1550 Beginning of a period of war and social disruption on Easter Island; *ahu* building ceases, many statues toppled and destroyed	**1565** Spain claims the Mariana Islands
	c. 1600 *Saudeleur* declines in power, Pohnpei; island divided into three autonomous political units
595–97 de Medaña and de Quiros visit the Marquesas Islands and Santa Cruz	**1668** First Spanish missionaries arrive in the Mariana Islands
642–43 Tasman visits New Zealand, Tonga	**1783** English navigator Henry Wilson shipwrecked in Belau; leader's son, Lee Boo, returns with Wilson to England
721–22 Dutch navigator Jacob Roggeveen visits Easter Island, the Tuamotus, Samoa	
769–71 Cook's first voyage visits New Zealand, Society Islands	
772–75 Cook's second voyage visits New Zealand, Society Islands, Tonga, Easter Island, Marquesas Islands	
776–80 Cook's third voyage visits New Zealand, Tonga, Society Islands, Hawaii	
797 Members of the London Missionary Society settle in the Society and Marquesas Islands	
810 Kamehameha I becomes ruler of all the Hawaiian islands	**c. 1820s** Final abandonment of Nan Madol, Pohnpei
820 Overthrow of *kapu* (*tapu*) system, Hawaii; American Congregationalist missionaries arrive the following year	**1899** Spain sells Belau and other possessions to Germany
	1921 League of Nations Mandate gives control of former German possessions to Japan
840 New Zealand annexed by the UK; English settlers and Maori sign treaty of Waitangi	**1947** Establishment of US Trust Territory (Belau, Marshall Islands, northern Marianas, Caroline Islands)
843–55 War between Rewa and Bau in Fiji	**1968** Nauru achieves independence; formerly Australian Trust Territory
888 Chile takes possession of Easter Island (Rapanui)	**1975** Marianas Commonwealth Covenant allows the US territorial and military rights in the northern Mariana Islands
893 US merchants overthrow the Hawaiian queen Lili'uokalani; annexed 1900	
907 New Zealand achieves Dominion status	**1979** Kiribati becomes independent republic
959 Hawaii is granted statehood	**1981** Republic of Belau established
962 Western Samoa achieves independence	**1986** US Commonwealth status for northern Marianas; Caroline Islands become Federated States of Micronesia
970 Fiji gains independence, becomes member of the British Commonwealth	
989 Ka Pakaukau, a coalition of sixty indigenous Hawaiian groups, is formed to reassert Hawaiian sovereignty	

Glossary

ac a person (New Caledonia)

'ahu'ula feather cloak worn by the highest-ranking Hawaiian men on state occasions when going into battle (Hawaii)

aiga a landholding extended family (Samoa)

ak a person (New Caledonia)

akua mōi "the lord of the god image." A term referring to a central temple image that faced the altar and was a focus of ritual activities (Hawaii)

ali'i The hereditary elite, the highest-ranking social class (Hawaii). Forms of this word (*ariki, ari'i*) are used throughout Polynesia to indicate hereditary elite

amalau a community spirit house where figures depicting spirits reside (Nukuoro)

anu ancestral spirit (Caroline Is.)

ari'i see *ali'i*

ariki see *ali'i*

atua a god, sometimes a deified ancestor (Marquesas Islands). Variations on this word are used throughout Polynesia to refer to the gods

awa see kava (Hawaii)

bagei married; also the name of Dilukai's brother (Belau)

bai a men's house (Belau); the term probably derives from *balai* or *bale* (Indonesia)

balai see *bai*

bale see *bai*

bilum a netbag usually made by women in the highlands of Papua New Guinea

bioma an ancestral figure carved of wood and displayed with the skulls of ancestors, pigs, and crocodiles in the men's house (Papua New Guinea)

bisj a memorial pole carved to commemorate the spirits of the deceased when the community is about to avenge them (Asmat, Irian Jaya)

bisj mbu ceremony to display bisj poles (Asmat, Irian Jaya)

bolyim a cult house among the Wahgi people (Papua New Guinea)

boti a patrilineal clan (Kiribati)

boulaibi bounbout a staff made of greenstone (New Caledonia)

bride wealth a payment of currency or ritual objects, made by the groom's family to the bride's family to cement the relationship

bung wantaim "true coming together" (Papua New Guinea)

civaconovono an ivory and shell breastplate worn by high-ranking leaders (Fiji)

da a generic term for bird (northern New Caledonia)

damarau large ceramic jars used to store sago (Iatmul, Papua New Guinea)

duk duk a society that promotes social control among the Tolai; also the masks that represent male spirits (New Britain)

fale a house (Samoa)

falefol a large ceremonial house (Satawan atoll, Mortlake Islands, Caroline Islands)

fono the governing council of a village (Samoa)

gange plot of land serving as a sanctuary (Kiribati)

gawa tao a schematic image of a totem, painted on canoes (Gogodola, Papua New Guinea)

geru a board used in the Pig Festival among the Wahgi people (Highlands, Papua New Guinea)

gope oval plaque depicting a spirit or ancestor (Gulf of Papua, Papua New Guinea)

haku'ohi'a "god of the 'ohi'a" (Hawaii); a term referring to a central temple image that faced the altar and was a focus of ritual activities (Hawaii)

haus tambaran pidgin word for ceremonial house (Papua New Guinea)

hei-tiki an ancestor pendant usually made of greenstone (New Zealand)

heiau a temple enclosure (Hawaii)

hemlaut a mask representing a powerful spirit (Sulka, New Britain)

hevehe a female sea spirit, daughter of *ma-hevehe*, represented by a monumental mask (Elema, Papua New Guinea)

hula a dance (Hawaii)

hura a dance performed by young, high-ranking women (Tahiti, the Society Islands)

iBūbūraunibete a wooden dish for *yaqona*, used by priests (Fiji)

'ie toga a finely woven pandanus mat (Samoa)

igah sacredness of women (Malekula, Vanuatu)

ikat weaving technique, typical of Indonesia, in which the threads are dyed before they are woven

ileo sacredness of men (Malekula, Vanuatu)

in square mat for clothing (Marshall Islands)

jipae masked dancer who represents the spirit of a deceased person (Asmat, Irian Jaya)

kahiri a feather wand used as a sign of high status by the elite (Hawaii)

kahoa feather ornament (Tonga)

kahuna ritual specialist (Hawaii)

kainga an ancestral estate (Kiribati)

kaona veiled meaning or symbolism in poetry, dance, or music (Hawaii)

kara-ut a fiber and boar-tusk ornament worn by dancers and warriors (Abelam, Papua New Guinea)

karkarau human protective figure or frog (Humboldt Bay, Irian Jaya)

kava a mildly narcotic drink made from the roots of the *Pipen methysticum* plant, used on social and spiritual occasions in Polynesian cultures

kele the color black (Kwoma, New Guinea)

kesoko dangerous water spirit (Solomon Islands)

kihei garment (Hawaii)

korambo a ceremonial house (Abelam, Papua New Guinea)

koréri process of rejuvenation and generation (Papua New Guinea)

korwar a wooden ancestor figure (Geelvink Bay, Irian Jaya)

kōwhaiwhai scroll patterns on the rafters of a meeting house (New Zealand)

kula a cycle of exchange based on shell necklaces and armbands (Trobriand Islands, Papua New Guinea)

kulap a chalk mortuary figure (New Ireland)

la-ni "road of riches"; a term referring to the ceremonial exchange of greenstone (New Caledonia)

langambas women's grade society (Malekula, Vanuatu)

lapas women's grade society (Malekula, Vanuatu)

lei niho palaoa a neck ornament composed of an ivory hook suspended from human hair bundles (Hawaii)

ma-hevehe female sea spirit (Elema, Papua New Guinea)

machiy a ceremonial cloth used by leaders to mark rites of passage (Fais, Micronesia, Caroline Islands)

mahiole crested feather helmet worn by the highest ranking members of the *ali'i,* the elite (Hawaii)

mahoni a wealthy and powerful man, a community leader (New Britain)

mai masks that are performed during initiations and to mark other special events (Iatmul people, Papua New Guinea)

makahiki season in which commoners gave feathers and other goods to the elite as tribute (Hawaii)

malae a ceremonial ground, usually located in the center of the village (Samoa); forms of this word (*marae, me'ae*) are used throughout Polynesia

malangan a mortuary ritual and initiation ritual that involves feasting, dances, and the display of wood sculpture (New Ireland)

mana an Austronesian word used throughout the Pacific to indicate a spiritual power or force that can be vested in people or objects

manahune a commoner (Tahiti, the Society Islands)

manaia a spirit figure that represents a profile human figure sometimes incorporating animal and bird characteristics (Maori, New Zealand)

manatunga "standing mana" refers to Maori customs and lifeways (Maori, New Zealand)

maneaba a large meeting house used by the community (Kiribati)

manu-tara sooty tern (Easter Island)

marae see *malae*

maro a decorated skirt (Lake Sentani/Humboldt Bay, Irian Jaya)

mbul banana-fiber cloth used for ritual purposes and made by men (Yap, Caroline Islands)

menehune legendary race of small people (Hawaii); commoners (e.g. Tahitian *manehune*) in other Polynesian languages

mindja a dance to celebrate the building of a new spirit house (Abelam, Papua New Guinea)

mla "writing": patterns on masks (Sulka, New Britain)

moai kavakava a wooden sculpture depicting an emaciated male figure (Easter Island)

moiety a group of clans

mon "thoughts," used to indicate the inspiration of tattooists (Maisin, Papua New Guinea)

mon shaman (Geelvink Bay, Irian Jaya)

nduduwine ancestral spirits (Abelam, Papua New Guinea)

nguzunguzu canoe figurehead depicting a spirit that can frighten harmful water spirits (Solomon Islands)

ngwalndu ancestral spirit (Abelam, Papua New Guinea)

ngwalngwal ancestral spirits (Abelam, Papua New Guinea)

nieded square mat for clothing (Marshall Islands)

noute feather and fiber headdress (Abelam, Papua New Guinea)

nu'u a village (Samoa)

o kono stone club (New Caledonia)

oahi a type of rough lava used to polish wooden bowls (Hawaii)

oio a type of stone used to polish wooden bowls (Hawaii)

ondoforo men's houses (Lake Sentani, Irian Jaya)

oogis supremely functional or attractive (Mariana Islands)

ourrot leading women of village (Belau)

pa a fortified village, usually situated on a hill or headland

(Maori, New Zealand)

pahu a drum (Austral Islands)

paina feast to honour deceased relatives (Easter Island)

petroglyph an image carved, ground, or pecked into a rock surface, such as a boulder or cliff face

po'ena a high-ranking warrior (Austral Islands)

rambaramp painted and modeled statues used to preserve the skulls of important men (Malekula, Vanuatu)

riteak "writing': patterns on masks (Sulka, New Britain)

rongorongo sacred tablet covered with engraved glyphs (Easter Island)

sago a type of palm; the pith provides a starchy flour used as a staple food by the Asmat, Iatmul, and other Pacific peoples

sakema an artist (Gogodola, Papua New Guinea)

salago lapila an anthropomorphic feathered image that represents a male clan ancestor (Gogodola, Papua New Guinea)

saudeleur title for rulers associated with the Nan Madol complex (Pohnpei)

sese a large mat (Pentecost Island, Banks Islands, Vanuatu)

sisi a floral waist decoration (Tonga)

soutapuanu initiatory society that organized the performance of masked dancers (Satawan atoll, Mortlake Islands, Caroline Islands)

supplementary weft a weaving technique in which extra threads are worked through the warp to create special motifs

suque a grade society (northern Vanuatu)

tabua whale tooth used as a sign of prestige and in ceremonial exchanges (Fiji)

Tabuhaus German word for sacred house or men's house (Papua New Guinea)

tahunga see *kahuna*

tahunga whakairo master architect (Maori, New Zealand)

tangata-manu "bird-man," a ritual

position (Easter Island)

taonga "the treasures of the people" used to describe art and precious artefacts (Maori, New Zealand)

tapu sacred or restricted; the quality of being invested with mana (Austronesian cultures)

tapuanu mask (Satawan atoll, Mortlock Group, Caroline Islands)

tatanua a type of mask often performed during *malangan* ceremonies (northern New Ireland)

tavine motar "women of distinction," one who has achieved high rank (Banks Islands, Vanuatu)

te marae sacred place (Kiribati)

teneriffe openwork woven designs (Marshall Islands)

ti'i image of deified ancestor (Tahiti and Society Islands)

tiki see ti'i

tino ancestral figure (Nukuoro)

tivaevae manu appliquéd quilt (Cook Islands)

tivaevae taorei piecework quilt (Cook Islands)

tsip small mat (Pentecost Island, Banks Islands, Vanuatu)

tsjemen openwork projection that forms part of the topmost figure on a *bisj* pole (Asmat, Irian Jaya)

tubuan mask depicting female spirit (Tolai, New Britain)

tukutuku woven design (Maori, New Zealand)

uli mortuary rituals for high-ranking individuals (Mandak people, New Ireland)

upeti rectangular tablet used to make patterns on barkcloth (western Polynesia)

u'u a club with a Janus-faced head (Marquesas Islands)

vaygu'a shell valuables exchanged in the *kula* trade (Trobriand Islands, Papua New Guinea)

waa faten paddled war canoe (Chuuk, Caroline Islands)

wagen spirit that helps the community, often personified in the orator's chair (Iatmul, Papua New Guinea)

waiwaia spirit child (Trobriand Islands)

waku taua war canoe (Maori, New Zealand)

wharenui meeting house (Maori, New Zealand)

whare whakairo meeting house (Maori, New Zealand)

yalulawei beneficent water spirit (Caroline Islands)

yalu spirit (Caroline Islands)

yaqona see *kava*

yipwon a spirit figure represented by a hook figure (Karawari River, Papua New Guinea)

Bibliography

The most comprehensive treatment of Pacific Islands art available

KAEPPLER, A.L., C. KAUFMANN, and D. NEWTON, *L'Art océanien* (Paris: Citadelles & Mazenod, 1993)
Other useful surveys include
BOUNOURE, V., *Vision d'Océanie* (Paris: Editions Dapper, 1992)
BRAKE, B., J. MCNEISH, and D. SIMMONS, *Art of the Pacific* (New York: Harry N. Abrams, 1979)
CORBIN, G., *Native Arts of North America, Africa, and the South Pacific* (New York: Harper & Row, 1988)
GATHERCOLE, P., A.L. KAEPPLER, and D. NEWTON, *Art of the Pacific Islands* (Washington, DC: National Gallery of Art, 1979)
GUIART, J., *Océanie* (Paris: Editions Gallimard, 1963)
PHELPS, S., *Art and Artefacts of the Pacific, Africa and the Americas: The James Hooper Collection* (London: Hutchinson, 1976)
SCHMITZ, C.A., *Oceanic Art: Myth, Man, and Image in the South Seas* (New York: Harry N. Abrams, 1971)
STÖHR, W., *Kunst und Kultur aus der Südsee: Sammlung Clausmeyer Melanesien* (Köln: Rautenstrauch-Joest-Museum für Vлlkerkunde, 1987)
THOMAS, N., *Oceanic Art* (London: Thames and Hudson, 1995)
WARDWELL, A., *Island Ancestors: Oceanic Art from the Masco Collection* (Seattle and Detroit: University of Washington Press in association with Detroit Institute of Arts, 1994)

The volumes of essays from the Pacific Arts Association conferences present a wide-ranging introduction to important topics in and approaches to Pacific arts:

DARK, P., and R.G. ROSE (eds), *Artistic Heritage in a Changing Pacific* (Honolulu: University of Hawaii Press, 1993)
HANSON, A., and L.H. HANSON (eds), *Art and Identity in Oceania* (Honolulu: University of Hawaii Press, 1990)
MEAD, S.M. (ed.), *Exploring the Visual Arts of Oceania: Australia, Melanesia, Micronesia, and Polynesia* (Honolulu: University of Hawaii Press, 1979)
MEAD, S.M., and B. KERNOT (eds), *Art and Artists of Oceania* (Palmerston North: Dunmore Press, 1983)

For a general history of early European exploration of the Pacific, J.C. BEAGLEHOLE's *The Exploration of the Pacific*, 3rd ed. (Stanford: Stanford University Press, 1966) and O.H.K. SPATE's *The Pacific since Magellan*, 3 vols (Canberra: Australian National University Press, 1979–88) are still very good. For Western audiences, the voyages of Captain James Cook, which took place between 1769 and 1780, have provided some of the quintessential images of the Pacific and its peoples. Essential sources on the art created and collected by the Cook voyagers include

KAEPPLER, A.L., *"Artificial Curiosities" being an Exposition of Native Manufactures Collected on the Three Pacific Voyages of Captain James Cook, R.N.*, Bernice P. Bishop Museum Special Publication 65 (Honolulu: Bishop Museum Press, 1978)
JOPPIEN, R., and B. SMITH, *The Art of Captain Cook's Voyages*. Vol. 1, *The Voyage of the Endeavour 1768–1771* (1985); Vol. 2, *The Voyage of the Resolution and Adventure 1772–1775* (1985); Vol. 3, *The Voyage of the Resolution and Discovery 1776–1780* (1988); (Vols 1 and 2: New Haven and London: Yale University Press. Vol. 3: Melbourne: Oxford University Press and Australian Academy of the Humanities)
SMITH, B., *European Vision and the South Pacific*, 2nd edn (New Haven and London: Yale University Press, 1985)

Missionaries have often contributed a great deal to Pacific scholarship. The accounts of the English missionary William Ellis are particularly valuable, *Narrative of a Tour thorugh Hawaii, or Owhyhee* (1827. Reprinted, Rutland: Tuttle, 1979) and *Polynesian Researches* (1829. Reprinted, London: Dawsons, 1967). Gift-giving and exchange are major areas of research on Pacific arts and cultures, especially as they affect intercultural contact and gender relations. Three recent studies are

STRATHERN, M., *The Gender of the Gift* (Berkeley and London: University of California Press, 1988)
THOMAS, N., *Entangled Objects: Exchange, Material Culture, and Colonialism in the Pacific* (Cambridge: Harvard University Press, 1991)
WEINER, A.B., *Inalienable Possessions: The Paradox of Keeping-While-Giving* (Berkeley: University of California Press, 1992)

For the study of women and women's artistic practice in the Pacific, also see

RALSTON, C., "The Study of Women in the Pacific," *The Contemporary Pacific*, 4, no. 1 (1992): 162-175.
TEILHET-FISK, J., "The Role of Women Artists in Polynesia and Melanesia," *Art and Artists of Oceania*, ed. S.M. MEAD and B. KERNOT (Palmerston North: Dunmore Press, 1983): 45–56

For general information on Pacific peoples and their early history, see

BELLWOOD, P., *Man's Conquest of the Pacific* (New York: Oxford University Press, 1979)
BELLWOOD, P., J. FOX and D. TRYON (eds), *The Austronesians: Historical and Comparative Perspectives* (Canberra: Australian National University, 1995)
KIRCH, P.V., *The Evolution of the Polynesian Chiefdoms* (Cambridge and New York: Cambridge University Press, 1984)
OLIVER, D., *Oceania: The Native Cultures of Australia and the Pacific Islands* (Honolulu: University of Hawaii Press, 1989)

Cross-cultural studies of specific media and forms include

CARPENTER, E., and C. SCHUSTER, *Patterns that Connect: Social Symbolism in Ancient and Tribal Art* (New York: Harry N. Abrams, 1996)

HADDON, A.C., and J. HORNELL, *Canoes of Oceania*, 3 vols, Bernice P. Bishop Museum Special Publications, 27, 28, 29 (Honolulu: Bishop Museum Press, 1936)

RUBIN, A. (ed.), *Marks of Civilization: Artistic Transformations of the Human Body* (Los Angeles: Museum of Cultural History, UCLA, 1988)

TAVARELLI, A. (ed.), *Protection, Power, and Display: Shields of Island Southeast Asia and Melanesia* (Chestnut Hill, MA: Boston College Museum of Art, 1995)

WEINER. A.B., "Why Cloth? Wealth, Gender and Power in Oceania," *Cloth and Human Experience*, eds. WEINER, A.B., and J. SCHNEIDER (Washington, DC, Smithsonian Institution Press, 1989): 33–72

The following sections list sources relevant to each chapter.

INTRODUCTION

BELL, L., *Colonial Constructs: European Images of Maori, 1840–1914* (Auckland: Auckland University Press, 1992)

CLIFFORD, J., "On Ethnographic Allegory," *Writing Culture: The Poetics and Politics of Ethnography*, ed. J. CLIFFORD and G.E. MARCUS (Berkeley: University of California Press, 1986): 98–121

GLADWIN, T., *East is a Big Bird: Navigation and Logic on Puluwat Atoll* (Cambridge: Harvard University Press, 1970)

GREEN, R.C., "Early Lapita Art from Polynesia and Island Melanesia: Continuities in Ceramic, Barkcloth, and Tattoo Decorations," *Exploring the Visual Arts of Oceania*, ed. S.M. MEAD (Honolulu: University of Hawaii Press, 1979): 13–31

HANSON, F.A., "Female Pollution in Polynesia?," *Journal of the Polynesian Society*, 91 (1982): 335–81

KEESING, R., "Rethinking Mana," *Journal of Anthropological Research*, 40, no. 1 (1984): 137–56

MARGUERON, D., *Tahiti dans toute sa littérature* (Paris: Editions l'Harmattan, 1989)

NEWTON, D., "Reflections in Bronze: Lapita and Dong-Son Art in the Western Pacific," *Islands and Ancestors: Indigenous Styles of Southeast Asia*, ed. J.P. BARBIER and D. NEWTON (New York: Metropolitan Museum of Art, 1988): 10–23

RUBINSTEIN, D.H., "The Social Fabric: Micronesian Textile Patterns as an Embodiment of Social Order," *Mirror and Metaphor: Material and Social Constructions of Reality*, eds D.W. INGERSOLL and G. BRONITSKY (Lanham: University Press of America, 1987): 63–82

SHORE, B., "*Mana* and *Tapu*," *Developments in Polynesian Ethnology*, ed. A. HOWARD and R. BOROFSKY (Honolulu: University of Hawaii Press, 1989): 137–73

CHAPTER ONE

New Guinea

CRAWFORD, A.L., *Aida: Life and Ceremony of the Gogodala* (Bathurst: Robert Brown & Associates, 1981)

GERBRANDS, A.A. (ed.), *The Asmat of New Guinea: The Journal of Michael Rockefeller*. (New York: Museum of Primitive Art, 1967)

GREUB, S. (ed.) *Art of Northwest New Guinea From Geelvink Bay, Humboldt Bay, and Lake Sentani* (New York: Rizzoli, 1992)

— (ed.), *Authority and Ornament: Art of the Sepik River* (Basel: Tribal Art Centre, 1985)

HAUSER-SCHÄUBLIN, B., *Leben in Linie, Muster und Farbe: Einführung in die Betrachtung aussereuropaischer Kunst am Beispiel der Abelam, Papua-Neuguinea* (Basel: Birkhauser, 1989)

—, "The Mai Masks of the Iatmul," *Oral History*, 11, no. 2 (1983): 1–53

KOOIJMAN, S., *The Art of Lake Sentani* (New York: The Museum of Primitive Art, 1959)

LUTKEHAUS, N. (ed.), *Sepik Heritage: Tradition and Change in Papua New Guinea* (Durham: Carolina Academic Press, 1990)

MAY, P., and M. TUCKSON, *The Traditional Pottery of Papua New Guinea* (Sydney: Bay Books, 1982)

MOORE, D.R., *Arts and Crafts of Torres Strait*, Shire Ethnography, 10 (Aylesbury: Shire Publications, 1989)

NEWTON, D., *Art Styles of the Papuan Gulf* (New York: Museum of Primitive Art, 1961)

—, *Crocodile and Cassowary: Religious Art of the Upper Sepik River, New Guinea* (New York: Museum of Primitive Art, 1971)

—, *Massim: Art of the Massim Area, New Guinea* (New York: The Museum of Primitive Art, 1975)

—, *New Guinea Art in the Collection of the Museum of Primitive Art* (New York: The Museum of Primitive Art, 1967)

O'HANLON, M., *Reading the Skin: Adornment, Display and Society among the Wahgi* (London: British Museum Publications, 1989)

—, *Paradise: Portraying the New Guinea Highlands* (London: British Museum Press, 1993)

SCHNEEBAUM, T., *Embodied Spirits: Ritual Carvings of the Asmat* (Salem: Peabody Museum of Salem, 1990)

SCODITTI, G., *Kitawa: A Linguistic and Aesthetic Analysis of Visual Art in Melanesia*, Approaches to Semiotics, 83 (Berlin and New York: Mouton de Gruyter, 1990)

SMIDT, D. (ed.), *Asmat Art: Woodcarvings of Southwest New Guinea* (Leiden: Rijksmuseum voor Volkenkunde and Periplus Editions, 1993)

STRATHERN, A., and M. STRATHERN, *Self-Decoration in Mount Hagen* (London: Gerald Duckworth, 1971)

WEINER, A.B., *The Trobrianders of Papua New Guinea* (New York: Harcourt Brace Jovanovich, 1988)

—, *Women of Value and Men of Renown* (Austin: University of Texas Press, 1976)

CHAPTER TWO

Island Melanesia

The source of the Giacometti quote is Georges Charbonnier *Le monologue du peintre* (Paris: Gallimard, 1959). The publications of the research expedition sponsored by the Hamburg Museum Für Völkerkunde (*Ergebnisse der Südsee-Expedition 1908–1910*, 13 vols, Hamburg: Friederichsen, de Bruyter, 1914–38) are an invaluable source for Melanesia. Other important sources are BADNER, M., "Admiralty Island

'Ancestor' Figures?," *Exploring the Visual Art of Oceania*: 227–37

—, *The Figural Sculpture and Iconography of Admiralty Island Art* (Ph.D. dissertation, Columbia University, 1968)

BONNEMAISON, J. (ed.) *Arts de Vanuatu* (Honolulu: University of Hawaii Press, 1996)

BOULAY, R., *De Jade et de nacre: Patrimoine artistique kanak* (Paris: Réunion des Musées Nationaux, 1990)

CODRINGTON, R.H., *The Melanesians: Studies in their Anthropology and Folk-lore* (Oxford: Clarendon Press, 1891)

CORBIN, G., "The Art of the Baining: New Britain," *Exploring the Visual Art of Oceania: Australia, Melanesia, Micronesia, and Polynesia*, ed. S.M. MEAD (Honolulu: University Press of Hawaii, 1979): 159–79

—, "The Central Baining Revisited: 'Salvage' Art History among the Kirak and Uramot Baining of East New Britain, Papua New Guinea," *RES*, 7/8: 44–69

DEACON, A.B., *Malekula: A Vanishing People in the New Hebrides*, ed. C.H. WEDGEWOOD (Oosterhout: Anthropological Publications, 1970)

ERRINGTON, F.K., *Karavar: Masks and Power in a Melanesian Ritual* (London and Ithaca: Cornell University Press, 1974)

GIFFORD, P.C., *The Iconology of the Uli Figure of Central New Ireland* (Ph.D. dissertation, Columbia University, 1974)

LINCOLN, L. (ed.), *Assemblage of Spirits: Idea and Image in New Ireland* (New York and Minneapolis: George Braziller and the Minneapolis Institute of Arts, 1987)

MESCAM, G., and D. COULOMBIER, *Pentecost: An Island in Vanuatu* (Suva: University of the South Pacific, 1989)

OHNEMUS, S., *Zur Kultur der Admiralitäts-Insulaner in Melanesien: Die Sammlung Alfred Buhler im Museum für Völkerkunde Basel* (Basel: Museum für Völkerkunde, 1996)

POWDERMAKER, H., *Life in Lesu: The Study of a Melanesian Society in New Ireland* (London: Williams & Norgate, 1933)

SPEISER, F., *Ethnology of Vanuatu: An Early Twentieth-century Study* (Trans. by D.Q. Stephenson; Bathurst: Crawford House Press, 1900)

SPRIGGS, M., *The Island Melanesians* (Oxford: Blackwell, 1987)

WAITE, D., *Art of the Solomon Islands from the Collection of the Barbier-Müller Museum* (Geneva: Musée Barbier-Müller, 1983)

CHAPTER THREE
Polynesia

ARBEIT, W., *Tapa in Tonga* (Honolulu: Palm Front Productions, 1994)

BARROW, T., *The Art of Tahiti and the Neighbouring Society, Austral and Cook Island.s* (London: Thames and Hudson, 1979)

CLUNIE, F., *Yali i Viti: Shades of Viti: A Fiji Museum Catalogue* (Suva: Fiji Museum, 1986)

COX, J.H., and W.H. DAVENPORT, *Hawaiian Sculpture*, 2nd edn (Honolulu: University of Hawaii Press, 1988)

D'ALLEVA, A., "Representing the Body Politic: Status, Gender, and Anatomy in Eighteenth-century Society Islands Art," *Pacific Arts* 13–14, July (1996): 1–8

DENING, G., "Sharks that Walk on Land," *Meanjin* 41 (1982): 417–37

ESEN-BAUER, H.-M. (ed.), *1500 Jahre Kultur der Osterinsel: Schätze aus dem Land des Hotu Matua* (Main am Rhein: Verlag Philipp von Zabern, 1989)

GELL, A., *Wrapping in Images: Tattooing in Polynesia*, Oxford Studies in Social and Cultural Anthropology (Oxford: Clarendon Press, 1993)

GATHERCOLE, P., "Contexts of Maori Moko," *Marks of Civilization: Artistic Transformations of the Human Body* (Los Angeles: UCLA Fowler Museum of Cultural History): 171–78

HOWARD, A., and R. BOROFSKY (eds.), *Developments in Polynesian Ethnology* (Honolulu: University of Hawaii Press, 1989)

IDIENS, D., *Cook Islands Art*, Shire Ethnography 18 (Princes Risborough: Shire Publications, 1990)

IVORY, C.S., "Marquesan Art in the Early Contact Period, 1774–1821" (Ph.D. dissertation, University of Washington, 1990)

—, "Marquesan *U'u*: A Stylistic and Historical Review," *Pacific Arts* 9/10 (1994)

KAEPPLER, A.L., "Art and Aesthetics," *Developments in Polynesian Ethnology*, ed. A. HOWARD and R.

BOROFSKY (Honolulu: University of Hawaii Press, 1989): 211–40

—, "Feather Cloaks, Ship Captains and Lords," Occasional Papers of Bernice P. Bishop Museum, 24, no. 6 (1970): 92-114

—, "Genealogy and Disrespect: A Study of Symbolism in Hawaiian Images," *RES*, 3 (1982): 82–107

—, "Melody, Drone, and Decoration: Underlying Structures and Surface Manifestations in Tongan Art and Society," *Art in Society: Studies in Styles, Culture and Aesthetics*, ed. M. GREENHALGH and V. MEGAW (London: Duckworth, 1978): 261–74

KOOIJMAN, S., *Tapa in Polynesia*, Bernice Pauahi Bishop Museum Bulletin 234 (Honolulu: Bishop Museum Press, 1972)

LEE, G., *Rock Art of Easter Island: Symbols of Power, Prayers to the Gods*, Monumenta Archaeologica 17 (Los Angeles: UCLA Institute of Archaeology, 1992)

MALO, D., *Hawaiian Antiquities (Mooleo Hawaii)* (trans. N. EMERSON; Honolulu: Bernice P. Bishop Museum, 1951)

MEAD, S.M. (ed.), *Te Maori: Maori Art from New Zealand Collections* (Auckland: Heinemann in association with the American Federation of Arts, 1984)

METRAUX, A., *Ethnology of Easter Island*, Bernice P. Bishop Museum Bulletin 160 (Honolulu: Bishop Museum Press, 1971)

NEICH, R., *Painted Histories: Early Maori Figurative Painting* (Auckland: Auckland University Press, 1994)

PRITCHARD, M.J., *Siapo: Barkcloth Art of Samoa* (American Samoa: Council on Culture, Arts, and Humanities, 1984)

PUKETAPU-HETET, E., *Maori Weaving* (Auckland: Pitman Publishing, 1989)

RONGOKEA, L., *Tivaevae: Portraits of Cook Islands Quilting* (Wellington: Daphne Brasell Associates Press, 1992)

ROSE, R.G., The Material Culture of Ancient Tahiti" (Ph.D. dissertation, Harvard University, 1971)

SALMOND, A., *Two Worlds: First Meetings between Maori and Europeans 1642–1772* (Auckland and London: Viking, 1991)

STARZECKA, D.C. (ed.), *Maori Art and Culture* (Chicago: Art Media

Resources, 1996)

STEINE, K. von den, *Die Marquesaner und ihre Kunste*, 3 vols (New York: Hacker Art Books, 1969)

STEVENSON, K.M., " 'Heiva': Continuity and Change of a Tahitian Celebration," *The Contemporary Pacific*, 2, no. 2 (1990): 255–78

—, "The Museum as a Research Tool: A Tahitian Example," *Artistic Heritage in a Changing Pacific*, eds. P.J.C. DARK and R.G. ROSE (Honolulu: University of Hawaii Press, 1993): 74–83

VERAIN, P., *L'ancienne civilisation de Rurutu* (Paris: Orstom, 1969)

CHAPTER FOUR
Micronesia

The publications of the research expedition sponsored by the Hamburg Museum für Völkerkunde (*Ergebnisse der Südsee-Expedition 1908–1910*, 13 vols, Hamburg: Friederichsen, de Guyter, 1914–38) are an invaluable resource for Micronesia. Other important sources are

ALKIRE, W.H., *An Introduction to the Peoples and Cultures of Micronesia* (Menlo Park: Cummings Publishing Company, 1977)

BARNETT, H.G., *Being a Palauan* (New York: Henry Holt & Co., 1960)

FELDMAN, J., and D.H. RUBINSTEIN, *The Art of Micronesia* (Honolulu: University of Hawaii Art Gallery, 1986)

HOCKINGS, J., *Traditional Architecture in the Gilbert Islands: A Cultural Perspective* (St Lucia: University of Queensland Press, 1989)

MASON, L., "Micronesian Culture,"

Encyclopedia of World Art (New York: McGraw Hill, 1964): 915–30

—, *Kiribati, A Changing Atoll Culture* (Suva: Institute of Pacific Studies of the University of the South Pacific, 1985)

MAUDE, H.E., *The Gilbertese Maneaba* (Suva: Institute of Pacific Studies and the Kiribati Extension Centre, University of the South Pacific, 1980)

MORGAN, W.N., *Prehistoric Architecture of Micronesia* (Austin: University of Texas Press, 1988)

MULFORD, J., *Decorative Marshallese Baskets* (Los Angeles: Warder Publications, 1991)

PARMENTIER, R.J., *The Sacred Remains: Myth, History, and Polity in Belau* (Chicago: University of Chicago Press, 1987)

ROBINSON, D., "The Decorative Motifs of Palauan Clubhouses," *Art and Artists of Oceania*, eds. S.M. MEAD and B. KERNOT (Palmerston North: Dunmore Press, 1983): 163–78

SUVA, INSTITUTE OF PACIFIC STUDIES AND EXTENSION SERVICES, *Kiribati: Aspects of History* (1979)

CONCLUSION

COCHRANE, S., "Art in the Contemporary Pacific," *Art Asia Pacific*, 2, no. 4 (1995): 50–59

DARK, P., "Shop Signs in Kiribati: Today's Folk Art," *Pacific Arts Newsletter*, 17 (1983): 25–6

KEESING, R., "Creating the Past: Custom and Identity in the Contemporary Pacific," *The*

Contemporary Pacific, 1 & 2 (1989): 19–42

McALOON, W., "Amidst Seas and Skies," *Art Asia Pacific*, 3, no. 4 (1996): 32–3

MOLISA, G.M., *Black Stone* (Suva: Mana Publications, 1983)

MORIARTY, L.P., "Contemporary Native Hawaiian Art," *Art Asia Pacific*, 2, no. 4 (1995): 76–81

ROSI, P.C., "Papua New Guinea's New Parliament House: A Contested National Symbol," *The Contemporary Pacific*, 3, no. 2 (1991): 289–323

SIMONS, S.C., and H. STEVENSON (eds.), *Luk Luk Gen! Look Again! Contemporary Art from Papua New Guinea* (Townsville: Perc Tucker Regional Gallery, 1990)

THURSBY, P., "The Spirit of the Solomons," *Art Asia Pacific*, 2, no. 4 (1995): 82–89

TRASK, H.-K., "Natives and Anthropologists: The Colonial Struggle," *The Contemporary Pacific*, 3, no. 1 (1991): 159–167

VAIGRO, W., "Totally Wired: Jaqueline Fraser's Poetics of Space," *Art Asia Pacific*, 3, no. 2 (1996): 76–80

VERCOE, C., and R. LEONARD, "Pacific Sisters: Doing it for Themselves," *Art Asia Pacific*, 14 (1997): 42–5

WENDT, A., "Contemporary Arts in Oceania: Trying to Stay Alive in Paradise as an Artist," *Art and Artists of Oceania*, eds S.M. MEAD and B. KERNOT (Palmerston North: Dunmore Press, 1983): 198–209

Picture Credits

Collections are given in the captions alongside the illustrations. Sources for illustrations not supplied by museums or collections, additional information, and copyright credits are given below. Numbers are figure numbers unless otherwise indicated.

page 95 detail of figure 71 © British Museum, London # LMS 19

70 Auckland Museum # 7375

71 © British Museum, London # LMS 19

72 Cambridge University Museum of Archaeology and Anthropology # Z 6099

73 © British Museum, London # 1839-4-26-8

74 Institut und Sammlung für Völkerkunde der Universität Göttingen # OZ 254 photo by Harry Haase

75 Staatliches Museum für Völkerkunde, Munich # 193, Photo S.Autrum-Mulzer

76 Peabody Museum of Archaeology and Ethnology, Cambridge MA # 53542, photo Hillel Burger

77 © British Museum, London # TAH'60

78 Cambridge University Museum of Archaeology and Anthropology # 1955-247

80 © British Museum, London # +2011

81 © British Museum, London # HAW 133

82 © British Museum, London # HAW 46

83 Fiji Museum # 55.40, photo by William Copeland

84 The Baltimore Museum of Art, Gift of Alan Wurtzburger BMA 1955.251.160

85 © British Museum, London # 1933.1.12.1

86 Carl von den Steinen, Die Marquesaner und ihre kunst, 1925, vol. I page 104

87 © Karen Stevenson, Christchurch, New Zealand

88 Pitt Rivers Museum, University of Oxford # 1886.1.1637

90 Photo John Daley, Auckland, New Zealand

91 Royal Albert Memorial Museum and Art Gallery, Exeter # 1208

92 Photo © Wendy Arbeit, Hawaii

93 National Trust Photographic Library London, photo P.Lacey

94 Auckland Museum # 160

95 © Anne E Guernsey Allen, Indiana

96 © Georgia Lee, Rapa Nui Journal-Easter Island Foundation, California

97 © Museum für Volkenkunde, Hamburg # 7970 II

page 127 detail of figure 101, photo Judy Mulford, Los Angeles

98 © Museum für Volkenkunde, Hamburg, field photograph by Wilhelm Müller-Wismar, 1909

99 The Metropolitan Museum of Art, New York, The Michael C.RockefellerMemorial Collection, Gift of Mr. and Mrs. Sidney Burnett, 1960 # 1978.412.756

100 © British Museum, London # 1875,10-2.2

101 Photo Judy Mulford, Los Angeles from the collection of Judy Mulford

102 Auckland Museum # 38740

103 © British Museum, London # 98.42

104 Fine Arts Museums of San Francisco, Gift of the Park Commission # 26168

105 Linden-Museum, Stuttgart # 118949

106 © British Museum, London # 2000

107 Paul Hambruch, *Ponape*, 1908-10, volume 7, 2nd part page 277

108 © British Museum, London # 1921.2-21.135

109 The Metropolitan Museum of Art, New York, Gift of the American Friends of the Israel Museum, 1983 # 1883.545.28.

110 © Philip Dark, Truro, Cornwall

111 Photograph from *Prehistoric Architecture in Micronesia* by William N. Morgan, Copyright © 1988. By permission of the author and the University of Texas Press, Austin

112 Photo © Adrienne L. Kaeppler 1992, Washington D.C.

113 Linden-Museum, Stuttgart # 76 310

114 Photo 1982 © Leonard Mason, Hawaii

115 © Hugh Stevenson, P.N.G. Arts Advisers, New South Wales

page 149 detail of figure 118, photo 1974 © Peter Thursby, New South Wales

116 Courtesy the artist

117 Courtesy Addison Wesley Longman, Auckland. Photo by Graham Simpson in Erenora Puketapu-Hetet, *Maori Weaving*, 1989

118 © 1974 Peter Thursby, New South Wales

119 © Philip Dark, Truro, Cornwall

120 © Hugh Stevenson, P.N.G. Arts Advisers, New South Wales

121 Australian Museum/Nature Focus, Sydney

123 © Karen Stevenson, Christchurch, New Zealand

Index